Letters from Linda M. Montano

Linda M. Montano

Edited by Jennie Klein

Routledge
Taylor & Francis Group

LONDON AND NEW YORK

First published 2005
by Routledge
2 Park Square, Milton Park, Abingdon, Oxfordshire OX14 4RN

Simultaneously published in the USA and Canada
by Routledge
270 Madison Ave, New York, NY 10016

Routledge is an imprint of the Taylor & Francis Group

Typeset in Meridien and Regula by
Keystroke, Jacaranda Lodge, Wolverhampton
Printed and bound in Great Britain by MPG Books Ltd, Bodmin

Library of Congress Cataloging in Publication Data
Montano, Linda, 1942–
 Letters from Linda M. Montano / Linda M. Montano, edited by
 Jennie Klein.
 p. cm.
 Includes bibliographical references and index.
 1. Montano, Linda, 1942– 2. Performance artists–United States–Biography.
 I. Klein, Jennie. II. Title.
NX512.M6A2 2005
700′.92–dc22 2004014615

British Library Cataloguing in Publication Data
A catalogue record for this book is available from the British Library

ISBN 0–415–33942–1 (hbk)
ISBN 0–415–33943–X (pbk)

Dear Mom and Dad,

In appreciation of your creativity, I dedicate this book to you both.
Jennie Klein and I worked hard on it and I hope everything I wrote is OK with you both!
I will pray a rosary for you.

Love always, your grateful daughter,
Linda Rose

P.S. Mitchell: I dedicate this book to you too.

Contents

Preface

When she was thirty-nine years old, Linda M. Montano published *Art in Everyday Life*, a collection documenting her performances, interviews, chicken stories ("donated" by friends), scripts for her various characters from *Learning to Talk* (1979), the complete text for *Mitchell's Death* (1977), and an art/life vita. Published in 1981 by Astro Artz Press and Station Hill Press in Los Angeles, *Art in Everyday Life* grew out of Montano's involvement with *High Performance Magazine*, a publication dedicated to performance art edited by Linda Frye Burnham and later Steven Durland. *High Performance* was a freewheeling, experimental publication that included interviews, scripts, artists' statements, and profiles of institutions devoted to performance art. *Art in Everyday Life* reflects the aesthetic of *High Performance*. Lacking a table of contents or page numbers, it opens abruptly with the documentation and description of Montano's favorite performances. Midway through the book, the preface appears in the form of an interview with Pauline Oliveros, Montano's longtime friend and collaborator. Appropriately, *Art in Everyday Life* concludes with two curricula: one for art (the shorter one) and one for life.

Art in Everyday Life was published in 1981, just before Montano returned to upstate New York to live in a Zen center. Since that time, much has happened to her in art and in life. In 1983/4, Montano spent a year tied at the waist with a rope to Tehching Hsieh in his endurance piece *Art/Life: One Year Performance*. After the performance, she returned to upstate New York in order to found The Art/Life Institute. She also embarked upon *14 Years of Living Art* (initially *7 Years of Living Art*, 1984–98) based on the seven centers in the body, seven colors, seven tones, and the seven characters that she

had developed for her video *Learning to Talk* (1977), documented in *Art in Everyday Life*. Montano performatively aided her mother in going from this world to the next, hosted summer saint camps, and accepted a teaching position at the University of Texas in Austin, where she continued her performance *14 Years of Living Art*. While at Texas, she continued her exploration of the meaning of death by journeying to Benares, India in order to view and research the ghats where bodies were cremated.

In 1998, Montano returned to The Art/Life Institute in Kingston, New York in order to begin the endurance pieces in which she is presently immersed: *Blood Family Art* and *Dad Art*. In 2000, she published *Performance Artists Talking in the Eighties*, a book that she started while tied to Tehching Hsieh. She participated on panels, gave workshops and lectures, and returned to the Catholic Church. Inspired by the spirit of Teresa of Avila, a sixteenth-century Spanish saint, mystic, anorexic, author, and Doctor of the Church, who was responsible for reforming the Carmelite order and guiding Montano during Year 2 of *7 Years of Living Art*, Montano has continued to work in the liminal area between art and life/the spiritual and the mundane while collecting her writings for publication.

Although she trained as a sculptor, Montano has worked primarily in the medium of performance. Performance, as Peggy Phelan has argued in her important and often-quoted book *Unmarked*, is unique because it enacts in disappearance. Being "marked," for Phelan, is a means by which identity becomes fixed. Being "unmarked," therefore, can become a powerful tool against fixed and therefore hegemonic representations.[1] Phelan is of course particularly interested in the potential of performance art as a feminist tool to challenge hegemonic representations of identity. Linda M. Montano's work, which contin-ues long after the spectator has left (or, in some cases, has gone to sleep), is an art of disappearance. What she presents to the viewer, even here in a book that ostensibly documents these feats of endur-ance, are simply the remnants or relics of what she has done. They are bits and pieces left for the spectator – or, in the case of this book, the reader – to reconstitute as a performance memory. As the editor of this book and the author of the preface, I could perhaps be designated the expert on the work of Linda M. Montano. Nevertheless, what I know is simply what I have reconstituted through her memories, archives, photographs, her book, and my participation in *Dad Art*.

Why then, should we bother reading a book about performances that for the most part have already taken place? First, reading and re-experiencing these pieces (or in some cases experiencing them for the first time) is a means by which they can continue to have an effect on business as usual in the art world. Phelan's theorization of performance as an art of disappearance does not preclude writing about it after the fact. Rather, she cautions against trying to fix it down by recording all of the details. Second, what is revealed in *Letters from Linda M. Montano* is an identity that is in a constant state of transformation. Montano strives for, but never attains, spiritual perfection. Through the agency of her writing and performance, we can chart that process. As Jeanie Forte has argued,

> Through the lens of postmodern feminist theory, women's per-
> formance art (whether overtly so or not) appears as inherently
> political. All women's performances are derived from the
> relationship of women to the dominant system of representa-
> tion, situating them within a feminist critique. Their disruption
> of the dominant system constitutes a subversive and radical
> strategy of intervention *vis à vis* patriarchal culture.[2]

Following Forte's logic, Montano's work could be read as feminist through its act of articulating and giving voice to what is generally not acknowledged. Certainly her present piece, *Dad Art* (1998–) is unusual in its recognition and articulation of the mundane acts associated with caring for the dying. By elevating these otherwise hidden acts to the level of "art," Montano forces us (the spectators, viewers, and participants) to examine our own attitudes about death and dying, just as she did many years earlier with *Mitchell's Death*.

Finally, in the history of feminist performance art Montano's work is unique in its emphasis on endurance and spiritual athleticism. As with much of the feminist performance done in the 1970s and 1980s and documented in *High Performance Magazine*, Montano's work has employed her own speaking, acting, abject body. From her relatively short early pieces such as *Happiness Piece* (1973), a month-long performance during which she photographed herself smiling every day to teach herself the habit of happiness, to *14 Years of Living Art* (documented in this book), Montano has seemingly attempted to subdue her slightly unruly body and emotions. Significantly, she is

never quite successful, nor does she really want to be. As she has stated often in both her writings and in interviews, she realizes that she is "not a perfect saint" – through enacting her attempts to become a saint, to discipline the unruly, menstruating and then menopausal and aging female body, Montano demonstrates the impossibility of ever attaining feminine perfection – either spiritual or corporeal. Her refusal to fix the meaning of her identity is reinforced by her use of different names – Sister Rose Augustine, Rose, Mary Montano, Mummie, Linda Mary Montano, Linda Montano, Linda M. Montano.

Letters from Linda M. Montano documents, records, interprets, and performatively rewrites Montano's art/life since 1981. While it is a sequel to *Art in Everyday Life*, it is also very different from that earlier text. *Art in Everyday Life* was the work of a young woman and ex-nun who was still developing her style of performance. *Letters from Linda M. Montano*, on the other hand, is the work of a mature artist who has pushed herself to and beyond her limits – physical, mental, and spiritual – and survived. *Art in Everyday Life* concluded with the text for Montano's 1977 performance *Mitchell's Death* (included here as well). In 1981, the accidental death of her young husband, from whom she was recently divorced, was traumatic, shocking, a raw wound that resonated within Montano's psyche. In 2004, Montano has faced many deaths, including a minor one of her own when she experienced a small stroke during *7 Years of Living Art*. She experienced becoming part of the academic establishment when she took the position at the University of Texas in Austin and she experienced rejection by the academic community when her request for tenure was denied. She has become a major international presence in the art world, featured in group and one-woman exhibitions and interviewed in both national and international publications. She has successfully completed *14 Years of Living Art*. And with the publication of this book, she has shared this process with the reader.

Letters from Linda M. Montano is thus a bit more "disciplined" than *Art in Everyday Life*, which is perhaps due to Montano's own pursuit of self-discipline in the ensuing years as well as the addition of an editor for this book. It has a preface and introduction in the expected place at the beginning of the book. It is organized thematically rather than chronologically, making it easier for the reader to understand the trajectory of Montano's work and interests. It includes a bibliography and an index. Editorial commentary is included at the

beginning of most texts in order to put them in the context of Montano's work. Nevertheless, it retains some of the spirit of the more freewheeling *Art in Everyday Life*. Rather than write a traditional introduction for *Letters from Linda M. Montano*, Montano decided to use the format of the interview, as she had in her earlier book, followed by a second introduction, "A Chakra Fairytale." Eschewing the copious photo documentation from *Art in Everyday Life*, Montano has instead chosen to reproduce pictures from her family and one original work of art: the chakra chart from *14 Years of Living Art*. Finally, the conclusion, which contains the acknowledgments traditionally included at the beginning of the book, includes a vow that is completely unexpected.

Interviews were an important component of both *Art in Everyday Life* and *Performance Artists Talking in the Eighties*. The first chapter of the book is devoted to interviews, many of them unpublished or published only on the Internet, that Montano has given in the past twenty years. The second chapter, "The Ecstasy of Sister Rose," is comprised of writings that deal in some way with spirituality, concluding with a video script in which Montano speaks to her followers as Teresa of Avila. The third chapter, "Writings," is a collection of stories, fairy tales, and presentations. *14 Years of Living Art*, which represents fourteen years of Montano's art/life, should have been a book unto itself. The fourth chapter, "*14 Years of Living Art* and *21 Years of Living Art*," includes Montano's original proposal for the piece, an interview with Judy Kussoy, a chakra drawing, and a letter that Montano wrote to the piece, apologizing for giving it short shrift. The fifth chapter, "Transitions," is divided into three sections: Tenure, *Dad Art*, and Death, all of which explore Montano's preoccupation with death and dying, her journey to Benares, and her performances as caretaker to the dying. The final chapter is for aspiring performance-art saints and college professors who teach performance art. Entitled "How-to Manual," it contains syllabi, teaching statements, predictions, and recipes.

Montano was raised a Roman Catholic. Many of the writings included in this book chart her spiritual and, in some cases, corporeal journey in the years following the publication of *Art in Everyday Life*. In her writings and statements, Montano has often suggested that performance artists are the twentieth- and twenty-first-century equivalent of saints. Indeed, had she lived during the time of Catherine

of Sienna or Teresa of Avila, Montano's art/life performances, which have flaunted the conventional expectations of society, would have perhaps made her a powerful female saint rather than a struggling performance artist. It thus seems fitting to turn to Teresa of Avila as we embark upon this book. "Let us go back and finish the journey which I have been describing, for the Lord seems to have been saving me labour by teaching both you and me the Way," Teresa of Avila wrote to her nuns in *The Way of Perfection*.[3] Montano's journey, which began when she was born, still continues. Let us join her in the hopes of finding the Performance-Art Saint Way!

Jennie Klein
February 2004

Introduction 1

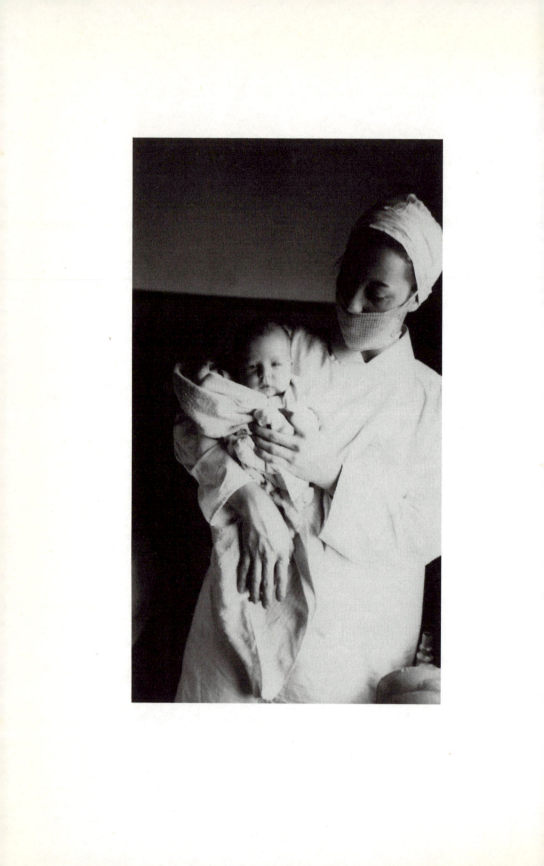

An Astral Interview

An email exchange between Linda M. Montano
and Jennie Klein

Klein: I think the best place to start this interview is by talking about *Letters from Linda M. Montano*. Why did you write this book, and how is it related to your earlier book from 1980 *Art in Everyday Life*?

Montano: When I moved back to Kingston after my time in Austin, I wrote to make sense of the not-getting-tenure dance. I guess I also had that academic, professorial gene left over in my blood because I was writing about performance and audience and ideas in a new way. Writing became a cure-all; just the way reading at the Saugerties Public Library was a solace for me when I was a child. And then one day when I was cleaning out papers I discovered essays and poems and fairy tales and all of these new writings and said, "It looks like book time." Art follows need and abundance.

Art in Everyday Life was more about images and visuals. It includes about forty documents of performances, which have short descriptions of the event itself, and why life made me do it! For example, if I wasn't working at a job, I would make a performance about working – art/life scenarios like that. It is a how-to manual because of the see-and-do qualities. I am now revising it as an interactive workbook titled *You Too Are a Performance Artist*!

Klein: While looking through my copy of *Art in Everyday Life*, I noticed how central your family was to both your performances and to the book itself. Does your family have the same importance in this book?

Montano: In this book, my mother's suggestion that I should write *Letters from Linda M. Montano*, and my father's willingness

3

to collaborate with me in a new way before his stroke, fueled this book. He said, "yes" to my videotaping him. Also, because I was his caregiver I could closely observe his gift of focus while spending time with someone I had not been with since I was seventeen. This inspired my writings from 1998 to the present, the time during which many of the essays in the book were written. Back to my Dad: Since his stroke he has become a PAINTER (!!!!!!) and paints at least an hour a day (on one painting), with such unbelievable and unbreakable concentration. There are no words to describe the atmosphere of quiet that his new art generates.

I truly believe that for each of us, family is our fodder, our diving board, our memory bank, our first story, our image maker, our reason for doing, our magnetic talent maker, our mystery to solve and blood to honor. The way this is de-scrambled in each artist's work is unique to his or her individual vision.

Klein: On the front cover of *Art in Everyday Life*, there is a picture of you as a nun standing between your mother and father [see p. vi]. Even though you had left the convent by the time you wrote *Art in Everyday Life*, you still had many references to Catholicism in your work. In several early performances you took on the persona of a nun.[1] Could you talk about your relationship to Catholicism then, and how that relationship has evolved now?

Montano: Catholicism is the religion of my youth and made a very, very deep impression on me. Catholicism IS IMPRESSIVE!!!! It is aromatic and aural and visual and deeply compelling. Soon Mel Gibson's movie *The Passion* will be in theaters. Anyone who has seen the trailer will get the feel of why this religion is so eye-opening! But again, we can't be too Brahmanic about this; thinking and acting like only the Roman Catholic Church is the best and highest and singular way to go, which was actually taught back in the 1950s. Popularity Charts aside, now I'm there for the Sacramental Real Presence.

We all have a spiritual quadrant inside our brain stems; we all must honor the Great Mystery. If we are born into an orthodox system that takes our innate desire for order and patterns and that system structures those desires into a theology of beliefs, then it is only logical that we might return to these roots once we get to middle age and start coming down the other side of the mountain singing, "What's it all about, Alfie?"

There is a great misunderstanding about people who seem to be spiritual. Just because we practice a strict or obvious "religion" is NO GUARANTEE of any saint-status. In fact, that's why I give *Performance-Art Saint Certificates* as art – to counter the nervousness and jealousy about inclusion into this spiritual club of holiness. Padre Pio, the great stigmatic, said "Religion is a hospital for spiritually sick people who want to be healed." That is the truth for me. I am not "doing religion" because I'm so fabulous spiritually, but because I'm so wounded by trying to be my own muse. You've spent some time with me, Jennie, and have seen my simian unreasonableness!

Religion is my passion of choice, it certainly is my hospital and nun's habits are the costume worn by the workers. In the 1970s I used the nun's costume as just that, a costume. Now that I'm "respectful" in another way and less concerned with cultural comment and irony, I will be using the nun's habit as Teresa of Avila's blessed clothing in a video. Mockery has disappeared and fear of the Lord set in, although on my feet you will always find tap shoes.[2]

Klein: *Art in Everyday Life* ends while you are still in San Diego, more or less shortly after you performed *Mitchell's Death*, an important piece that you did in both performance and video form. Could you talk briefly about *Mitchell's Death* [included here, pp. 220–26]?

Montano: *Mitchell's Death* was the text I wrote immediately after he died and the song I sang for the performance at the Center for Music Experiment, University of California, San Diego, where Pauline Oliveros was director at the time, encouraging wonderful events just as she does now.

Briefly, I can say that performance was the way I grieved him. Where else can you have a "wake" for a loved one with friends and supporters surrounding you, breathing with you, helping you continue to live? Yes this happens at funerals, but I have found that performance art also allows individuals to create opportunities for healing as well!

Klein: There is an incredibly powerful moment in *Mitchell's Death* where you describe seeing and touching his body. Peggy Phelan, in her lovely book on mourning, has written that we "burrow" into bodies to which we wish to be attached, but "that attachment is also what motivates the catastrophe and curative

lure of touch . . . What should be done with the remains of (redeeming) bodies?"[3] Why was the sense of touch so central to this performance, both in terms of what actually transpired and in terms of your placing acupuncture needles in your face prior to performing the piece for the video version? Do you see any contradiction in the fact that you employed a singsong chant rather than a straightforward delivery of the horrific events that unfolded around Mitchell's death?

Montano: As a child I was nicknamed "Hands" because of my need to roll paper into small spit balls, my need to make things, and my need to fiddle! As a sculptor, my hands are my tools. In addition, I've studied tons of massage techniques and healing modalities that use hands. Touch is a language. Some people are good with words. Some are good with ideas. Some are good with the kinesthetic response to life. In *Mitchell's Death* I was using touch as a last gasp, life/death way to relate. It was about the curiosity of touching my dead friend's body and the hope that my touch would restore life energy. My touch was also about the knowledge of the artist that everything is material for creation.

Chanting singsong was a device I used to make a churchlike experience out of horror. Also, don't "singing words" go to a more sensitive part of the brain than do spoken words?

Klein: Why did you leave San Diego after *Mitchell's Death* and return to upstate New York? What did you do once you had arrived back in your home state?

Montano: Arriving back in New York State birthed a desire to retire! Tragedy had struck with Mitchell dying and it also took "work" to move and return to root-digging in the place where I was born and raised. A perfect opportunity presented itself when Pauline found the Zen Mountain Monastery where we lived in a wood-stove-equipped A-frame on top of a big hill. Walking to dawn meditations and making believe I was Japanese was enough for me. Perfect, in fact. Art, be gone, I thought, this life suffices. And I highly recommend a group-retreat center, if only for a while, so that empty mind can be experienced and cultivated. Silence supreme!

Klein: I am wondering if you could talk a bit about *Art/Life: One Year Performance*, the piece that you did with Tehching Hsieh during which you were tied together for one year. Most of the interviews that you or you and Tehching Hsieh did at the time were more

concerned with the unusualness of the feat – i.e. what was it like being tied together with a rope, did the rope shrink, were you ever in any danger, how did you handle going to the bathroom. Since you have answered these questions (many times) elsewhere, I am wondering if you could instead address why this type of performance appealed to you on a spiritual level.

Montano: There is a wonderful interview with Tehching and me by Alex and Allyson Grey that answers some of the rope questions (see pp. 39–47). Actually we did very little PR about the piece so I can offer a few things I remember. You do know it's twenty years ago!

While in the Zen center, I went to the city and saw these soulful posters of Tehching who was doing his one-year outdoor performance [during which he lived on the street without going inside] and my inside voice said, "You've got to meet him!" So I called Martha Wilson (who runs Franklin Furnace in New York City), the woman who knows everything about performance, and asked her to help me meet him. We met and he said he was looking for somebody to be tied to for a year. Oy, temptation set in. I had retired for two years was settled into the silence of the Zen monastery but I couldn't pass up this opportunity to work with a master like Tehching, making art that I adored and loved and which I saw would be a continuation of my practice of intensely focused meditation with Daido, the abbot. Tied with an 8-foot rope for a year and not touching would foster the same mindfulness as sitting for two to eight hours a day in silence. A trade-off, I thought. Did it work? The beauty of the piece is that the difficulties and the wonderfulness were so volcanic that they stirred me emotionally to the point that I was able to later on do therapy that was very beneficial. Plus, I came out of retirement and entered the art world again, reseeing endurance under the tutelage of this magician of the form.

Klein: You had done earlier pieces that had prepared you for this one-year feat of endurance, such as being handcuffed to Tom Marioni for three days and being blindfolded for days or weeks at a time.[4] Although the loss of corporeal freedom or sensory input is not "painful" per se, it also occurs to me that it is not particularly comfortable either. In preparation for this interview, I was looking over Elaine Scarry's *The Body in Pain*. I was struck by her claim that

the self-flagellation of the religious ascetic, for example, is not (as is often asserted) an act of denying the body, eliminating its claims from attention, but a way of so emphasizing the body that the contents of the world are cancelled and the path is clear for the entry of an unworldly, contentless force.[5]

I remember reading in various early interviews and *Art In Everyday Life* that you left the Maryknoll Sisters an anorexic, yet loved the entire experience. It struck me that your anorexia, rather than being about a kind of Foucauldian internalized discipline was in fact motivated by the desire to clear the body, and that this same desire has motivated many of your later performances. I am wondering if you could address that aspect of your work?

Montano: We all do what we do because it feels absolutely right to us, no matter what it is! Anorexia invigorates people because starvation probably releases chemicals in the brain. The body is becoming efficient in a new way – a self-preservation machine! Was I flagellating? Clearing? I appreciate your reading of my work as using my anorexia and my endurance pieces to "clear" the way for entry of an unworldly force, but who knows? Maybe I was just playing with power and control! What I do know is that after taking care of Dad for two years, I've suddenly begun to love food because I need so much of it to do this "seva." I leave the answer to this question up to you and the other experts!

Klein: After you finished the piece with Tehching Hsieh, you wrote that you had moved to a new place emotionally. You had also recently learned that your mother, Mildred Montano, was very ill. You returned to Kingston [a town near Saugerties, NY] and founded The Art/Life Institute. In the 1970s, you had made your home with Mitchell Payne into a museum and called it the Montano-Payne Museum. Was The Art/Life Institute an extension of that earlier performance?

Montano: Yes, The Art/Life Institute was an extension of The Montano-Payne Museum in San Francisco (1975). I have to "artify" everything. I always have and I always will. So a house is a museum or an institute. Naming it this way gives it status and social respectability. I get to play with the "legality" of titling, appropriating, of naming. It is risky, calling a small house an

8

institute without having the chops or credentials to do it. I like that. Art allows for this kind of outrageousness.

The Institute is now a building in Kingston that I resurrected from fifteen years of abandonment. I touched and redid every inch myself along with understanding carpenters and plumbers and electricians. It is truly a sculpture, dedicated to my mother who had interior-design talents. After she died I dedicated it to her and told her spirit, "I can't cry well but I can sweat." So I put that sweat-equity energy of her creativity into the Institute.

Have you noticed how all of these TV shows such as *Trading Spaces* and *Curb Appeal* are planting seeds in the viewer's mind that they too can be artists of their own spaces? That is so much fun. Creativity for all who now need to stay home because outside is so strange these days!

Klein: In addition to founding The Art/Life Institute, you also began *7 Years of Living Art*, which you turned into *14 Years of Living Art*. I am wondering if you could talk about that performance, particularly since space constraints necessitated leaving much of its documentation out of this book.

Montano: While living roped with Tehching that year, I became hungry for more endurance as art. When we had time to ourselves each day, sitting back to back at separate desks, I designed a seven-year performance based on the seven chakras and the seven personas I created for video. It was to be an "art job" imposed on me, for me, for seven years. An "art vow." I still think the design of the inner and outer disciplines was fine. Doing the performance cut through habituation, which is what I intended. How can you get into a boring thinking pattern when the color of your winter coat changes every year and your coat matches your hat, socks, underwear, shirt and purse! Jennifer Fisher did a fine article on it for *Parachute* magazine and Moira Roth wrote the essay that accompanied the New Museum performance, changing the color of paper it was printed on to match the color of my wild outfits![6]

Each year I did a year-end report, for example for red, I wrote:

January 15, 1985: I felt last night that if I didn't get up out of bed immediately, I would get so overstimulated and sick from the red room, red clothes, sound, etc., that I would fall apart. I considered calling Family [a counseling center

in Woodstock, NY]. I am beginning to worry about the consequences. Will I go crazy?

And for white, top of head, 1991:

Top chakra, bliss. Bliss of worry, bliss of bliss. Year to blow my mind. I have a pain in my head; have to go for a CAT scan. Soon. Short-term memory gone. I stutter. What's that about? Will have medical check-up but I think it's a combination of my age, hormones and psychological stress.

(In 1992 I go for an MRI and find out I have had a silent stroke).

Klein: It sounds as though you experienced *14 Years of Living Art* through your body in rather unexpected ways. It is almost as though your unruly body, with its demands, neuroses, and frailties disrupted the rather pristine and formalist structure of the performance. In 1998, the year that you finished *14 Years of Living Art*, Amelia Jones published a very important book on body art, in which she argued that body art "opens out subjectivity as performative, contingent, and always particularized rather than universal, implicating the interpreter within the meanings and cultural values ascribed to the work of art."[7] At one point in *14 Years of Living Art*, Annie Sprinkle and Veronica Vera arrived to participate in Summer Saint Camp after seeing your flyer [reproduced pp. 271–72] in the bathroom at Franklin Furnace. It could be and has been argued (by Amelia Jones, among others) that Annie Sprinkle is all about the disruptive body. From the description of the event that was published in *TDR*, I sensed that the female body/bodies constantly threatened to undermine the rather strict rules that you had set up – two squares of toilet paper, a minimal diet, and all yellow clothes.[8] You also didn't seem to mind very much and in fact went with the flow. Was this the case?

Montano: Bodies are Puritan or primal or Catholic, etc. because bodies are culturally designated and trained to follow the instructions of conditioning. Being in the aura of Sprinkle/Vera/Carrellas,[9] etc. is instructive. It is a journey into re-seeing how ridiculous my two squares of toilet paper rule actually is! Freedom always disrupts fear.[10]

Klein: What did you learn from *7 Years of Living Art*?

Montano: Essentially I learned four things from *7 Years of Living Art*.

1. I learned that I had to do the performance again because it really was just the beginning of learning and I had literally tons of colored clothes. This time it was titled *Another 7 Years of Living Art*. Although I gave myself RULES, I followed only the dress rule by continuing to wear clothes of all one color for an entire year.
2. I realized that wherever my attention was placed, for example, fourth chakra, then fourth chakra things began to happen. It's not that my attention caused things to happen, but my self-scrutiny and focus allowed me to notice the minutiae of my inner world. I became a detective of the interior.
3. I also learned that I was a good rule-maker but life was better at making rules. I needed to back off, so I softened my approach. During the next seven years I went into a more surrendered stance.
4. And finally, I learned that I didn't need to do my own work anymore. At the end of the fourteen years, I gave the performance to three other artists and titled it *21 Years of Living Art* (1998–2019).

Klein: *Another 7 Years of Living Art* was an eventful time in your life. You accepted a position in the Art Department at the University of Texas in Austin and experienced the pain and anxiety associated with tenure. You have done some performance pieces and writings based on this experience [included in this book, pp. 175–96]. Could you speak briefly about what tenure meant to you?

Montano: Tenure . . . Tenure was a snag in the sweater. At first it seemed really important that academia accept me! Moi, Me, My, Mine, I – even though I internally "heard" the message, "Linda, go back to New York and take care of your Dad," while going through the entire tenure struggle in Texas.

I remember a very important happening from that time. Two professors helped me very much, one a woman (head of the Grievance Committee), one a professor of law. They were untiring, patient, and insistent on my being represented correctly. We worked for a few years together. Then one day, the lawyer called me and said, "Linda, you've had your day in court." Loosely translated, that meant that without major reconstructive legal surgery,

the administrator's decisions would not change. That mantra released me from the struggle to be hired, knowing that we all had tried beyond our best. Justice was now my friend, although her scales did tip off balance.

For anyone seeking tenure, you should ask yourself these three questions:

1. If I (Linda/your name) were president of the University, would I want to be working with myself, given my proclivities, for the next thirty-five years?
2. If I (Linda/your name) were the chair of the department, would I want to be seeing myself in team-playing situations for the next twenty-five years?
3. If I (Linda/your name) were the chair of the department, would I be able to communicate reasonably with myself for the next ten years?

If you answer yes to all three, consider an academic career. If not, ask your muse to find you your next job.

Once back, having not gotten tenure, I fumed and fussed and wrote and wondered and felt like I had been left without a date for the senior prom. Time and doing 4875847475 errands for Dad helped me realize that my new work had begun. I totally forgot that I had even ever lived in Texas. I began *Dad Art*. At first I made it more inclusive by calling it *Blood Family Art*. I was back in the home, house, church, and library of my childhood. I raised this experience to the level of great "fun" by calling it ART.

Klein: Most of that time in Austin was consumed with *Another 7 Years of Living Art* and with working on your book *Performance Artists Talking in the Eighties*.[11] I know that you worked a long, long time on that book. What was the genesis of a series of interviews with artists on sex, food, money/fame, and ritual/death? Why did it take so long to complete?

Montano: I am a self-educator. In fact, taking classes is always a horrible experience and I rebel with a sour face and a vibe that implies that the microphone and lectern belong to ME!!!!! Give it to me or I won't play. This might be because I am socially shy but love being on stage.

So doing *Performance Artists Talking in the Eighties* was like taking

a class. But I was in charge. Since I'm not a talker, I found a way to be taught how to talk by asking other people questions and seeing how THEY talked. That way I could learn something and take a graduate class in my own school!

It didn't take "long," it took years! Maybe twenty from start to finish. Can I talk now? I'm pretty good chatting and schmoozing about weather and food these days. Do I know anything from all I learned from all those generous people who talked with me? Hmmmm. When I write I seem to know something, otherwise not.

Klein: Speaking of not knowing, your work could be characterized as being obsessed with death, which is also a form of not knowing. As Peggy Phelan has asked, "What are we mourning when we flee the catastrophe and exhilaration of embodiment?"[12] During one summer, you used a University Research Grant to travel to Benares, India. Could you discuss briefly what you learned about death, and how that has subsequently affected your work?

Montano: That trip to Benares provided me with the eastern piece of the puzzle to my western preoccupation with death and my own hoopla around it. Since I've never seen *Six Feet Under* on TV, which I've heard is doing a good job of making death more conversational, I've instead used that Benares experience at the ghats, which I talk about in this book [pp. 228–33], to serve as my personal aaaaaahhhh breakthrough. Now death has a different kind of theological sting for me. Humor opened the door to balance.

Klein: What is next for Sister Rose Augustine? Do you have anything to add?

Montano: Not really. I can't see a new project coming because *Dad Art* is not about time. I am committed to this project until I get the message to change. However, in the middle of January 2004 I saw a *New York Times* article on doulas who volunteer as companions for the terminally ill who have no family or visitors.

Now that I have learned about caregiving, AND if I am allowed to be the "Mother Superior," I would like to start a branch of caregivers here in Saugerties that would be called "Performance-Art Doulas: Caring for the Living and the Dying." Our first rule is that we, the Performance-Art Doulas, would have to take a bubble bath every day.

Klein: Do you have any advice for performance-art saints?

Montano: Sure, I love giving advice!

1. "Let nothing disturb you." Teresa of Avila.
2. "Love! You don't know what will happen tomorrow!" Dr. Aruna Mehta.
3. "Have a problem? Pray first, then put on a wig and do a performance!" Linda M. Montano.

January 2004

Introduction II

A Chakra Fairy Tale

For my Meditation Teacher, Dr. R.S. Mishra

"The Chakra Fairy Tale" was first published on <http://www.bobsart.org>, a virtual gallery/catalogue sponsored by the Robert J. Shiffler Foundation. Peter Huttinger was the archivist and project coordinator, Barry A. Rosenberg was the website administrator and Randall Wright was responsible for the web design.

Once upon a time, a long, long time ago, in 1942 to be exact, in a very small village in upstate New York called Saugerties there was born a girl-child named Linda Mary Montano. Her father told her she was named after an independent businesswoman who lived in the village. So her name meant independence and loveliness. What a tall order but a noble goal for Little Linda! And her middle name Mary was the Catholic component. Linda had three siblings and very creative parents. Her father played in an orchestra that he helped found and her mother sang in the orchestra and was a painter.

Linda's childhood was like the childhood of all girls born in the early 1940s and raised in a conservative village atmosphere. Memories of outdoor winter sports, horseback riding, swimming and tap-dance lessons plus hours in church observing the Catholic saints, ceremonies, and rituals filled her days. Her mother said that she was a wonderful child. But Little Linda had a mixed heritage and mixed emotions. Her stately silent and dignified Italian grandparents fascinated her, as did her other incredible grandmother, Nan. She

visited Nan every day and watched her sew clothes, quilts, and make food from roadkill. Often Nan would take her teeth out and sing at holiday gatherings. All of her grandparents fascinated her. She studied them closely and Little Linda felt lucky to be part of this fairy tale.

What Linda learned from the years 1942–52

1. Parents change diapers, make trillions of meals to feed us, spend untold amounts of money on our clothing, education and well-being.
2. Adult art is a collage of childhood images, dreams, memories, and needs.
3. Gratitude goes to our parents and grandparents for handing down their love of creativity.
4. Reproducing the "smells" of childhood that produced our early ecstasies is a subconscious agenda of artists.
5. There is always a creative way to empower a seeming lack of power.
6. Influencing others is a constant conscious choice for some and inevitably comes with age. Like it or not we are always visible.

Little Linda became interested in one thing – being a saint. She tried different ways of doing that, including dressing like the Virgin Mary and giving out Necco wafers to her playmates. She attended every First Friday Mass, Stations of the Cross and even entered the convent because the persona that most inspired her was that of a "Holy Girl." Her constant question was how can I be one? How can I get close to God? How can I be just like Jesus?

Little Linda's time in the convent was short: two years. During those years she was constantly involved in art projects when not praying, chanting, learning, and working. Those two years were an incredibly rich time with hours of silence, one hour talking each day, and the preparation for her favorite thing: sainthood! But she left the convent really, really thin. Oops again! Little Linda didn't get that one right! Following the convent she went back to college and was inspired by a new mentor, Mother Mary Jane, an art teacher/nun who gave Linda permission to fly just like her painter mother did. She created, blossomed, painted, sculpted, and learned to communicate

in a new way, ending her college studies with a series of sculptures in different media titled *Visitation*.

What Linda learned from the years 1953-63

1. Open your heart and say everything on your mind until you feel understood. If you can't do that, make art. Better yet, do both.
2. The soul is quite simple. It wants passionate gentleness. The way it expresses the need and the way it gets it is unique to the soul path of each person.
3. It takes outstanding positive role models/mentors at each life passage to get us through the particular tunnel that we're stuck in.
4. It's satisfying to encourage and inspire a younger person to express their ideas. Sometimes the gift of a drawing book, drawing pencil or box of crayons is all that's needed to jump-start their journey.

She went to Italy, made believe she was Italian, which she is (one-half), earned her MA in sculpture and then went to the University of Wisconsin for an MFA in sculpture. At each place she began to break art rules. She asked: why can't putting junk together be art? Why do artists have to make objects in a studio and call that art? Why can't animals be art? For her MFA she put nine chickens in three big cages and called that her show. Linda was becoming a bad girl! Oops again! First she wanted to be Holy Girl. Now she wants to be Bad Girl. Something's fishy! Pushing the envelope, she explored all of her chakras, including her urges, her dreams and her own definition of religion/sainthood. Remember it was the 1970s.

After marrying photographer Mitchell Payne and beginning yoga, Little Linda started performing as a saint with white gauze covering her, white face, lying down and sitting as still as a church statue. Chicken Woman was born and she was also known as Chicken Linda. Married and ecstatic she danced and lay down and sat as a statue/ saint. Supported by her handsome, loving, and talented husband who photographed her and encouraged her on every level, she hand-cuffed herself to Tom Marioni, remained blindfolded for a week many different times, taped a stethoscope to her heart to learn how to listen, and told the story of her life while walking on a treadmill. She flourished.

But life changed as it does. The big bad wolf came out a lot to bother Little Linda. She cried and cried and had to sing extra loud to scare the wolf away. But the wolf stayed for a long, long time scaring her a lot. She began a new phase she termed "creative schizophrenia," a dissolving of an inner core of herself. Out of the confusion of divorce and the death of her ex-husband she began a series of works that attempted to explore grief and loss as well as personal changes that allowed her to get out of her own skin.

What Linda learned from the years 1964-78

1. Pursuing freedom without considering consequences is like gambling. You might win or you might lose.
2. The 1970s were right for the 1970s not right for now.
3. The impulses of the artist don't need to be translated into the impulses of the "lifeist."
4. Without consistent emotional cleansing and maintenance we are often blind to or incapable of healthy intimacy.
5. If there is armoring against compassion and love it often takes more than one trauma to learn life's mysteries and open the heart center.

Little Linda's ability to be another was fascinating. It was both instructive and entertaining and without knowing it, a preparation for *14 Years of Living Art*. She was able to dissolve her personality into that of another and practice having what she wanted without having to really go through the actual training, work or sweat. For example some of the characters she portrayed published books, made record albums, were missionary nuns or had a martial arts black belt. She could be whatever she wanted: a jazz singer, a French poetess, a nun, a nun locked in a room for a week, a man, or a priest. She could tell all of her sins from the balcony of a museum. In short, she could do whatever she wanted, whenever she wanted. Ummm. That made Little Linda smile sometimes, well actually, she didn't smile, her make-believe self smiled. What a great game she was playing!

Her collaboration with the composer Pauline Oliveros at that time was a deeply fertile interaction and chance for both of them to learn from and inspire each other. It allowed her to incorporate her real love, sound and singing, into her art in an even more conscious way.

Throughout the 1970s, 1980s and 1990s her Guru, Dr. Mishra, taught, mentored, and directed her toward meditation. Little Linda loved to shut her eyes and go deep down inside to a big silent and mysterious place. Sometimes lights were there, sometimes beautiful sounds. Wow, what a beautiful fairyland place that was. Little Linda spent hours and hours and hours there. She didn't care what it was called, Zen or Yoga or Centering Prayer, she just knew that she was in ecstasy and hungry for more and more and more.

Pauline and Little Linda moved to a Zen meditation community for two years and had she not met the conceptual artist Tehching Hsieh she would never have left her "retirement." But his incredible history of endurance performances was so compelling, and the fact that he was looking for someone to be tied to him for a year for his next conceptual performance, pulled Little Linda out of monastic life. She asked herself "Can I leave the monastery and still be a saint?" She was so scared that art might mess up her sainthood but she left anyway. She joined Hsieh in his piece titled *Art/Life: One Year Performance* in which they were tied together by a rope (July 4, 1983–July 4, 1984). During that time they worked jobs, were in the same room at the same time (even the bathroom) for an entire year. Never touching, they slept in separate beds, and had visitors. And man, that piece changed Little Linda a lot. She started growing art muscles and felt she scaled the art Olympics! Sometimes that made her achy and sore.

What Little Linda learned from the years 1979-84

1. Art allows the artist to grieve, mourn, act creatively schizophrenic, and be publicly analyzed.
2. The staged dangers artists perform homeopathically prepare them for the real dangers of life.
3. Constant redefinition of the monastery is essential to soul health.
4. Being cautious and sensitive to giving credit to sources, teachers, and the initial creators of concepts is a necessity, but well-intended writers, the rumor-mill, and the media often get it all wrong. And so do we sometimes. So do the best you can and stay focused. Someone will always be mad about something you do, or leave out, or include. Never be careless intentionally with intellectual

property. And do learn from your mistakes. Respect your neigh-bor's work and mind!

5. We never really know if our "work" is pulling us toward or away from true contentment until twenty years after the fact.

Not wanting to stop the incredible flow of creative juices and inspiration from her inspiring work with Tehching, she jumped into a long-term performance titled *7 Years of Living Art*. [For more on this project and the two that followed it, see pp. 153–72.] She really, really, really wanted to find out for herself about energy, about what is happening to not only the body, but to the Mystical Body as well. Little Linda had numerous public museum and gallery performance collaborations with many Creative Chakra Collaborators including Minnette Lehmann and Annie Sprinkle. As well as the friendship/support/work of other generous Chakraettes who gave flying wings to her art/life: _____ (place your name here – you know who you are and are too numerous to mention). So she created a seven-year journey and each year was represented by a different color and different sound; she made one drawing each year, and now, hold onto your seat belts and take a journey through *The Seven Chakras*.

First chakra: red, root energy

December 8, 1984–85
Little Linda with tattoos of chakras on her back.
Little Linda with dog.
Little Linda's red clothes.
With art/life car.
With machine used to listen to sound for seven hours a day.
Red Little Linda at the New Museum of Contemporary Art (In SoHo, New York City) where she did Art/Life Counseling once a month for seven years in the colored room/installation.
My guide for the year was Joan of Arc.
The one drawing I did the red year.
The photo and drawing combined by Katherine Gates, photo by Annie Sprinkle.
Little Linda in red at the New Museum of Contemporary Art window.

Second chakra: orange, security

December 8, 1985–86
Little Linda with her machine that she carried so she could listen to
 the sound.
Little Linda's orange clothes.
Little Linda reading palms at the New Museum of Contemporary Art.
Little Linda in orange in front of the New Museum of Contemporary
 Art.
My guide for the year, Teresa of Avila.
The one and only drawing she did that year.
The combo drawing/photo/collage.

Third chakra: yellow, courage

December 8, 1986–87
Little Linda as guru Linda by Annie Sprinkle.
Little Linda in yellow clothes.
Little Linda yellow in front of gate.
Yellow cloth over bed because had to be in colored space seven hours
 a day.
Little Linda with my friends Annie Sprinkle and Veronica Vera. Annie
 and I continued to collaborate since then.
Guide for the year Alberta Hunter.
The one and only drawing she did that year.
The collage for that year.

Fourth chakra: green, compassion

December 8, 1987–88
Little Linda in green coat.
Green room, bed environment.
Little Linda at the New Museum of Contemporary Art.
The New Museum of Contemporary Art green room.
Guide Meridel Leseur.
The one and only drawing she did that year.
Collage of drawing photo/computer images.

23

Fifth chakra: blue, throat communication

December 8, 1988–89
Little Linda standing dressed in blue.
Little Linda with Bharati Mishra beside her father's portrait.
Blue room at New Museum of Contemporary Art.
Guide for that year Katherine Hepburn.
The one and only drawing she did that year.
Collage.

Sixth chakra: purple, intuition

December 8, 1989–90
Little Linda with her family.
Guide for year Mother Teresa.
The one and only drawing she did that year.
Collage.

Seventh chakra: white, joy

December 8, 1990–91
White clothes in closet.
Little Linda at New Museum reading palms.
White room at New Museum. of Contemporary Art.
Guide for year Dr. Aruna Mehta.
The one and only drawing she did that year.
Collage by me.
The only time I broke my dress code is when I wore my Karate clothes.
The performance coincided with my menopause and at the end of
 seven years I was postmenopausal.

What Little Linda learned from the years 1984-91

1. Intuition is a good friend. Irony is sometimes better.
2. Giving ourselves the absolutely best job that we need to "shine"
 is inherent in our nature.

3. Self-discipline can never become self-punishment or it will back-fire.

4. If you need to be a priest, and are a woman, then make rules that are nonconsequential, creative and fun and proceed to break them so you can forgive yourself.

5. Life will open the chakras much more naturally than an imposed discipline ever could if the intention is in place.

6. Intention is everything.

7. Wearing one-color clothes every day, a different color each year allows the mind to play with and defy habituation and keeps the mind alert and conscious to purpose. When you look down at what you are wearing and see only purple, you remember to remember and that exercises attention states/consciousness. (Art becomes meditation.)

8. The purpose of art is to create a silent mind and open heart. The art is secondary to the purpose and when the purpose is achieved, art can be dropped if it is an impediment to consciousness.

9. It takes courage, art sponsors, curators, collectors, archivists, friends, critics, art historians, etc. to co-create work that is non-conversant with the mainstream.

10. If you set yourself up as an authority figure/counselor even in an art context (New Museum of Contemporary Art) and consistently appear there (once a month for seven years), the audience will cooperate with your intention.

Little Linda was ecstatic after *7 Years of Living Art*. She had finished a big art job and she had tons of red, orange, yellow, green, and blue clothes: Little Linda red shoes, Little Linda yellow jackets, Little Linda purple dresses . . . Ummm, and when she placed all the clothes on the floor, the red, orange, yellow, green, blue, and purple clothes she made a rainbow. Little Linda sang and clapped and danced around the rainbow she made. Her song was happy and she was the most joyful she had ever been, just like a saint felt, she thought. Now I'm a real Art Saint. I want to do it again. I want to be happy again and again and again.

So Little Linda pulled out all of her clothes from the attic and renewed all of her vows but this time she made it real simple for herself. She said "Chakras, you change me in your way! I'm not going to boss you around anymore. I'm not going to sit in a colored room

or listen to a red, orange or yellow sound or talk in an accent. I'm just going to be." I guess Little Linda was tired of talking to the big bad wolf alone. She began to ask for more and more and more help.

For those seven years, 1991–8, Little Linda made only one photograph of herself. She appeared astrally at the Chagall Chapel seasonally and made a drawing with her left hand of the drawings she did those first seven years with her right hand. What a great big girl she was becoming. A good, not so good, and little bit Holy Big Little Linda. Yes, maybe she really was a guru. Her friend, Annie Sprinkle thought she looked real saintly and fabulous and when she looked at photographs of herself that Annie took, she thought she might really truly be an authentic saint too!

What Little Linda learned from the years 1991-8

1. If you are going to take a job, realize that it has its own rules and regulations. To remain naive, self-referential and non-flexible while playing in somebody else's playpen is cause for dismissal.
2. The second time around things are done simpler. It is like having a second child.
3. *Another 7 Years of Living Art* was a fashion statement. The disciplines became internal and secret and the clothes were indicators of the art happening in real time plus cues for practicing awareness.
4. Not everyone can like everyone else but there are ways of showing basic respect in the workplace. That's an art and should not be seen as political schmoozing.
5. Being supported by colleagues births a feeling of compassion in the recipient that is indescribable.
6. Letting go of a good thing sometimes makes room for better things.
7. Big Changes (job, marriage, deaths, illness) need big support.
8. Die daily to prepare for final retirement.

At the conclusion of *Another 7 Years of Living Art*, Little Linda began *21 Years of Living Art*. For the next twenty-one years, Little Linda will give her performance to three other artists. Betsey Caygill of California is performing the first from December 8, 1998 to December 8, 2005. Since she was becoming an old Little Linda Holy Girl Saint, other Art Saints were helping her do her art job. Ummm, good.

As Little Linda aged, she found that a lot of things changed. Her body, her mind, and her needs. She made art about her bones, then found out that she had the beginnings of osteoporosis. She made art about absence, and then found that she was returning to the Catholic Church and her roots for new information and for a completion of her spiritual journey. And once *14 Years of Living Art* was completed, she found that the clothes were not only documents but charged "art relics". And the prayers were to be performed by all.

Wow! The scary bad wolf, time and challenges of life woke Little Linda right up. And sometimes in the moonlight she and the wolf started dancing around and around.

Little Linda said to herself finally, "Go home." Start over from the beginning. Become a New Holy Little Linda and talk to the big bad wolf in a new way. Her dad welcomed her back home and she re-did her whole life over, right from the start: going to Church again (but in a new way), eating breakfast with eighty-eight-year-old dad (but in a new way), skipping and dancing and giving out Necco wafers (but in a new way). As she got older and older she got better and better and younger and smaller and Little Linda called it *Blood Family Art* and also *Dad Art* when it was more specifically performed this way. Home on the range. Oh give me a home. Give me integration and completion and compassion and integrity! Her teacher used to say, hurry OM. Little Linda is now hurrying OM and hurrying Home with the help of all friends who help her with scary wolves and dancing and laughing, time after time after time. ommmmmmmmmmmmmmmmmmmmm mmmmmmmmm, ommmmmmmmmmmmm, ommmm mmmmmmmm.

What Little Linda learned from the years 1998-present

1. Getting to know blood family when you are a senior citizen yourself is a valuable and humbling performance.
2. Everything is a performance and everyone is always acting.
3. Visionaries and scientists will find even more creative ways of integrating knowledge so that Truth can play with truth.
4. Danger must not be invited to become a lifelong partner; there are gentler ways to wake up and stimulate life force.
5. Impulse, when it works, looks like creative genius; when it doesn't, it's a highway to foolishness.

6. Use your form of confession to keep your heart clean. Confess, confess, confess. Then remember how you were forgiven and forgive all of your detractors.

7. Reexamine your early childhood for spiritual sustenance and then go back 100 percent or borrow what you need from that time so you can live with principles and values in keeping with your new priorities.

8. All we ever really want is the ecstasy of Presence/presence.

2002

Chapter 1

Interviews

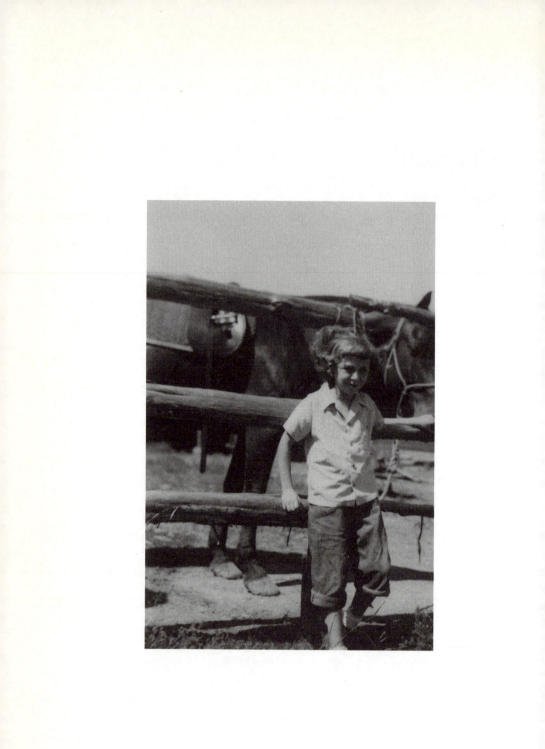

God I Love Time

Hilary Robinson

This interview took place when Montano was invited by Catalyst Arts in Belfast, Northern Ireland to do a performance. *Chakraphonics* was a duration performed for three days, 21–24 September 1999, for three hours a day. The purpose of the performance was to connect with her grandfather who was originally from Co. Cork. Below is an excerpt from that interview which was first published in *n.paradoxa: international feminist art journal* 5 (January 2000): 63–70.

Robinson: In your book, *Art in Everyday Life* (1981), you photo-documented thirty-nine different performances with a few words about "art" and a few words about "life" for each piece. I was very interested in the way in which you had produced that book and, in particular, the way in which your writings set up a parallel between the time of the art piece, the development of your work and its various manifestations, and the changes and shifts in your life. Could we start by talking about how we can now look back through time at time-based work through its documentation? I came to know your own work, for example, through photographs, through writing, through the writings of other people and so on. I haven't been able to see the majority of your work really because it has been situated in time-based performances, mainly in the USA. I wondered if you had anything to say about that to start with and your interest in time in general?

Montano: What I did unconsciously was to appropriate different structures, time being one of them, in order to empower myself at a very young age. Somehow I knew that time was a pretty

powerful vehicle that was held by the patriarchy. In that very, very early explanation of number 1: God the father, number 2: God the Son, number 3: God the Holy Spirit, I knew I was not included and I knew there was no woman included. I knew that I wanted to be a man for obvious reasons. There's a strange mix: numbers, women, theology, and time.

I truly believe that we are the result of early parenting, early institutions and training that form paradigms and become impositions. We are walking replicas of Mom, Dad, and Church. I can remember using time as a way to choose to listen to my mother or father or the school – who were saying "Linda! You have another fifteen minutes in order to make school." And counting, making the ritual of getting up in the morning a time ritual so that I would say 'twelve, eleven, ten, nine, eight, seven, six, five, four, three, two, one' then it would get down to milliseconds, down to the 1001, 1000 . . . Getting up in the morning was performative and ritualistic. I chose from an early age to listen to my parents via my own structure as well as knowing from some kind of inner sense that whatever I did I had to document in memory, photos, or writing.

The fourth element in there was that in order to stay alive and out of the mental hospital and give myself the energy I needed to live, I had to do public actions because there was no sense of me outside the other. There was no sense of me outside my action done. I was meaningless unless I was the other. This translates into a pretty wonderful freedom to perform anytime, anywhere and I always made sure a photographer was there. By working this way, I used my audience as healers until I reached the place where I eventually got enough public attention, courage and validity to turn this around and give attention to my audiences.

Robinson: So, you were/are creating yourself through your work and your performing.

Montano: Right. I was excellent at getting attention by speaking a language I had developed because probably there was no verbal language I can remember speaking at home. The language was one of telepathy, we spoke telepathy, and we spoke music. That's not speaking about music, but listening, so a lot of this was heard on just this upper pineal pituitary level; the thyroid, parathyroid, the belly laugh, the heart – these lower chakras were pretty shy.

Then you add to that tendency stories of the saints and the kinds of visually powerful images (the only way to be good was to be crucified or have breasts cut off) and the other ability to time travel at night, looking out of windows; put all of that together and you just can't help translating those images, and levels of institutional, spiritual biography into performance. It's a great vehicle; it's a great vehicle. And I say this out of gratitude to my autobiography, not out of victimhood or complaint.

Robinson: I mentioned the publication documenting your works from the 1960s through to the 1980s. I liked in particular that it documents a clear separation and a relationship between life and art, but there was no way that one was going to be confused with the other. There was a definite balance being woven – if that is the right metaphor – between the two. The chronologies of what was developing in your life and in your art seemed to be weaving very much in and out of each other.

Montano: Well, one created the other, the other created the other and then created the other, you know. Also I think in looking back it was also a way, it was a reaction to "the only way to do it was via the New York art stable scene" attitude, which posited that you had a rotten life and great art, and never the twain shall meet. What was happening in one's bathroom had nothing to do with what was happening in one's gallery. I think women know better because of genetics or the body, the nurture instinct or whatever. Unless we include cooking, unless we include sleeping, we're not going to get it or be famous! So once I demanded that the studio was over and done with and gone and it was no longer a necessity, it became an easy dance, an easy weave. I would say basically that my art made me and that I used my audience as healers, until I reached a place where we could co-heal. That took time, a lot of "bad" performance and the courage to continue this vulnerable working practice.

I just wrote an article, a very nice article on different kinds of audiences at performances, about the different levels of audience, the audience as co-creators, the audience as critic, the audience as voyeur, the audience as healer, the audience as unnecessary, the audience as absolutely necessary, the audience as intervener, the audience as "I would have died if they hadn't been there." Of course there are different levels of interaction and the secret, private, personal vow-taking performances can't be forgotten.

Robinson: Does this put you at odds with, from what I perceive from this side of the Atlantic, that the trend within American (maybe Northern American, in a broader sense) performance which seems to be much more theatrical and which uses time in a much more curtailed form in the work? For example, work in which there is a set stage, and often very text-based, script-based performances. From what I know of your work it seems to be that you want your audience to be much freer to experience the duration of your work with which they feel comfortable. You seem to do durational performances, expanding the time of what might constitute a performance. Is that a tension that you feel with yourself and maybe mainstream art practice in America?

Montano: Performance is already now commodified and imbibed, and the public and popular culture is drunk with it now. It exists everywhere. There is the example of an airport scene (in Chicago maybe) of a woman walking down from a plane to baggage claim, wailing, crying and everyone giving her that performance space, but it wasn't a "performance", although it was life/art. It was a very beautiful piece that I saw. Or the performance of the Heaven's Gate group – the mass suicide – where they all wore the same shoes, a highly choreographed performance as if done by an MFA student. But it is not to be repeated, not to be imitated. There is another example, a TV advertisement for "Stop Drugs" in which a young woman performatively destroys a kitchen. It looks like a great autobiographical piece that you would find in any workshop or class or gallery. Performance is no longer avant-garde – it truly is practiced universally.

So let's go back to time because that is the issue here. The times have changed, performance artists don't need to do what they did because they've gotten to the place they need to be, given the interchange between audience and themselves unless there's a real call for a continuation of that way of working. For example, Paul McCarthy couldn't keep doing what he was doing because of censorship, policing, jailing, and "driving down the LA freeway was danger enough" for Chris Burden.[1] Performance artists can't always continue to make highly emotional work. We age, we burn out. And performance issues, duration, and the times change.

The next generation I think is TV-timed, media-timed, even media-bound by the time it takes to click a channel or return an

email. The computer mouse and TV channel clicker have short-ened attention spans so that entertainment is where it's at. How can I keep you with me? I'm either going to go into trance as duration and you're going to go with me or I'm going to entertain you, take care of you so that you stay with me. Some artists are committed to what they're doing even though it has nothing to do with the times, and everything to do with time itself. They say: "I'm going to do it, it's going to be so time-based, it's going to be so long that you are forced to come with me. You just have to, because I'm a habit now, I'm a habit." Isn't there a saying, do something long enough, somebody will notice or feel something or change their brainwaves?

Robinson: I was reading something that Martha Rosler wrote on "The Birth and Death of the Viewer: On the Public Function of Art."[2] She was talking about the difference between an audience and the public. At the end of this statement she asked a rhetorical question: "Why is it that none of my students under the age of forty even understand the difference between audience and public?" When you are talking about the times changing and per-formance artists getting older, do you think that working with a group of artists like those artists here in Catalyst Arts in Belfast, that they are coming with you? Do you think that there is something in the younger generation that is following you as participants in the work?

Montano: Well, we jump-start their process; they don't have to go to the same places, because they have other places to go. So they can hurry through the appetizer of the body to the main meal, which is the mind, the computer and trans-media. It's obvious that technology is their play-toy. The best meal probably is still conversing with super intelligence and such theorems while addressing the body, and even though that's a pretty hard meal to pull off, I think that's the direction we are going in. The next generation has digital technology that speaks of transformation visually and sonically in ways that we attempted to do from scratch so to speak. It's now packaged, cellophaned, and wrapped in a different way. I'm a real lover of Stelarc's theory and path. Obsolescence of the body, robotics, implants, genetic engineering, weightlessness, and paperlessness are our future. I think that we owe it to ourselves to evolve and now we are the students.

I feel I am the student of this younger generation. They will teach me a new meditation.

Robinson: That's a very generous thing to say. A very generous approach. You feel hopeful?

Montano: Well, I have a theory that everyone is becoming a performance artist. The reason there is so much censorship in America now is because it's very difficult to be "authentically" bodied in America. What is happening is that the great populus has found chat rooms, where they're doing persona changes, they're Cindy Sherman-ing themselves, Eleanor Antin-ing themselves, they're performing and when real artists use real bodies in real time to make a real statement, they are censored and seen as perverse. Actually the populus is projecting their own guilt on real-time-based performance artists. The first amendment is being crushed.

Robinson: But they're not Orlan-ing themselves?

Montano: No, not at all. Well they are, they run to their liposuction. The next generation does it digitally and technologically. Flesh is being morphed into an interesting container.

Robinson: Where does that leave, do you think, someone like Cindy Sherman or Eleanor Antin now?

Montano: There is no safe space any more. I think that this is a book time; it's CD-ROM time; it's theory time. That's why this particular generation is so entertainment-orientated. The cabaret signals the end, the saturation point. The TV clicker and the computer screen are fascinating, intoxicating, addicting, empowering, and engaging and unless artists make art as totally wonderful and engaging as The Teletubbies, who cares? Who wants to go out at night and be relegated to a seat in the theatre or traffic jams and leave all of that control and color and entertainment behind?

Robinson: Thinking of the works for which you are best known – I'm thinking of Tehching Hsieh's piece in which you collaborated (*Art/Life: One Year Performance*, 1983–84), and the piece with Tom Marioni which was earlier (*Handcuff: Linda Montano and Tom Marioni*, 1973) – where you were physically tied to other artists, and the other long, long piece, *14 Years of Living Art*, which was solo and included color and sound – that's the kind of experience and the kind of work that I see very little of these days. I think it is incredibly challenging to think how each of these pieces pushes to the limit notions that we might have about gender relations,

about how we spend time with people, about ethics, about aesthetics. I think one of the challenging things about these works (apart from the prurient interest that people might have) is how is it, ethically, possible that for a whole year or whatever, you actually get through day after day after day with that sort of discipline, or with being so physically attached to another person. What does that do to time, what does that do to the time of the performance?

Montano: God, I love time! I love playing with time because it is so powerful. Maybe because it's close to the whole Buddhist notion of impermanence and that brings up the notion of death and that is really powerful. In the 1970s I lived with other artists and I did a whole series of living art performances for three days, five days, eleven days, in the desert for eleven days. The idea is that an artist needs to be greedy and say "I am making art all the time" because unless you are in the studio, unless you're producing, unless you're painting, unless you're sculpting, you're not worthy, you're not being an artist, you're not disciplining. Luckily, I knew that was not so, and in the 1970s, conceptual artists, minimal artists, everyone was playing with the same idea at the same time. The idea was that the idea was the art. The idea that I "one-hundred-monkeyed" myself to was that the universe was my studio and I could relax already! So if the whole universe is my studio then whatever was happening within every moment of time and in every place is art. (This is a simplification of the theory.) Then within that, by carving, sculpting particular time frames within that universal theory, I could train myself mentally with creative meditation to face life more attentively. Basically, it's an effective cheap drug and a great high! And it's objectless. You can't buy an empty, clear, and unimpeded mind, which is the result of purificatory performances.

Robinson: Do you know Tarkovsky wrote a book called *Sculpting In Time* which was about his filmmaking – and he used that expression to refer to his filmmaking – which is a lovely title?[3] That seems to be more or less what you're indicating there.

Montano: My training was sculpture, and my love was sculpture, but I didn't want to make more things. So that the invisible, sculpting the invisible, seemed less polluting and more *arte povera*. Plus, I could be Living Sculpture.

I want to go back to what happened to time during the rope piece, Tehching Hsieh's *One Year Performance*, which I joined as he was looking for someone to be tied to. He had done many incredible performances before he met me. I was living in a Zen monastery at the time, I had retired from art, but I wanted to overlay the consciousness of the meditative discipline of mind through training within an art context. Although I would have preferred to have stayed in the monastery, I knew that my calling was to be a fringe, outsider artist. So I found Tehching, who was looking for someone, and asked if I could join him in his piece and we spent time before the piece, six months in fact, to see if we could be together – at the end of a rope so to speak.

What happened is that unlike the mother who is pushing the child in the wheelchair, unlike the wife who is managing the Alzheimer's husband, unlike the father whose daughter has come home to die in his house because she has AIDS, unlike all the scenarios we could imagine which are timeless, which go on and on, as if there is no end – unlike that, we had a year and I knew it and I chose it because it was a year. I'm not good when there's no time frame because I'm untrained, impatient, and faithless. But my performances train me for the long run; my performances train me for what may happen to me or others that I am karmically linked to. My performances are daily life and train me for daily life and any hardships that fate may send my way. I do hard work in case life gets hard. Then I will be ready.

1999

The Year of the Rope

Alex and Allyson Grey

During *Art/Life: One Year Performance* Alex and Allyson Grey, an artist couple who are married, were asked by the editors of *High Performance Magazine* to interview Montano and Tehching Hsieh. This interview first appeared in *High Performance Magazine* (Fall 1984): 24–29, republished in Linda Frye Burnham and Steven Duran, eds, *The Citizen Artist: Twenty Years of Art in the Public Arena. An Anthology from* High Performance Magazine (Gardiner, NY: Critical Press, 1998). It can be accessed online at <http://www.communityarts.net> (August 1, 2004).

Grey and Grey: When did you first meet and what inspired your collaboration?

Montano: I was living in a Zen center in upstate New York. During a trip to the city I saw one of Tehching's posters and literally heard a voice in my head that said, "Do a one-year piece with him." I was free to do that, so I asked Martha Wilson [of the New York art space Franklin Furnace] for his number, called him, and we met at Printed Matter where we talked intensely for two hours. He said that he was looking for a person to work with . . . I was looking for him . . . so we continued negotiating, talking and working from January to July when we started the piece.

Grey and Grey: [to Tehching Hsieh] So you were looking for somebody to work with before you met Linda?

Hsieh: Yes. I [had an] idea about this piece and I needed to find somebody for collaboration. After I met Linda, she told me that she had done a piece handcuffed with Tom Marioni for three days. Somehow I feel very good about collaboration because Linda had done something similar before.

Grey and Grey: What inspired your idea for the piece?

Hsieh: You know, I've done three performances before connecting art and life together. I like to create art about life from different angles. Most of my work is about struggle in life. Like in *The Cage* my life inside felt isolated – that's a kind of struggle. And in [the] *Punch Time Clock* piece I [did] the same thing over and over, like a mechanical man, and that's a kind of struggle. When I lived outdoors it was about struggle with the outside world.

I got the idea for this piece because there are problems about communication with people. I feel this is always my struggle. So I wanted to do one piece about human beings and their struggle in life with each other. I find being tied together is a very clear idea, because I feel that to survive we're all tied up. We cannot go in life alone, without people. Because everybody is individual we each have our own idea of something we want to do. But we're together. So we become each other's cage. We struggle because everybody wants to feel freedom. We don't touch, and this helps us to be conscious that this relationship connects individuals, but the individuals are independent. We are not a couple, but two separate people. So this piece to me is a symbol of life and human struggle. And why one year's time? Because then this has real experience of time and life. To do work one week or two weeks, I feel that it may become like just doing a performance. But I do it one year and then the piece becomes art and life – it's real connection and that has more power. Also a year is a symbol of things happening over and over.

Montano: I think that's what interested me in Tehching's work; having similar interests – merging art and life. For many years I have been framing my life and calling it art, so that everything – washing dishes, making love, walking, shopping, holding children – is seen as art. Formerly, I would separate out activities – run to the studio and that was my "creative time." Gradually I found this separation unnecessary and felt that it was important for me to be attentive all of the time – not to waste a second. That became the Art/Life task that I have given myself until I die.

I made many pieces from 1969 on that experimented with this idea of allowing my life to be a work of art. I lived with different people and called that art. I wrote the *Living Art Manifesto* in 1975, and later turned my home into a museum so that everything I

did there would be framed as art. I lived in galleries. I was sealed in a room for five days as five different people. All of it was an attempt to make every minute count. I knew that by working with Tehching I would experience his time frame, one year, and that kind of art rigor interested me.

Grey and Grey: [to Linda Montano] Tehching has talked about what the piece symbolizes to him. What does the piece mean to you?

Montano: By being tied with a rope and not touching, I am forced to remain alert and attentive because I am doing something different from what I ordinarily do. That way I break down habitual patterns because the task of being tied is so difficult and absorbing that I can only do just that. Supposedly there are seven stimuli that can simultaneously grab our attention every second. This piece demands that the mind pay attention to one idea, not seven, and because being tied is potentially dangerous, the mind gets focused or else our lives are threatened.

Besides training the mind, the piece raises so many emotions to the surface that the soap-opera quality eventually gets boring. I feel as if I've dredged up ancient rages and frustrations this year and, although I'm glad that I went through with them, I now feel that holding any emotional state for too long is actually an obsolete strategy. On the other hand, because I believe that everything we do is art – fighting, eating, sleeping – then even the negativities are raised to the dignity of art. As a result I now feel much more comfortable with the negative. It's all part of the same picture.

Grey and Grey: What is a typical day like?

Montano: We have this pattern. We go to bed around midnight, Tehching sleeps in the morning. I get up earlier, meditate, exercise, watch TV. Then he gets up. Sometimes we run. Three times a day we walk Betty, my dog. We take one picture every day and turn on the tape recorder whenever one of us is talking. Each month we switch off being responsible for either the camera or the tape recorder. If we aren't doing carpentry, teaching or part-time gallery work, then we go to our desks and sit back-to-back for about five hours.

Grey and Grey: [to Tehching Hsieh] What do you do at your desks during the day?

Hsieh: Thinking.

Montano: We think about what we want to do and then we talk until we come to a consensus. So it takes many hours of sitting before we can do one thing.

Grey and Grey: You both seem to have different ways of thinking about the piece.

Hsieh: Yes, because we are two individual human beings and two individual artists tied together for twenty-four hours a day and so individualism is very natural to this piece. It's interesting to me because if we want to be good human beings and good artists at the same time, that's one kind of clash and struggle. Also if we want a relationship and independence at the same time, that creates a double struggle.

The piece has other levels that make us feel more individual – there are cultural issues, men/women issues, ego issues. Sometimes we imagine that this piece is like Russia with America. How complicated the play of power.

Montano: This piece raises many questions. Like, how do two humans survive in such close physical proximity? A Russian journalist wanted to do an interview with us because she said that Soviet scientists were interested in exercises that their astronauts could do to prepare themselves for spending extended periods of time in space capsules. In many ways, the piece is valuable because I feel that it is necessary to learn new survival skills and to look at emotional conditioning and responses that are obsolete.

Grey and Grey: Waiting must be a big part of the piece.

Montano: We usually do a very simple thing, efficiently, so that we don't have to bother each other. Having fifteen minutes in the bathroom is a luxury. If we are fighting then we do only the basic things like eating and going to the bathroom, and those things are done quickly.

Grey and Grey: The piece obviously has negative and positive qualities.

Hsieh: Most artists who collaborate want to try to be one. But we both have very different ways to work and have different ideas. For survival we have to work things out. This brings out a lot of negativity and fighting. It is part of [the] piece, so I don't feel too negative. The positive, we don't have to worry about. We just enjoy it.

Montano: There are many people in worse conditions than we are – the person tied to a bad job or a bad place or a bad marriage. This piece is about the realities of life. They aren't always easy. Often we would just have to sit it out, sometimes for three weeks, until the "cloud of unknowing" passed.

Hsieh: Some people think I am choosing to suffer – I don't think that I want to bring more suffering to myself, but the work is difficult and in some ways that brings suffering. As an artist I have a lot of pleasure [doing] my work. If I don't get any pleasure out of doing difficult work then I don't have to do it. I don't think I want [to] suffer for no reason. I am not masochistic.

Montano: Artists choose forms that fit their internal image bank. Tehching has his own reasons for his images. Mine come from the ascetic, Catholic/spiritual world. I believe that if life is hard and I choose to do something harder, then I can homeopathically balance the two difficulties. Snake venom is used to cure snake bites!

Grey and Grey: How do you feel about not having sex for a year?

Montano: Actually, I'm beginning to reevaluate guilt, and lately have been more willing to sacrifice, not because I'm guilty but because it's an essential attitude. I also realize that not having sex is as interesting as having it. Besides, touch is highly overrated. In the past, I've often grasped without energy, charge or significance and called that touch.

Hsieh: We do not touch. We are sacrificing sex, not denying it. We could, in theory, have sex with other people. But that would just be a way to try to escape. It is not right for the piece.

Montano: Once you give the mind a command, then you watch the body carry out the process. When I went into the convent for two years, I informed myself that I would not have sex and noticed that the energy went to other things. This year I have a chance to experiment with desire. Am I turned on? To whom? When? How much? Also, since the body isn't touched, the mind is pushed into the astral.

I believe that in the next 200 years, we will all be in outer space so why not practice outer-space sex now by letting astral bodies merge.

Grey and Grey: So you are using this piece as a kind of training?

Montano: Yes. One thing that interests me very much about this piece is that a work of art can be used to practice remaining conscious.

43

Grey and Grey: Is that part of your understanding of the piece, Tehching – training your awareness?

Hsieh: Yes, but it is secondary. The piece becomes a mirror showing me my weakness, my limitations, my potentials, and trains my will.

Montano: Some artists choose difficult work. Other people do it in a celebratory way – Dionysian ecstasy, to get free enough to be themselves and to be in the moment. It's really a matter of choosing the style that goes with our inclinations and then hope-fully changing directions if the style isn't working, or if those old hindrances aren't there any more. Then we can do something else. Maybe end up on a mountain, gardening.

Grey and Grey: Linda mentioned before that the piece is "poten-tially dangerous." How so?

Hsieh: I do not feel that the piece is dangerous. I have to know my limitations in a piece. So I do a rehearsal for a week to see what happens. That's just technical kind of help. But I don't want to do a piece that I feel is too risky – 30 percent risk is okay. Accidents are possible in this piece, so we have to be very careful.

Montano: For Tehching this is not such a big issue. For me it is, because I'm not used to taking large physical risks. Actually we were very lucky and only two dangerous things happened. Once Tehching got into an elevator . . . I was outside and the door closed. He pushed the "door open" button before the elevator went down, but for days I had images and nightmares of being smashed against the elevator door or else cut in half by the rope. Another time we were walking in Chinatown when a woman ran between us into the rope and almost tripped. So in that instance, the rope was dangerous for someone else. Riding bikes, one in back of the other, was more liberating than dangerous, but we had to be careful.

Grey and Grey: How does this piece go along with your spiritual outlook on life?

Montano: I come from a very strict, religious tradition and have been disciplined most of my life. I continue with discipline, but now I am using the artist's way to be spiritual.

Hsieh: I have no interest in the spiritual but I am in some ways like a monk who is dedicated in a serious way. My dedication is to my art work. I am interested in the philosophical and in life

experience. I try to make sense of who I am and what I am doing in my life without God. If I say I don't believe in God maybe it means that I am trying to find my own belief.

Grey and Grey: What are some of the influences on your work?

Hsieh: New York art, Dostoyevsky, Franz Kafka, existentialism – that influences me. Also, I am oriental. I grew up in Taiwan, and I have an oriental kind of technique and oriental kind of experience, that influences me too. Also, my mother influenced me – she is a very dedicated person.

Montano: My influences have been – my grandmother, who took out her false teeth at most family gatherings and sang, "If I Had the Wings of an Angel"; my mother, who is a painter; Lily Tomlin; Marcel Duchamp; Eva Hesse; and St. Teresa of Avila. I am also interested in using art therapeutically, probably because when I was twenty I was anorexic (82 lbs.) and it's only because I immersed myself in "art" that I came out of that experience intact. So for that reason, I will always be aware of the psychological/ sociological effects of the creative process.

Grey and Grey: Now that you've been tied together for almost a year, how do you feel about each other?

Hsieh: I think Linda is the most honest person I've known in my life and I feel very comfortable to talk – to share my personality with her. That's enough. I feel that's pretty good. We had a lot of fights and I don't feel that is negative. Anybody who was tied this way, even if they were a nice couple, I'm sure they would fight, too. This piece is about being like an animal, naked. We cannot hide our negative sides. We cannot be shy. It's more than just honesty – we show our weakness.

Montano: Tehching is my friend, confidant, lover, son, opponent, husband, brother, playmate, sparring partner, mother, father, etc. The list goes on and on. There isn't one word or one archetype that fits. I feel very deeply for him.

Grey and Grey: Talk more about how your relationship progressed through this piece and how you will face your separation.

Montano: We developed four ways of communicating. In the first phase we were verbal, talking about six hours a day. Phase two – we started pulling on each other, yanking on the rope. We had talked ourselves out, but yanking led to anger. In phase three we were less physical with each other and used gestures, so we would

point when we wanted to go to the bathroom or point to the kitchen when we wanted to eat. Phase four – we grunted, and made audible, moaning sounds when we needed to go somewhere . . . that was a signal for the other to get up and follow the initiator. Communication went from verbal to nonverbal. It regressed beautifully.

It was also interesting to watch the overall energy of the piece. Eighty days before the end of the piece, we started to act like normal people. It was almost as if we surfaced from a submarine. Before that we were limited to doing just the piece.

Hsieh: Our communication was mostly about this piece. Like, I have to ask Linda if I want a glass of water. It takes up all of our energy.

Grey and Grey: Your piece has been on the newswire. You've had a tremendous amount of media attention nationally. How do you feel about the publicity?

Hsieh: I have positive and negative feelings. Negative is that I don't really like that kind of publicity. But I would like for people to know. The problem is that they are more interested in the life issues and don't understand art. That bothers me. But I feel positive that people who know about it feel something even if they don't know about art. For example, mothers with young children often say to us: "You know, I've been tied to my baby for two years." That means she understands in some way.

Montano: Pregnant women also respond because we are making the umbilical cord visible. We also get responses from policemen, feminists, religious people, S&M practitioners, people walking dogs . . . the image evokes many projections.

Actually the publicity has won over my father . . . He is a businessman and read about it in the *Wall Street Journal*, so now he's much more supportive of my work. And being deluged by the media has helped me come to a new understanding of documentation. It seems that the primary document is the change inside the performer and audience. The results are felt and cannot always be photographed or expressed.

Grey and Grey: How does it feel to have the piece nearing an end?

Montano: We're so much easier on each other now that it's almost over, and there is a nostalgia that we couldn't have been this way earlier. But I've learned a good lesson . . . to give 100 percent all the time. Usually in relationships I have thought, "I'll open up

tomorrow," or "I'll communicate tomorrow." Now I realize that life is short, and it's ridiculous to waste time. I also feel a sadness that Tehching and I won't be doing an eighty-year piece together . . . maybe we'll do it from a distance.

Hsieh: On a philosophical level, I feel that the piece is not nearing an end. It's just that we are tied to each other psychologically. When we die it ends. Until then we are all tied up.

1984

I Slept with Linda Montano

Paul Couillard

This interview took place in conjunction with a festival entitled *TIME TIME TIME*, a twelve-month series of durational performances by artists from the US, UK, and Canada curated by Paul Couillard. Montano's contribution *Appreciating the Chakras* took place from January 30–31 in the Canadia dell'Arte Theater Troupe Studio Space. The title, "I Slept With Linda Montano," refers to the seven-hour endurance, *Chakra Sleepover/Workshop*, Montano offered as part of the event. The unedited interview can be accessed online at <http://www.performanceart.ca/> (January 1, 2004).

Couillard: Given your history in performance, I wanted to start by asking whether you see a distinction between performance or art and life?

Montano: Until I wrote a recipe that indicated that every minute was performance, there was a distinction. In 1984 I appropriated all time as performance time or art, meaning every minute of my life was an opportunity for that kind of higher – not higher – but that kind of consciousness, a kind of awareness or – sacredness is a word that is laden – but that kind of sacredness. Before 1984 I made attempts, but they were for a week or a month or for shorter periods of time. In 1984 I designed it so that the rest of my life will be a work of art.

Of course, Tehching Hsieh's concept *Art/Life: One Year Performance* was inspiring, and when I decided to join him in his rope piece for a year and I got to work with this "genius of art," I learned so much about time from him.

Couillard: So, everything you do is art because you've consciously identified it as that?

Montano: Yes.

Couillard: Are there other things wrapped up in that, like a sense of discipline or a certain kind of awareness you try to bring to things?

Montano: It's almost like . . . There's a massage form called Reiki, and in Reiki, there's a little bit of study, maybe a weekend workshop and three levels. Then there's this so-called initiation, and it's really an initiation into nothingness. It's so simple; it's just a laying-on of hands. It's not as if it's a complicated massage form. And for me it was just a matter of consciously setting up the parameters that allowed me to incorporate, appropriate, grab all time as art. It's – what was that question?

Couillard: I was wondering about discipline.

Montano: In the beginning it was about discipline. I had to do this, this, this, and this for numbers of hours and days and weeks and months. Then I found that the overall intentionality worked to incorporate my needs, and the disciplines were really my own ego struggling, pushing. So when I lightened up and stopped pushing so much and creating boundaries and formulas, the permission to live in the state of art loosened me up. I started making more things that looked like traditional art because I was free. Before, it was always this sort of guilt of not being in the studio, not producing enough, not working – which comes out of an art-school training or a western model of abundance and consumerism. How can you say you're something if there's no product? When I took that away, I actually started producing, which is always an interesting kind of contrast. But given my philosophy, there's no need for production, because I am in the state of art, so to speak, at all times.

Couillard: Why was it important for you to identify what you were doing as art?

Montano: Art gave me the same kinds of pleasures and aesthetic ecstasy as the Church used to give me. And because a woman is denied priesthood in Roman Catholicism, I knew instinctively that I would never be able to be a ritual-maker.

Couillard: Within the Church –

Montano: Yes, in the Church. I took that aesthetic ritual-making

paradigm and placed it in art. Not as second best, but as deep as –
and as wonderful as – experiences I was having in the Church.[4]

Couillard: Do you make distinctions? For example, when I con-
tacted you about *TIME TIME TIME*, I told you I was looking at
durational performance and I wanted to present a series of pieces
that were at least twelve hours long. You could have said, "well,
I'm doing that right now" or "I'll come to Toronto and just be Linda
Montano," but instead you organized a specific event with an
audience component to it that could be published or announced.
Is there a distinction to be made between performing a piece called
Appreciating the Chakras and being in your kitchen making dinner?

Montano: Sometimes you eat chocolate cake with raspberries on it,
and sometimes you have a rice cake. Doing a performance like
Appreciating the Chakras is the chocolate cake with raspberry sauce.
It's a luxury, not necessary, but certainly something fun that I am
still interested in. I see it as a night out.

Couillard: In calling everything you do art, and thinking of what
you do as being an artist, do you think an artist necessarily has an
audience? Is there a relationship between artist and audience?

Montano: I think it's changing with computers and websites etc.
It's becoming a virtual audience – a nonvisible, nonvisual,
nonphysical audience. Then there's the audience of rumor, the
audience of legend and gossip – "oh isn't that the person that, you
know . . ." being known for one piece. There is a hunger now for
community, for bodily closeness, for performance. But there's also
a plethora of taste. Things have gotten so specific to the person,
that the people who will come to see a particular piece are drawn
chemically by the taste of that person. The flavor of the piece
coincides with the flavor of the audience members. I think there
are a lot of different levels of audience, unless it's a person or a
piece that has such a following or such a need to be seen. Other
than that, I think that as performance artists we draw the audience
with the taste that corresponds with ours.

Couillard: In an interview you did before the Toronto show, you
mentioned that one of the aspects of maturing as artists – I wasn't
sure whether you meant specifically in performance art or just for
yourself as an individual – was accepting or recognizing that not
all audiences are going to love what you do, or have to like what
you do.

Montano: I think that's an important lesson to learn, not getting attached to numbers of people in the audience, not getting attached to being loved, so that you can really do the work for the right motivation. Hopefully the timing of the work is right. I really think a lot of it is about the presenter. If the presenter is coming from the right place and is well loved in the community and does a good job of making the artist comfortable, the audience can feel that and they respond. I think it's a real collaboration, because you can do something in the right place with the wrong kind of treatment or atmosphere, and it's not a good time for anyone. Sometimes it's not the artist so much that's drawing the crowd, but the presenter.

Couillard: When you do a piece, what are you hoping the audience will get? Or does that matter?

Montano: Community – that they'll have a place where they can wash their subconscious of ideas or fears or taboos, and a place where they can touch a kind of magical sacredness, have a spiritual high. Moving through matter and the dirt and detritus of matter as a jumping-off place to this ecstasy.

Couillard: Do you have any thoughts about the element of time in your work? I chose you for *TIME TIME TIME* because I was familiar with the fact that you had done pieces that had unusual durations, like being tied to Tehching Hsieh for a year. Or doing a seven-year project of exploring the chakras, where every moment of every day for quite a substantial length of time was devoted to or charged with the intent of the particular project you were working on.

Montano: Working with time allows for a timelessness. You almost have to grab time to go out of time. Focus and concentration and discipline and spaciousness all happen at the same time when you work with endurance and time. It inhibits scatteredness. It inhibits shallowness. It helps us to go to places that change brain waves, literally. If something's done for a long period of time, then brain chemistry changes. All of those things interest me.

Couillard: I was very intrigued by the way you chose to structure what we called the 'piece' *Appreciating the Chakras*. Essentially, there were two parts. The first part of three and a half hours was a soundscape that people could enter or leave as they wished, just soaking in the energy of it. The second part required a different level of commitment on the part of the people who were involved.

They were no longer participating spectators; they were being what they were being. You asked us, in a sense, to sleep together.

Montano: "I've slept with Linda Montano."

Couillard: [laughing] I'll bet you have! In the morning, when we were ending the performance, one of the things you spoke about was that there was a sense of community created in our being together, just in doing a simple action together like sleeping. But people had to commit to be there for that seven-hour period and not leave in the middle, whereas the first part was set up so that anyone could come and go.

Montano: A lot of that was just practical safety, in terms of doors opening and closing, people coming in, and protecting the space. Because people were sleeping, the space had to be different, so the parameters were different. But time is energy. We are energy. And energy needs a lot of attention. If we're busy, if there's a divorce from energy, then it's like not being nurtured, not getting enough food. All of these actions are vehicles. They're designed to produce the effect of feeling aliveness and energy – and maybe, if there is such a thing, a chemical shift in the brain where it's touching bliss or sacredness.

Couillard: Is it fair to say that what's involved is a commitment to acknowledging and working with the particular energy of time?

Montano: When you translate time, the next word you get after time is death – because time is so mysterious and it's all about the race against time, or time out, or time is over, or time is up, etc. Time is a real piece of the puzzle that nature holds and has control of. When artists play with time, they're playing with God's toy, nature's toy. It wasn't designed for us to play with, but artists never play with anything that isn't sacred. Or, it's the artist's prerogative to go into that playground. Time brings up issues of dying and of death. And of impermanence and of change and of flux and of loss. "Time marches on." "I don't have enough time for that." It seems to dog us and nip at our heels and run after us. We don't have enough of it, but when the focus changes, when the artist uses time as a material – a clay to mold – the artist can use that material to reach timelessness – no-time. And no-time is bliss or ecstasy or energy, pure energy.

1999

Interviews with Conceptual Artists: Linda M. Montano

Terri Cohn

This interview took place in the Bay Area when Montano was the visiting artist at San Francisco Art Institute.

Cohn: My first question is, when did you become a conceptual artist or realize you were a conceptual artist?

Montano: There were hints going back in time . . . gatherings of hints from watching my grandmother perform conceptually. She was physically large, took her teeth out to sing, cooked road-kill and called it chicken. Nan was aesthetically directed! She did things that were performative, art therapeutic, and I was her witness, watching her every day in silence for hours. I therefore got imprinted conceptually at an early age. Other hints came from my mother and father, who also were both creative . . . my mother was a painter and singer; Dad is a musician. Even though he owned a shoe store, music was his love. My other grandparents were Italian, almost completely non-English-speaking, and conceptually I learned persona-morphing from being around them . . . changing my consciousness by changing my accent. We can't forget the influence of the Catholic Church! I was not only raised strictly in that religion, but also became a nun for a few years. The Church must breed conceptual artists/performance artists because the configuration of the theology – the visual stimuli, the sounds, the saints, the miracles and the incense – train young minds in "transcendence-thinking" and become perfect components for "conceptual-thinking" later on when those Catholic girls and boys become grown-up artists. After the convent, I went to a Catholic

college and studied with an art teacher who is a nun/sculptress, Mother Mary Jane. She skillfully opened my conceptual world by giving me the "key of permission." Because of her spontaneity and creative joy, I found myself twirling around the school with loose energy.

My finest memory is of a conceptual adventure I had there – I organized the other art students to join me in making a clay mural on the school's staircase wall. It felt forbidden in its freedom. Her permission allowed me to be a creative leader, a self-propelled rule-maker, and a wild artist! Isn't that a wonderful gift to give someone! That's what mentors are made for! Conceptually I birthed my first "art-child" in her class, and for my senior thesis in sculpture I made five versions of the *Visitation*; that's the mystery of Mary/Elizabeth embracing, both pregnant, exchanging energy. I interpreted the *Visitation* in clay, wood, car parts, plaster, and that's pretty conceptual. But the most interesting part of the story is that she and I are now talking about sculpting a 45-foot-high version of the *Visitation* in response to 9/11. Two human towers embracing this time. For my MA I studied sculpture in Italy (with a Hungarian violinist-turned-sculptor and ex-student of the composer Zoltán Kodály). It was 1966, an incredible year at Villa Schifanoia, a Catholic graduate school for art and music in Florence, and I discovered that I loved the studio as well as real-time art-making, having presented a "happening" at my sculpture opening.

Another conceptual highlight! I went on to more grad school and an MFA at the University of Wisconsin, from 1966–69. There I studied conceptual art, minimal art, and watched the jock guys weld things as tall as Quonset huts. It was humiliating and so I just followed the crowd, stopped assembling crucifixes, made believe I had never even heard the word "Catholic" before, and presented live chickens as art on the roof of the just-opened art building. Hmmm, I guess at that time I thought artists shouldn't be Catholics (was that peer art pressure?), and it's taken me over twenty-five years to re-assemble the components of my early life. As we speak, I've come back to the Church and am contemplating making crucifixes again!

The next evolutionary conceptual step was to present MYSELF AS ART. All of the previous things I had done happened within

the confines of the academy. But the concept of performing "me" was self-propelled, and it was then that my conceptual intelligence and mind took flight and form outside the institutions. I became a conceptual clone of my thoughts.

Cohn: So with that in mind, what does being a conceptual artist mean in your terms; how do you define it?

Montano: What it means is saying "goodbye" to matter, "goodbye" to painting, and "goodbye" to sculpture and flying into freedom, having permission, feeling the excitement of doing what you want, when you want, how you want, why you want. It was complete play, but brilliant and new play. In a sense, if you talk about it in terms of the chakras, it's moving from the first chakra to the seventh chakra, moving from matter and stuff to spirit and clear mind/concept. It was about being completely cerebral and completely telepathic and completely rumor-based and completely mind-based and completely trickster-based because you know, the origin of conceptual art was not about money, it was not about galleries, not about audiences – it was about a group, shining their minds into other minds of like-minded people who were having fun and hanging out in that game-world. We were a tribe. Of course, you have to remember that eastern theologies were being courted and introduced at that time, and all of the secrets and the mysteries of the east were feeding us, along with the women's movement and anti-war politics. It was a soup of influence.

Cohn: How does your identity as a conceptual artist intersect with what you do as a sculptor and as a performance artist?

Montano: It's like a hierarchy of title. The conceptual artist is sort of a grandparent, and then the lineage branches out with variations or subchapters or subchildren of the grandparents. Conceptual art is the peak of the umbrella of this graph or tree, a family tree. Conceptual art is translated into performance art for me. I am a living sculpture; notice I didn't say living sculptor but a living sculpture. So I would never divorce sculpture from my vocabulary or my love, and I would never divorce performance art. Conceptual art is a little bit out of my range, so to speak, because it is that grandfather lineage. The popular street title I use is "performance art." Therefore, as a performance artist, I am also a living sculpture.

Cohn: Can you talk a bit more about that idea of being a living sculpture?

Montano: I'd have to talk about money here because it's about growing up with my parents' memory of the 1930s and World War II. I'm sure my parents and grandparents were resonating with not only the Depression, but also with World War II. And rationing: I remember kneading together white margarine in a sac with a little yellow ball; and I remember ration books and I remember money and food issues as a child, and the Holocaust. Then I remember a kind of permission to live a life of simplicity via Catholicism as a child. And then I remember being a nun. These are images of austerity that formed my style. Oh, but getting back to living sculpture. As a nun I took "temporary" but not professed vows of poverty. So from war to frugality to poverty, it was very easy for me to graduate from making things to making myself. So easy. I wasn't great at making things look great, but I knew intuitively that I would be more satisfied with making my inner self shine like a wonderful shiny sculpture. Plus it's cheaper! I haven't accomplished that transformation, but it's less publicly obvious than making a sculpture that isn't completely perfect. I'm safer being a living sculpture than I am making something that's easily judged from the outside and costs tons of money.

Cohn: That seems important, because in using yourself, you also get to be a lifetime work in progress. So it's perhaps a quest for ultimates?

Montano: It never ends. I think the concept of impermanence and the resurgence of conceptual art is here again because the World Trade Center attack has taught us about the impermanence of objects and the need for pure ideas. It's very timely to be conceptual, and it's very timely to rethink all of the good reasons for conceptual art. It's a purification of the dross, of the way things evolved and got commodified.

Cohn: It's interesting to hear you talk about yourself and your work as being art in everyday life. Did any other artist influence your thinking about the intersections between art and life?

Montano: The spiritual artists and specifically my yoga and meditation teacher Dr. R. S. Mishra, who has ashrams in Monroe, New York, and San Francisco, influenced me tremendously. Even though he was an adept yogi, he valued the arts and creative expression as the frosting on life's cake! He suggested that you've got to do something to celebrate and cure life. I was also reading *Artforum* and *ARTnews* and hearing about Allan Kaprow, and one

of my early art mentors was Marcel Duchamp. I adored Duchamp. I think I really wanted to be his art-child. When I came to San Francisco, I met Tom Marioni (kind of Duchamp in Italian form) and Howard Fried and Terry Fox. Although I had performed before I came here, I was inspired by the feel of San Francisco and started dancing and celebrating myself. Of course, so many powerful women were here: Pauline Oliveros, Moira Roth, Minnette Lehmann, Lynn Hershman, Eleanor Antin, *High Performance Magazine*, Bonnie Sherk, Barbara T. Smith, and all of the fabulous female artists from LA who greatly influenced me and supported my dream. Plus my photographer/husband Mitchell Payne and I lived an art/life collaboration that was conceptually/really intense and celebratory.

Another one of my main influences was Eva Hesse. Once I sent her a postcard that I was doing something someplace, and I guess I included my phone number . . . I was a fan. One night I was with my husband-to-be, and I said to him, "Someone's died that I'm very, very close to," and the phone rang. I answered it and this man said to me, "Eva Hesse would have wanted you to know that she died." That was pretty conceptual! So I felt that she's one of my invisible guiding lights.

Cohn: That's amazing. One of the questions that keeps coming up for me is why did you come to San Francisco?

Montano: My husband had been in the Presbyterian seminary in Marin, loved it, and wanted to come back. I followed him. It was the right thing to do.

Cohn: How long did you stay?

Montano: I stayed five years in San Francisco and five years in San Diego.

Cohn: Why did you move back to New York?

Montano: I followed my next partner, who wanted to move back to where I was from because they fell in love with upstate New York. Is it true that there are no accidents? I'm not sure, but we moved to a meditation center and I retired from art. It was 1980, and I really wanted to stop documenting myself and performing. The A-frame we lived in had no running water, only electricity and a wood stove. It was on top of a mountain: the Zen Mountain Monastery. And it was divine. Early morning meditations happened at the main hall down the path. It was a training center for

Empty Mind. Great concepts floated through my mental computer while I sat silently eight hours a day! I highly recommend the practice.

Cohn: It seems that you followed the path that you wanted to or what your life dictated rather than being worried about career. So many artists make the choice to move to New York City or to be in LA or in San Francisco in order to make a name for themselves.

Montano: I left the monastery to be tied by a rope to Tehching Hsieh during his one-year performance. I joined him in his concept and that was a hard decision because I chose to leave the monastic life and to live in New York City and make "art" again. I struggled very, very hard with this decision: wanting life to be meditation disguised as art and doing it in the world. What I gave up was Zen monkhood for conceptual arthood!

Cohn: That seems to be an ongoing set of issues for you. Returning to the early 1970s, could you talk about what type of work you were doing then and whether you are still doing that type of work now?

Montano: I was exuberant; I was newly married. I was so happy to be here. I loved San Francisco along with marriage, and had recently discovered yoga, which helped me unlock the doors of self-acceptance, self-celebration of the body and mind and spirit. Symbolically, I communicated this ecstasy by wearing a prom dress and dancing on the streets in the dress. I also started developing personae, but that was maybe four or five years later. That work became a serious investigation after I left my husband. I called it creative schizophrenia because I did start splitting off from myself from the trauma of divorce. But I turned this crisis of life into art with the video *Learning to Talk* (1976–78 Video Data Bank).

I was also very enamored of the performance art scene here and figured out that I had the right juice to come up with a project that allowed me to fit in. For example, I performed in front of the Art Institute on a treadmill, translating my autobiography into action and therapy and sculpture (living sculpture made from living life). I also collaborated with Tom Marioni; danced on the Golden Gate Bridge. It was fun. Mitchell and I went to MOCA.[5] Terry Fox's performances, Bonnie Sherk's Farm . . . it was performance ecstasy time.

Cohn: Do you think that there is a continuity between what you were doing then with what you're doing now?

Montano: The concept of permission is the ocean, and the waves are how that manifests. My recent translation of how I permission myself to make art of life is care taking my eighty-nine-year-old dad. I knew in the back of my brain that I would declare it "art" one day and then teach it, but that took two years to formulate. At first I just stayed with Dad. Now I call it art and videotape him. So the ocean of permission, the brilliance and pristineness of that permission has been always there. Then, it's how I permission myself, how I change with my own influences, my own broken-ness, my own aging, my own illnesses, my own autobiography, my own living conditions, my own translations of the daily news, my own inner World Trade Center . . . how I live and then make art of that life-matter. The delicate part is trying not to invade another's space with my own creative need to make art. Often I declare things to be art mentally and put down my video camera.

Cohn: One of the ideas that comes to mind is if you're going to call yourself a conceptual artist, you have to have invented something. It seems that most of the artists in your group created various kinds of "firsts" during the early 1970s. I was wondering if you could talk about that a little bit. Do you feel you've been acknowl-edged for it?

Montano: For what I created?

Cohn: Yes, what you invented; what you did in that period of time. I was thinking about the *Chicken Dance*, and the fact that you had been in a convent, and the ways in which you have continually reinvented yourself.

Montano: I think I invented a way for the "Catholic girl" inside me to get what she wanted. As artists, we give ourselves what the inner child or the little girl or the little boy always wanted. My gift to art is a "Catholic gift." We see the statues, we see the Crucifixion, and we see these unmoving, perfect beings. I tried to imitate the statues by becoming a saint via art: dressed in white, sitting still, white on my face.

Another influence was my mother's questioning and fun-loving mind. My father is extremely pious, but my mother was a real comedian. I took their gifts and I was able to convert spiritual imagery into art piety. I also have this great ability to make myself and others smile at the irony, the mystery, the tragedy, and the fun of life, and at the beauty of the color of it all. I also hope that

I invented a way for spirit to be felt in performance in a uniquely female way.

Cohn: How do you think Catholicism formed the inception of your vision of color?

Montano: I'm writing a paper on early childhood spiritual memory and its translation into art. I literally took the smells of church, the sights of church, the sounds of church, and almost, as if speaking another language, translated those into my work. I templated Catholicism into art. It was a feminist gesture, not knowing at the time, of course, that I was really just envious of the priests and totally mystified by the Eucharist and the Crucifixion. I wanted that feeling of vibrating resonance in my work.

Cohn: Did you want to suffer?

Montano: The Crucifixion is an interesting model. I've stayed at my work long enough to be able to understand suffering. Hopefully I didn't get addicted to it, because it is historically enforced in art books (the Van Gogh model), and it's also enforced in the ritual model of the Crucifixion, except when theology stresses the Resurrection and Transfiguration. So I'm happy that I've stayed in my work long enough to celebrate, to laugh, and when I have to suffer in my art, I do it less neurotically than I did before. This all takes time and detachment from having a reputation for endurance or difficult art. You can't put acupuncture needles in your face for every event or a catheter up your nose and out your mouth! That would be taking advantage of a good idea.

Cohn: It seems as if you've gone through a transcendent experience or some process of enlightenment in terms of your knowledge of yourself.

Montano: My whole life, I made my living hand to mouth, gig to gig. Then I got a cushy teaching job, and then I got children (students); I got lots of children (students)! That experience really catapulted me back to the Church (I needed help because teaching is a responsibility) and to really looking at my work on a different level. For example, what about sexual imagery in the academy? Hmmm. Big question. You can't let students explore the erotic openly in the academy and then mix that climate of experimentation with the concerns of donors, deans, parents, and colleagues. What a puzzle. People who have children of their own have an opportunity to clean up their act because they want to become a

"good example" for their children. Responsibility comes to parents naturally. Non-parents learn other ways. Or you can bypass the system and become a visiting artist, not a tenured professor.

Cohn: Talk more about responsibility.

Montano: In the 1960s and 1970s we all were very permissive. We were doing research on food, sex, money, and death, all of which are taboo. We had to decode those issues; we had to strip the taboo out of them. We had to immerse ourselves in all of those secrets. And we made mistakes. I feel now that I made many mistakes, but back then I thought I was cool. So teaching those "children" about responsible actions and telling them, "Do not imitate dangerous art, don't hurt yourself," that was responsibility! Teaching helped me to redefine my direction. In fact, it lured me back to Roman Catholicism and I reenergized my roots. In doing that, I traded my art muse for a spiritual muse. My soul was hungry for a higher level of satisfaction. I really believe in obedience, and before I was obeying myself and my art. Now, I feel I did everything that I wanted to do, and I'm saying, "Okay, you tell me what to do. Church, you be my guide. I surrender." It's all very spiritually retro.

Cohn: You've done so many things – do you feel you've been acknowledged for them?

Montano: We are not acknowledged until we are able to acknowledge ourselves emotionally. The work has to be done on the intellectual, psychological, economic, and chakra levels, so to speak. Acknowledgment is a complex issue. But I'm really happy with where I am. I'm extremely happy. I've occasionally put out career feelers and then pulled back. I've become insistent on having a show someplace. And other times I go into hiding mode and am happy that I can do that for years at a time. It balances the work. There was a great painter who made his living as a dentist and then did his art freely and without art world compulsions. I always liked that story. A hidden artist story. Also there is a movie about a woman healer-preacher who gets burned by the world, goes away, opens a gas station in a desert, and heals occasionally without calling attention to herself. That fascinates me.

Cohn: Have you always been like that?

Montano: Yes, I've always been like that.

Cohn: Was there anything about living in San Francisco during the

early 1970s that you feel supported that or supported you as an artist?

Montano: When I come back to San Francisco, I'm reminded that people here are respectful. I remember five years ago, walking from where I was staying to teach at the Art Institute, which is like a second home, and I saw a traffic mishap on one of the major roads that comes in from Marin County. One man hit the car in front of him and they both got out of their cars and shook hands. Isn't that fabulous? Only in San Francisco! That's why I feel supported. The inner/outer life is more balanced here.

Cohn: It's so interesting, to hear you talk San Francisco this way. It seems to have had so much importance in the context of sustaining your life in the most positive sense.

Montano: We have different sites that nourish our muse and help mature us. Some places heat us and bend us sculpturally and with force. Other places are softer in their embrace. But ever since 9/11, the game has changed.

Cohn: Do you mean in terms of the commodification of performances?

Montano: Yes, it's over. Performance and all the arts are innocent again.

Cohn: That brings to mind something that Albert Einstein said, that I think relates to this: "Everything has changed – except for our way of thinking." I'm not sure I fully agree with it, because with that single event of the World Trade Center Towers going down, everything instantly changed.

Montano: I think artists have not been stopped or muzzled by tragedy, but we certainly have been symbolically tossed about. Is the storm over? What do we do now? What do we not do?

Cohn: I'm interested in hearing you talk a bit more about the 1970s. What fit into your vision at that time politically?

Montano: There was a subtle understanding of equality in the San Francisco scene. Gender-wise, the players were equally matched. There wasn't a fighting for inclusion. There was a real, high-quality respect for each other. Females and males as equals, just sharing the title "artists." That's great politics.

Cohn: Do you think that sense of gender equality grew because so many of you were involved with identity investigations?

Montano: Yes, we were all inspired by Duchamp's Rose Sélavy. I don't know why. Also the celebratory "costuming" of the times:

the women's movement's costume, the political movement's costume, the spiritual movement's costume, the drug movement's costume, the hippie movement's costume, the artist movement's costume, the rock 'n' roll movement's costume. All of these permissions to experiment externally/internally were happening at the same time and are a convincing argument for why we responded performatively by adopting aliases, and becoming different people and different personas. Now the reasons for our creative responses are scientific and more about cloning, genetic research, and UFO sightings.

My response in the 1970s was to birth myself as my totem animal, and I called myself "Chicken Woman." Later it was hard, difficult things that resurrected different personas and my interest in character, my interest in personalities, and my interest in using accents. For example, when I moved to San Diego from San Francisco and started spontaneously to talk in a French accent, and later I sat in front of a video camera for a year talking in accents that became a kind of more formally constructed investigation of personality. That was my Southern California work, which was fed by the Woman's Building[6] and trauma.

Now, I've stepped back from risk-taking that looks creatively celebratory; now I'm not being recognized for my creative self, but rather, I'm seen as the daughter, the sister, the caretaker, the one who left the small town at an early age but went back again. It's like re-making myself, and I do it as a challenge, I do it as a performance. Sometimes it's very, very painful because I'm not getting recognition and there is no celebratory permission. Just ordinary life. But the endurance is still there. The endurance of the ordinariness of daily life. The challenge is finding small, hidden ways to make that art. For balance, I enjoy coming to San Francisco, and I enjoy being in the presence of the Art Institute and other places where I can shine as this other persona, which is "the artist in perpetual permission."

Cohn: What is your manifesto?

Montano: LIFE IS ART. ART IS LIFE. GOOD LIFE IS GOOD ART. ART IS RETIRED WHEN MIND SINKS INTO SILENCE. THEN SILENCE/LIFE IS ENOUGH.

2002

Burger King and the Avant-Garde

Jenni Sorkin

This interview took place on December 7, 2001 in Kingston, New York at the local Burger King in preparation for the exhibition *High Performance: The First Five Years, 1978–82* that Sorkin curated as part of her MA Thesis at The Center for Curatorial Studies, Bard College.

Sorkin: Tell me when you first heard about *High Performance*, how you got involved with it, and how you ended up in the magazine.

Montano: When I was living in San Diego, I met Moira Roth, who was teaching at UCSD [University of California, San Diego] and was very involved with interviewing performance artists. My interview with her appeared in one of the early issues of *High Performance*[7] along with the text from the performance *Mitchell's Death*.

Sorkin: Was the video of *Mitchell's Death* made before or after the performance or simultaneously?

Montano: It was made after the performance. I wrote the text and then performed it live to a video of myself putting in acupuncture needles in the room before I came out. I brought the video on stage with me and played it on a monitor – remember it was the 1970s, so things were pretty primitive – but it was large for the time and I stood in the middle between the monitor and on either side of me were two performers, Pauline Oliveros and Al Rossi, playing musical instruments, a bowl gong and a scruti box from India.

Sorkin: Can you talk about what *Mitchell's Death* was about for you?

Montano: It was basically confusion, guilt, tragedy, and shock. I had left my husband, Mitchell Payne, we were divorced, and a year and a half after our divorce he tragically died in Kansas City.

Sorkin: So was *Mitchell's Death* a really cathartic piece for you?

Montano: It was a way that the Southern California art community was able to support me in my grief. I left Mitchell to be a 1970s' woman so to speak, and do what I wanted.

Sorkin: Had he been responsive to that change in you, or no?

Montano: He wanted to hold onto what we had, and where we were, and I was in an all-or-nothing situation, and I chose to go in the direction of my new life . . .

Sorkin: Which was art?

Montano: Yes. The 1970s wrecked havoc, you know, in many ways . . . it was a time permeated with feminist idealism and an American idealism and a hubris that suffused and sponged through the crevices of everything we did and thought. The odor of permission was so, so effusive that we did what we wanted, whenever we wanted and that meant changing sexual proclivities and styles, divorcing and marrying and leaving, and sleeping and drugging and everything. Everything was being experimented with.

Sorkin: How did you begin performing? You already had a graduate degree . . .

Montano: I had an MFA, and I could almost say that I started performing when I left the convent in 1962 and this incredible nun mentored me into artistic freedom. Before the convent I went to college for a year, then to the convent for two years, and then back to The College of New Rochelle (in New York) for three years, and this wonderful nun who is still alive gave me my art wings.

Sorkin: How was your Catholicism tolerated when you were in California?

Montano: Well, I was a wimp, and I opted out, thinking that artists weren't supposed to do it, and I was going to be a good artist and not do it, and I chose to hide my Catholicism and I stopped practicing.

Sorkin: The 1970s was a decade permeated with eastern religion . . . did you take up Buddhism or Hinduism, or yoga, can you talk a little bit about that?

Montano: In the 1970s I started yoga . . .

Sorkin: And did that feel spiritual?

Montano: It was also affirming. It really cut through a lot of the Puritanism that had seeped into American theology. Although now Catholicism is doing quite well, incorporating mysticism into religious practice, pre-Vatican II was a terrifying world of sin and punishment. So, happily, I found the eastern traditions, and started with yoga, moved to Tibetan Buddhism and then Zen and back to yoga, and then found a way to interface Catholicism into all of it. Now I practice a Catholicism that is informed by eastern traditions. It is called Centering Prayer.

Sorkin: But it took you a long time to get to that point?

Montano: A long time.

Sorkin: Did you ever want to work directly with the earth, did that ever appeal to you, or were you dealing more with the spirit?

Montano: One of the pieces where I did Living Art, Pauline and I lived for eleven days in her van, in the California desert. That was earthy. At the University of Wisconsin, Madison, there was an agricultural school and I found myself visiting the live chickens a lot. So for my MFA exhibition, I showed chickens in minimal-art-looking cages: three cages, nine chickens. I performed as the Chicken Woman. But I was never an Ana Mendieta kind of artist, I was always more humorously, conceptually oriented.

Sorkin: And not object-based?

Montano: Hopefully not. Hopefully I stayed away from objects as much as possible. I think any woman who was studying sculpture at the time when minimal and conceptual art were being practiced by heavy-duty welders and fabricators, male fabricators, were pretty intimidated, because these men were making incredibly clean-cut minimalist and mathematically precise, well-fabricated things that were very extremely formalistic . . .

Sorkin: And cold?

Montano: And cold.

Sorkin: And did that kind of work make you angry or uncomfortable?

Montano: I didn't know how to be furious until I embraced my fear, which happened after I was tied with a rope to Tehching Hsieh in his performance *Art/Life: One Year Performance* (1983–84). That event uprooted rage and anger, which as a good Catholic girl, I had hidden.

Sorkin: Did you go to Confession as a child?

Montano: Lots of Confession. *Lots* of Confession. *The Story of My Life* (1973) was based on having gone to Confession, and re-creating Confession as performance, and reclaiming performance as Confession, taking it out of the box and into the street. I mean, if you look at *7 Years of Living Art*, where I met people one-on-one for seven, ten hours a day for seven years at least once a month, that was *total* Confession all over again, only I was the priest, and I think we feminist women, gave ourselves roles to acquaint ourselves with professions of dignity and positions of power.

Sorkin: Do you also think it was giving yourself permission to confess in a public way, to put yourself out there, where if you were raised as a "good girl" where now you got to be a spectacle of some sort, or do you think that performance isn't ever spectacle?

Montano: That can be pushed only so far. I think that obedience is the issue here, and that obedience is necessary to the human condition, and we are either obedient to ourselves, or the muse, as an artist.

Sorkin: But you yourself, throughout your work, have really pushed this concept of obedience to become a kind of painful endurance. Very few women have done this kind of work. Correct me if I'm wrong, but I believe Tom Marioni was the first person you tied yourself to . . .

Montano: Handcuffed.

Sorkin: I don't know how long you did that piece for, was it five days?

Montano: Some time. I had been doing blindfolds for weeks.

Sorkin: A week at a time?

Montano: Yes.

Sorkin: Can you talk a bit about the blindfolds?

Montano: I found that if sight, or any of the senses, is altered, or taken away, or denied, then hormonally, or biologically, something is activated that raises a level of brain neurons that activate both endorphins and attentional states.

Sorkin: So did it take you to a different level to do that kind of work?

Montano: Absolutely. I had begun yoga and I was trying to initiate the vibratory brilliance of my teacher, Dr. R.S. Mishra.

Sorkin: Did it always feel that way at the beginning, or that's how it felt by the end of the performance?

Montano: Immediately at the beginning. It was taking away a habitual response. This is a *Gurdjieft* principle that says, if you brush your teeth with your right hand, then do it with your left. So something is done differently. Slow down if you are fast, speed up if you are slow. So these were assignments I was giving myself in order to taste the condition of high states of consciousness.

Sorkin: But do you think it was also tasting, or coming into this kind of being or awareness that you weren't permitted in your marriage, or as a woman in this society?

Montano: It's appropriating the priesthood. But then again, nuns were allowed those states. But again, only the mystics, and the holy anorexics.

Sorkin: So was it a state of ecstasy necessary for you to create endurance work?

Montano: All of us replicate states that we practiced as young children, and there were certain things that we all did, that we spend the rest of our lives trying to redo, either as life and/or art. I can remember being able to produce states of travel in a high ecstasy by standing on my bed and looking out of this little window in my parents' house, at night. That was a high-level mysticism for me and a real escape into the void.

Sorkin: Did you leave your body? Was it an out-of-body kind of experience?

Montano: It was more a feeling state, a kinesthesia, an expansion.

Sorkin: Was there power in it, to do that as a child?

Montano: Sure. And then I found that as an artist I could duplicate that by designing or creating actions that when disparate elements were collaged together by choice, my will, my palate, my recipe, I could magically make this magic happen again and share it with others. I would ask them to travel with me so it became not just me, but me in relation to others, all helping collectively to feel the mystery of life.

Sorkin: A lot of your work is rooted in an ascetic practice, where you are all alone, creating a ritual, with a kind of extreme commitment, where you stake out limits, and proceed to enact them. How does an audience come into that for you? Because a lot of your work doesn't involve a direct audience.

Montano: I used the audience for years as a witness, but now I'm very, very conscious of where they are, who they are, and are they

coming with me? If they are not, I'll adjust, I will make it happen so that is not just myself alone. So, I have really become quite mature in relation to the audience, I'm very, very conscious of them.

Sorkin: Are duty and family loyalty very important to you? You did that series of portraits of your mother, and she took photographs of you, so you've periodically incorporated your family into your work, so that they are part of it, whether they want to be or not. How does that happen? Are they willing subjects?

Montano: I'm noticing that I'm doing now what I call *Dad Art*. I am hanging around a lot with my father because I am his caretaker and actually, my dad just recently surprised me. Two weeks ago, I asked him if I could videotape him, and he said yes. So I've been videotaping this man and making art about him with his permission. We've become collaborators, not just father and daughter.

Sorkin: On tape do you talk to him, do you interview him?

Montano: No, I'm just doing visual images. But this is a really big deal for me, because this is my first collaboration with him. My mother and others were able to do that, but I feel this is *big*, it has that sense of "wow." It might not be great art, so to speak, might not, but the process is very satisfying.

Sorkin: So is the process more important to you than the finished product?

Montano: The weakness of my work is that I would never go for the product and always went for the process and so it's a shame and it's a strength.

Sorkin: I think it's courageous in the sense that you haven't been afraid to fail, if something didn't work out.

Montano: A Tai Chi master once came over to my studio, a really important one, a Taoist, and he said, "Don't ever look to the outside, your work is powerful, let the world come to you." So that's what I do.

2002

Chapter 2

The Ecstasy of Sister Rose

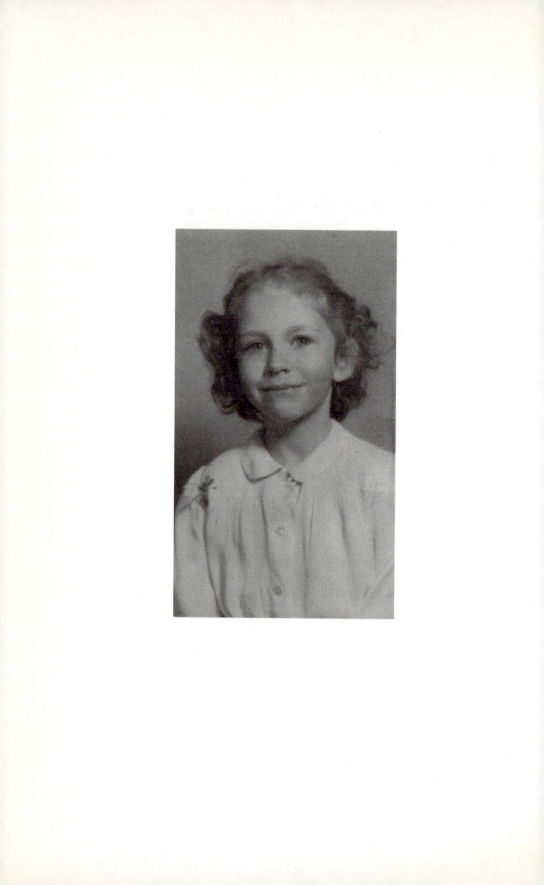

Forgiveness as Spring-Cleaning

Why artists now want to be saints

This is the script for a performance/lecture that Montano gave at Woodstock Library in Woodstock, NY as part of the library's Saturday Free Lecture Series.

Introduction

In an interview published in April 2001, a well-known actor discussed his priorities. He says he was once ambitious, once prolific, but had the wrong emphasis, didn't have the love of a wife and children the way he does now, didn't have a real home. It all felt real old, a "comedy of errors." Hmmmmm I thought, if S_____ is doing this, it must be in the air, and possibly the hundredth monkey theory is at work and we are all re-evaluating our lives at the same time? Or is millennium fever at work on aging superstars?

And here is another forgiveness story from the news. On a sunny April morning a local rock station featured a "Day of Atonement," inviting their listening audience to call in for forgiveness. Yes, they mentioned self-forgiveness as well as forgiveness from or to another person or event, indicating a familiarity with sophisticated teachings on the psychological effectiveness and need for self-forgiveness. Rock on, rock and roll. This paper will address issues of conscience, sin, and creativity and includes a cross-cultural look at forgiveness. At the end, please feel free to join in visualizing a sacramental spring-cleaning of your seven chakras. The slides I am showing are of Benares India and are from a book of that title and the music from the 1940s is a sonic presence that links us to mother, father; and in my life it is a tribute

to my eighty-eight-year-old dad who is here tonight. Both the slides and music are to remind the visual and listening quadrants of the brain that the underlying reason for conscience, forgiveness, and the maintenance of conscience is somehow linked to life, memory, and the end of life/death indicating one reason for being good . . . which is a guaranteed ticket to heaven!

The slides: Benares is the city of both life and death, a place I visited a few summers ago to research ghats, cremation grounds on the banks of the Ganges. This trip allowed me to not only witness numerous cremations (there are about 100 a day) but to also come to a few conclusions:

> My death is not to be feared. As Ram Das says, death is highly
> overrated. We shall see.
> My conscience is in need of cultivation.
> Becoming my dad's primary caretaker has informed my conscience
> for the better and resurrected my orthodox Catholic roots.

Now let's begin the paper.

Part 1. What is the conscience and how is it formed?

The late Karl Menninger, a well-known psychiatrist, spoke of certain acts being indecorous and not acceptable. In most cultures parents teach the cultural taboos of the tribe using stories and rituals. This is done with kindness and gentleness. Conversely, he says that we civilized are severe in our discipline and like to punish the infraction with heavy disciplines. I would ask the cultural anthropologists among us to check out Menninger's statement for tinges of romanticized and glorified exoticism on his part and, if he is being truthful, then I would ask why are the civilized so severe, so punitive?

Part 2. Forgiveness in other cultures

A. Jainism

Jains are a spiritual group within Hinduism and are the quiet and essential practitioners of nonviolence. In order to remind themselves

and their followers to be nonviolent, their monks and nuns wear an index-card-looking device over their mouths in public and when giving discourses so that they can avoid inhaling bugs of infinitesimal size. They also carry a small cloth broom everywhere and brush away small bugs or invisible germs when they sit. Daily, orthodox Jains recite long prayers of forgiveness and pardon to rocks, to water, to people, to food, reminding themselves of the living properties of all things and need for mindfulness. Once a year there is a day culminating many days of reciting Practicum, their prayer of pardon, when their asking for forgiveness and saying, "I'm sorry for any way I have hurt you in the past" [loose translation], is celebrated in a group. They move throughout the room and say "Michhami Dukrum" to each person, eye-to-eye, to man, woman, and child, in a ritual of forgiving/being forgiven.

B. Judaism

On the Day of Atonement, celebrated during Jewish New Year and high holy days, forgiveness is asked for sins committed during the previous year. This Yom Kippur ritual lasts twenty-four hours, from sundown to sundown and the haunting prayer of forgiveness, Kal Nidra, is chanted at this time.

C. Hinduism

Although the yamas and niyamas, rules and regulations are suggested practices in Hinduism, much emphasis is given to purification rituals, which remove blockages so that kundalini energy can be experienced in the shusumma or spinal cord. The path or preparation is cultivated and not as much attention is placed on good/bad which is tolerated and examined/placed in the context of past life karma and not seen as the business of the Real Reality of the practitioner.

D. Tibetans

Tibetans encourage prostrations, mantra repetition, and scripture study, memorization, and deity worship as preparation for realization.

Color, sound, and aroma overwhelm everyday neurotic concerns and this might be one of the reasons Americans trained in severe self-judgment find eastern theologies so nurturing and practice their new religions so devotedly. Thank you India, Tibet, and Japan for sending your teachers here and mirroring the practices of the early church fathers and mothers.

E. American Indians

The Occidental and Yucatan Indians confess only once in their lives, in public, surrounded by their tribe and family and only when they feel death is very near. There are stories of when death reverses itself, some interesting occurrences happen when they go back to their tribe with their confessions and sins now known to all. HMMMMMM! Try that one on! Take a look and try to imagine a similar situation, standing with a microphone making a general confession of absolutely everything, all mistakes, telling your entire family, your colleagues, your bosses, your children, your parents, your friends, your enemies, and your animals. Quite a formidable practice and an interesting motivation to goodness, just in case Sister Death (St. Francis's name for death) decided not to really do her thing!

F. Medicinal forgiveness

Some cultures treat the body itself in a purgative and confessional way. Yogis vigorously clean their tongues with a metal tongue cleaner; they are known to swallow a gauze cloth in the stomach, soak up liquids there and pull it back out of their mouths; some can reverse the sphincter and suck water into the rectum, cleaning the bowels and then discharging the water; some put a string or cathedra into their nose and pull it out of their mouths, cleaning the nasal passages; some put honey in the eyes to clear blocked tear ducts and produce the healing protein called tears; some sniff mustard oil into the nostrils to clear and shock the brain out of depression; some induce vomiting with warm salt water therefore cleaning the stomach etc.

These examples of medical "confession" are often as effective as American Medical Association drugs which cause hideous side effects,

hide astronomical costs, and create dependencies on pain-medicine-dispensing doctors. By the way, don't try any of the above suggestions without a doctor's prescription or a qualified yogi's presence and teachings.

G. *Group confession/Alcoholics Anonymous*

The AA twelve-step program suggests forgiveness of self and others plus reparation when appropriate and has successfully supported alcoholics in their journey toward healing and respect.

H. *Roman Catholicism*

Pre-Vatican II Catholics made weekly trips to medieval confessional boxes where sins of omission, sins of commission and mortal and venial sins were confessed to the priest. The more orthodox made a nightly examination of conscience, gathering material for Saturday's confession and asking pardon for the sins and mistakes of that day. In the past ten years much has changed; the box is optional, anonymity a choice and a face-to face open form can be chosen as a mode of confession. More importantly, the bells and whistles around sin have changed their tune because as theology explores the theories of mercy and grace, the deep sense of shame and guilt and that big Scarlet Letter stain has left this sacrament. The door to forgiveness has opened and the air is now clean.

Part 3. Those medically excused from sin

Medically speaking some are excused from sin even though they have had access to the ten commandments, social niceties and advanced courses in ethics. If the brain function is in disorder due to a variety of psychological or neurological reasons, then pathological behavior results. Conscience and culpability are no longer an issue. Extreme impairment changes the status of the sinner from sinner to criminal to impaired. Hairsplitting over voluntary, involuntary and partially voluntary actions distinguishes the spiritual from the legal to the medical analysis of fault.

Part 4. Those culturally excused from sin

For years, freedom-seeking folks, now in our sixties and seventies lived in the kingdom of no-sin, a mythological and real journey not only into Edenesque pleasure but one of political/spiritual/feminist revolution. Therapy became our confession of choice and was where we could convince our therapist-employee that:

1. Everything that happened to us was somebody else's fault.
2. That we were wonderful creative artists working out our patterns in ways verging on genius.

We gave our therapists gifts of our book, articles published or announcements of shows we starred in to soften the real reason we were there – to heal our souls. My therapists were paid to cheer me on even when my behavior seemed soul-searing. But in truth their presence was necessary to my own process of return, for having been brought up with an exacting conscience, it took time for me to find a way back to an appropriate harmony and an original luminosity, a state of grace in keeping with my roots.

Art historian and artist Kristine Stiles in her writings and research suggests that performance art always allows for a creative display of secrets, neuroses, trauma, and creative solution. Now that I have returned to a healthy alliance with my spiritual roots and the Catholic sacrament of reconciliation, there are no more excuses. No creative fixes to frost over my pain. No blame shifting, because in that confessional box where bad breath is literally visible, the soul gets stripped to its core and feels, "what I did was wrong." And out of the ashes of having been crucified by lapses and urges and temptations and mistakes comes the beautiful sacramental mystery of priestly forgiveness, the mystery of restitution, the mystery of penance, the mystery of sorrow and promise to sin no more. How this new life will affect my art, my politics, my performances, my bank account, only time will tell. (We aren't even going to go near issues of women and the church, women priests . . .)

Part 5. Possible reasons why conscience is back

Is it because New York Mayor [Rudolph] Giuliani called for a decency panel staffed by "decent" people to address "tainted" art-curatorial decisions by museums using public money and WE want to be a decent person, sitting on that panel? No, that's not the reason.

Is it because we survived the multifarious health crises of the 1980s and 1990s, hepatitis A, B, and C, Lyme disease, mad cow, west Nile, hoof and mouth? And now we've made a vow to lead a healthy and conscience-filled life?

Is it because the only reasonable response and backlash to TV's *Chains of Love, Temptation Island, Survivor* and *World Wide Wrestling* is to live a celibate, monastic, highly moral, secret spiritual life? No, that's not the reason.

Is it because the Dali Lama, Thuck Nat Than, Mother Teresa and Ram Dass have smiles that are authentic, nonsurgically induced and are the result of a clear conscience and we want that too? No, that's not the reason.

Is it because DNA, robotics, genetic engineering, weightless space travel, and UFOs are hard to comprehend and it is easier to go back to old paradigms, not ahead? No, that's not the reason.

No, it's none of the above. It is because of our computer, that's why we have developed this need for accountability and a conscience. That's why we are more responsible, more surrendered. The computer slaps our wrists with rules and invitations to carefulness:

Pause, Retrieve and Update, Anti-Virus, Escape, Help, Uninstall, Backspace, Remove, Delete, Crash, End, Download, Cancel, Retrieve, Date, Recycle Bin, Go Back Home, Stop, Refresh, Refresh, Go Back Home, Go Back Home. Ommmmmmmmmmmmmmmmmmmmmm.

Part 6. Sacramentally spring-clean the chakras

Can you imagine the first center, the Muladhara, at the base of the spine? Baptize it, invite it to be new, spotless, and celebrate the stuff of life: food, money, car insurance, computers and clothes. Feel invited to belong on this earth Mother.

Can you imagine your second center, the Swadhisthana chakra? It attracts others in relationships and yet feels complete in itself, in the sacrament of Communion and sacred inclusion. Mother-nurture this center.

Can you imagine the third center, the Manipura chakra, located at the tandien, the hara? It is the strong, courageous, warrior center. The sacrament of Confirmation resonates here, the place where we feel the impetus to perform divine and correct missions and use our talents with fortitude. We mother this talent of endurance in our lives and use it in our current obstacles.

Can you imagine your fourth center, your heart center – the Anahata chakra? Here Marriage is born and compassion is the name of the heart's child. Oh feel the luminous, gracefulness of one second of this spaciousness.

Can you imagine the fifth center, the thyroid – the parathyroid, the center of food and talking and decision-making? The chakra is called Vishuddha and the sacrament is Confession. Use this center to release the weight of shame and guilt and generational patterns that hinder inner joy. Talk it out, spit it out, laugh it out, and scream it out. Confess, confess, confess then lie on sweet mother's earth and smile.

Can you imagine the sixth center, the pineal gland, the third eye, the Ajna chakra? This is the site of divine reasoning, higher thinking, Ordination. It is the priest center; the what-should-I-do-with-my-life center, the listening to the message with intuitive discernment center. It is the center where path and dream and inner wisdom are nurtured and mothered.

Can you imagine the seventh center, the Sahasrara, the top of the head? Let it soften as in birth. Let all receive the Sacrament of the Sick to heal our past sick thoughts, words, and deeds, and eventually receive it on our deathbed. Now the skull is pressure-free and only honey flows from the skull, not worries and problems and terror and impossibilities. Softly, gently we mother-love the mother within.

This is not the end.

2001

Erotica

Once upon a time . . .

Time was running out. Brian returned not only to his upstate, home-town, village life, and prelude to retirement, but to the religion of his youth, Roman Catholicism. Age, lost innocence, near fatalities, poor judgment and harsh wake-up calls had forced a surrender that only his art had known until then. In obedience he traveled back, not ahead on his own trail, but back to the sights, smells, rituals, and sacraments; back to a physical posturing, an early, learned stance and awe-filled reticence that helped him survive his first seventeen years in that town of watching and loose-tongued gossip over the clothes line. Remember it was the 1950s.

BHAJI

1 cabbage sliced thin
3 large potatoes cut small
1 jalapeno, take out seeds if want mild
1 tablespoon mustard seed
¼ teaspoon turmeric
1 tablespoon coriander powder
Lemon juice to taste

Heat ghee. When hot add mustard, chili, and turmeric. When mustard pops add potatoes. Stir and cook 8 minutes. Medium heat. Add cabbage. Cook until both tender. Add coriander. Lemon to taste. Eat with yogurt.

Scrutiny by others was a small price to pay for THE RETURN because in going back he contacted a physical kinesthesia, an uncontrollable bodily response to Mystery and Presence which was swoonlike, ecstasylike, liminallike, back to a spontaneous desire to not move, rather BE moved from within. Brian's first "experience" when ten resulted in what seemed to be a fainting from hunger or overheating. It happened simultaneously with the Consecration of the Wine at Mass but after that one time he hid the feeling deep inside, modeling the Zen-quiet equanimity of the nuns who closely watched their flock, mentoring stillness both in church and the classroom.

BASMATI RICE

1½ cups basmati rice
2 tablespoons ghee
2 inch cinnamon stick
2 cloves
2 green cardamoms crushed

Wash rice in cold water until clear. Cover with water and soak 30 minutes. Heat ghee, add rice, stir on medium, one minute. Add water, spices, and boil. Cover, put on low with lid, and simmer about 20 minutes. When done let stand 5 minutes. Eat with yogurt.

Once back in the same village, Brian's hippocampus, reptilian brain, inner child, and drama-trained skills reemerged and he attempted to construct himself as he had once been. Given the task of incorporating tremendous surges of energy into cells habituated to his own proclivities, he found the tug-of-war fascinating. With scientific observation he noted how he coped those first fifteen years; voices were then punitive, repeating mantra-like to "Hold it in," "Deny," Don't show off," "Don't tell," and when the ecstatic force of Visitation washed over his soul-hunger at Mass or during prayer in public he

heard "Tighten up so the kids kneeling next to you don't have a clue what's happening. Only saints faint with love."

CHANNA KARI

2 cans chickpeas
1 tablespoon curry powder
¼ teaspoon cumin
1 onion
Ginger
Garlic
2 cloves
¼ cup fresh coriander

Fry onions, garlic and all spices in oil. Add drained chickpeas and lemon juice to taste. Sprinkle coriander on top.

For forty years he had been away in lands and mental states of permission and creativity and free intimacy and desire. As a result he was terribly spoiled. Inclusion of EVERYTHING as permissible had provided him with a playground for his secularized metaphysical flights. Orchestrating things so well, he actually made a living from doing what he wanted – at least that's what it seemed; days were an unending banquet, an art cruise, an uninterrupted ride into alpha. And on the way back, he re-arranged the muse's messages, sharing the wealth.

CASHEW RICE WITH PEAS

1 cup leftover basmati rice
½ cup roasted cashew pieces
½ cup frozen peas thawed in hot water
2 tablespoons ghee
Pinch of hing (a Hindu spice), turmeric

In pan put spices and cashews. Stir. Add rice. Stir and heat. Garnish with coriander.

That was then. Encased in shame, the Prodigal Son crashed, came home to the same bed, same house, same kitchen table, but this time something was different. Glued to the TV, he watched re-runs of

animal programs on the Discovery Channel and was heart-softened by one about wild ponies trained to be used differently. Actually, it made him cry – the ropes, the hoofs in the air, the handlers talking the wildness out until a saddle and bridle and bit, then rider won over the animal's will. Horse eyes went from flaming red to sweet surrender. Brian identified and Grace was the rider.

CHAPATI

1 cup flour
1 tablespoon oil
Water

Combine all ingredients. Knead and form a ball. Place in bowl, 30 minutes. Knead again and form about 7 small balls. Roll into a 5 inch circle. Use flour if too sticky. Heat until bubbles and turn, cooking the other side until it puffs.

Co-trainers there were many; critiques by blood family, his uncontested memories, and an amazingly wise and semicloistered monk who became his spiritual director. Father Gerald had been in India for thirty-five years and his international experience had karmically prepared him to understand Brian's soul, which was conversant with and practiced in eastern theologies. So when Brian said Kundalini, Father Gerald translated it as Gifts of the Spirit; Brian said Vedanta, Father Gerald said Transubstantiation; Brian said Nirvikalpa Samadhi, Father said Centering Prayer; Brian said Tantra, Father Gerald said Reconciliation; Brian said Makyo, Father said neurotic hallucinations. And on and on, spiritually echoing each other. It was much like a religious Berlitz course, a recipe for return and re-theologizing of Brian's ride back to Presence.

KEER

7 cups milk
1 cup rice
½ teaspoon cardamom powder
1 bay leaf
Sugar to taste
Raisins/sliced almonds optional

Combine rice, milk, and bay leaf. Cook to boil, stirring constantly. When thick remove bay leaf. Add cardamom, sugar, raisins, and almonds.

A year into his return home it began again: he was tossed to the floor. Just like before the walls whispered messages. Just like before he floated to the ceiling and beyond. Just like before he fainted when the Host was raised at Mass – just like before. To compensate he did three things:

1 He asked, Am I dreaming? Having a bioelectrical/neurological misfiring?
2 He overate, became heavier and used the logic that said more pounds, less levitation.
3 He met with Father Gerald and they talked for hours about the difference between demonic oppression and demonic possession. Once the difference was understood, Brian was encouraged to repeat Hail Marys, or the Memorare, or command the disturbance to leave in the name of the Blood of Jesus! Possession needed exorcism; oppression needed prayer. Father counseled further: "Learn to pray, Brian, that is your greatest weapon and don't get attached to any of this. I want to read you something written by St. John of the Cross:"

> The pure, cautious, simple and humble soul should resist and reject revelation and other visions with as much effort and care as it would extremely dangerous temptations, for in order to reach the UNION OF LOVE there is no need of desiring them, but rather of rejecting them. Solomon meant this when he exclaimed: "What need has a man to desire and seek what is above his natural capacity?" This means that to be perfect there is no need to desire or receive goods in a way that is supernatural and beyond one's capacity.

CHAI

7 cups water
7 cups milk
1 cinnamon stick

3 cloves
Ginger cut or whole
6 green cardamom, crushed
Few black peppercorns
Sugar to taste
12–14 full teaspoons black tea or tea bags

Heat milk, spices and water to boil, let sit 5 minutes. Add tea.
Boil again on low for 5 minutes. If in a hurry, boil and stir for
5 minutes, strain and serve.

Years of fearless Body Art was good training because now his 630
muscles relaxed when attacked; the 400 trillion cells of his body
exuded light when bothered; his cerebrum, cerebellum, cerebral
cortex, and hippocampus were no longer overpowered by chaos.
Humbled by all the newness and the simplicity of obedience, he let
go of his tensions, forgot about his tortured conscience, and gave up
his old proclivities for the extraordinary. Life quieted itself.

And then, while in prayer one chilly March dawn, he surrendered,
submitted, obeyed, received, and merged, when a feather-winged
light force wrapped him in a warmth beyond touch, piercing his side,
his hands, his feet, with an invisible knife-tipped arrow. This is not

THE END

MEDICINAL KICHEREE

1 cup rice
1 cup mung beans
4 cups water

Boil all together. Cover and simmer for 30 minutes or until
finished.

2001

Art as Spiritual Practice

Enculturation/brain waves/temporal-lobe seizures

What follows is a paper that Montano presented at a panel discussion organized by Bonnie Marranca as part of a series of public talks on the contemporary arts, entitled "Performance Ideas," which was curated by Marranca and Meredith Monk in Fall/Spring 2001–02. The Panel on Art As Spiritual Practice took place on November 5, 2001 at Location One, a SoHo gallery, media, and performance space. Members of the panel included Alison Knowles, Eleanor Heartney, Meredith Monk, Erik Ehn, and Montano. The panel was moderated by Marranca. The entire panel discussion was published in *Performing Art Journal* 72, 24, no. 3 (September 2002): 25–30.

All quotations from Teresa of Avila come from *The Way of Perfection* (trans. and ed. Alison Peers, New York: Doubleday Image Books, 1946).

Natural Voice: Honestly I must admit that I think that I have been selected for this prestigious panel because I've performed and dressed up as a mother superior, a saint, a guru, a mystic, a priest, a martyr, a swami and a healer for thirty years and called that play art. I must also confess that a nun's costume doesn't confer instant sanctity. As Shakespeare and Annie Sprinkle both say, "Dresseth liketh undt nuneth, duth noteth undt sainteth maketh!"

Saint Voice/Teresa of Avila: The first thing that we have to do, and that at once, is to rid ourselves of love for this body of ours: and some of us pamper our natures so much that this will cause no little labor, while others are so concerned about their health that the troubles these things give us is amazing.

Natural Voice: Once done, art has a life of its own. It's a separate entity, a being, a baby, a child. As a good and loyal parent who has given public birth to a body of work, I will let that baby art shine without the burden of my embarrassment or judgment, and will honestly talk about the subject using a self-imposed interview as a writing device.

Saint Voice/Teresa of Avila: It is when I possess least that I have fewest worries and the Lord knows that I am more afflicted when there is excess of anything than when there is a lack of it. I am not sure if that is the Lord's doing but I have noticed that he provides for us immediately.

British Voice: Question: Describe your early life.

Natural Voice: I was enculturated early into strict Roman Catholicism in an upstate New York village right out of a storybook. Mom: Irish/Yankee/convert from Episcopalianism was a comedienne, painter, and questioner of authority in a subtle way. Dad: pious/creative/silent/focused: his parents non-English speaking from Compobosso, devout, silent, and hardworking.

Alien Voice: What was your early childhood spiritual training?

Saint Voice/Teresa of Avila: There are two kinds of love, one is purely spiritual and has nothing to do with sensuality or the tenderness of nature, either of which might stain its purity. The other is also spiritual, but mingled with it are our sensuality and weakness; yet it is a worthy love, which as between relatives and friends, seems lawful.

British Voice: Question: What did your enculturation look like later on in your work? We all imitate our childhood and early issues. That is a given. Did your work look Roman Catholic?

Natural Voice: I will answer by reading two lists. The first list is composed of Catholic memories. The second list is a few performances that translated those memories into art.

List 1: Catholic memories

the smell of high-quality incense
the inflexibility of doctrine
the dedication of vow-taking nuns
the talking saint-statues

the patriarchical exclusivity
the Tiffany stained-glass windows
the fasting before Communion, First Fridays, and Lent
the stories of statues crying blood
the sounds of small bells at Communion
the sounds of the large Angelus bells
the fear of dropping the Host
the poetry of the Latin Mass
the ritually tailored vestments
the possibility of Purgatory
the daily examination of conscience
the mystery of Transubstantion
the ecstatic surrender to creed
the nun's/priest's unavailable celibacy
the obedience
the stories of miracles, martyrdoms, missionaries, curing of leprosy
the offering up (to God) anger, rage, traumas
the repetition of trance-inducing rosaries
the Stations of the Cross, the Stations of the Cross
the relief and humiliation of weekly confession
the prayer beads and holy cards
the Mayday hymn singing and rosary at the Lourdes shrine
the belonging, the belonging, the belonging
the promise of heavenly reward
the promise, the promise, the promise

List 2: A few of those memories as art

wearing blindfolds for a week (penance)
creation of Chicken Woman (saint statues)
anorexia videos (fasting)
riding bikes on Brooklyn Bridge tied by a rope (miracle of walking
 on water)
14 Years of Living Art (imitation of priest's vestments)

In another paper, I will look more closely at this hypothesis and translate all of my performances into reseen Catholic memories.

Saint Voice/Teresa of Avila: In every respect we must be careful and alert because the devil never slumbers.

British Voice: Question: That is certainly an idealized look at religion. You are looking without the politics, without the people, without the hypocrisy, without the complexities of human failure, human foibles and follies. I would convert immediately reading your memory list. You became a nun didn't you? I can certainly see why you did.

Natural Voice: It was only logical that this intense early training resulted in a desire for sanctity. In 1960 I entered a missionary convent and for two years did the following:

1. I talked only 1 hour a day and that was "in common," in a room with all nuns present.
2. I wore 4 layers of medieval, pre-Vatican-II clothes called a habit.
3. I chanted ecstatically with over 300 nuns in a Nun Story chapel and even though I was as high as a kite, emotionally I was unready and was told to leave by a Katherine Hepburn look-alike nun who said, "Go and be an actress, Sister Rose Augustine." I left, 82 pounds, anorexic and hungry for something that only art gave me. Mother art became my trauma catcher, my therapy, my confidante, my best friend, my guide, my confessor, and my salvation. Art became religion. And in separating from Catholicism, I married art.

British Voice: What kind of art did you practice?

Natural Voice: From 1962 to 1969, I sculpted/welded the Visitation (Mary embracing Elizabeth, both pregnant), made crucifixes, and eventually presented live chickens as art for my MFA. Sculpture I learned in graduate schools; performance I later invented for myself out of necessity. That necessity was a fascination with the energy of aliveness. When I performed I got attention from others that helped me attend to me. When I attended to me, I discovered that the 3 billion cells in the body, when properly treated, can produce a half-watt of electricity in all 3 billion cells. WOW!!! Also I could oscillate my brain waves at a frequency that produced addictively pleasing endorphin states of consciousness. The brain waves are:

Beta, 13–35 oscillations, (thinking)

Alpha, 8–13, (rest)

Theta, 4–8, (small children, adults sleeping, dream, strong emotions)

Delta, 0–5, (sleeping newborns)

By aesthetically purging subconscious material via public actions, via exposition of excesses of power, via exploration of autobiography as art, the brain empties of obscurations, guilts, fears, shames and goes into modes of consciousness curried by nuns, contemplatives and all seekers of samadhi.

Alien Voice: [Pause] How do you get high? What is your inner peacemaker?

Saint Voice/Teresa of Avila: Often commend to God any sister who is at fault and strive for your own part to practice the virtue which is the opposite of her fault with great perfection.

British Voice: Does it bother you that a University of California, San Diego professor, V. Ramachandran posits that spiritual ecstasy/ higher consciousness and the samadhi you talked about is the result of misfiring from the brain's temporal lobe when it goes into seizures? Some of his supporters are now saying that God is a G spot in the brain.

Natural Voice: That kind of information makes me both nervous and excited. I think it coexists and actually adds to my faith and doesn't shake it because although I am embracing blind obedience, I insist on practicing a more informed Catholicism. Obedience is a must. Before I was obedient only to my art muse.

Alien Voice: Where is your heart and soul? Where is your solidarity?

Saint Voice/Teresa of Avila: The soul is like an infant still at its mother's breast.

British Voice: I fear narcissism and too much self here. And I also see eastern influences and a nonart stance in what you are saying. Isn't your work more about art therapy than any formalist art-magazine-like investigation?

Natural Voice: Exactly.

Alien Voice: What allows you to do what you do when very few agree with you?

Saint Voice/Teresa of Avila: Avoid being bashful with God, as some people are, in the belief that they are being humble.

British Voice: Why didn't you remain Catholic and talk about your eastern influences?

Natural Voice: It wasn't cool to be a Catholic artist in the 1960s, and I regret that I followed the crowd and left the Church, but I must also congratulate myself for exploring eastern religions. They are so culturally and theologically rich. For example their take on the body and the inclusion of the sacredness of emotion and sex as a vehicle to higher consciousness is an immeasurable and breath-taking gift to the west where sin and fear of sinning reigned until that soul-fright changed after Vatican II. Thomas Merton, lucky boy, remained Catholic, researched both traditions and success-fully practiced both. After studying with my Hindu Guru, Dr. R.S. Mishra, living in his ashram (Ananda), a Zen center, and attending numerous Tibetan teachings, I was able to return to Catholicism in the early 1990s, enriched and better prepared to practice with more insight. Actually I crawled back on my hands and knees having taught seven years at a University and losing tenure. I was broken, getting old and I asked for re-entry, abashed for having left my deeply acculturated and deeply engrained early religious training yet happy to be more informed. Hopefully I'm not doing reverse spiritual materialism now by following the neo-Catholic returnee syndrome.

Recently I've been able to collage together the tolerance and beauty and warmth of yoga and all of the other lineages we ALL experience and include in our art practices. This is currently not a detriment to my (again) strict practice of Catholicism. In fact as we speak I am imagining a 45-foot tall bronze Visitation made in collaboration with the nun who first taught me sculptures in college.

Alien Voice: What does your art/spiritual collage/life look like?

Saint Voice/Teresa of Avila: If words do not fail you when you talk to people on earth, why should they do so when you talk to God?

British Voice: What is your art now?

Natural Voice: I'm back in life school performing and learning from my father in a performance called, *Dad Art*, part of a larger performance called *Blood Family Art*. I'm my eighty-nine-year-old dad's primary caretaker and I do this as art. That makes it inter-esting and sacred and it took two years of life caretaking to call it art. It's funny, when I call things art, they are sacred to me. So

when these two senior citizens, father and daughter, get to cross between the two worlds of the surreal and the real on a daily basis, it is very instructive and the training is helpful. He's playing with death and teaches me about that. I'm playing with aging and have not taught that yet.

Alien Voice: What is your next life change?

Saint Voice/Teresa of Avila: God leads those who he most loves by way of trials.

British Voice: Actually, I didn't want to know about your work now, but what is the work now, given 9/11?

Natural Voice: The trauma of 9/11 has forced the entire universe into a Monastic state of THETA brain wave oscillations. Trauma elicits THETA. We are all at 4–8 oscillations and like newborns, like adults sleeping, like those with death on our left shoulders, we live. Artists will never be muzzled or silenced forever, but we are taking our time to co-feel the ecstasy of impermanence, which this tragedy has presented to us. All of us are leveled by tragedy. As mystics of matter, we will soon know when to sing again.

Alien Voice: How did you create a new song from a past trauma?

Saint Voice/Teresa of Avila: Remember how Saint Augustine tells us about his seeking God in many places and eventually finding Him within himself?

2002

Teresa of Avila . . . a Story

During the second orange year of *7 Years of Living Art*, Montano was guided by the Spanish saint, author, visionary, mystic, and Doctor of the Church, Teresa of Avila. What follows is a video script currently in production.

Dear Sisters and Brothers in the Spirit,
Let me begin this letter to you with a prayer:

Lord, you came to heal the wounded heart, the troubled heart, and the anxious heart. I beg you to come and heal all of us including our psychological self and our mental memories so that we can walk fearlessly, compassionately and wisely in your light-filled grace.

Amen.

Pause

Now, let me tell you how I will structure this letter:
First I will relate my life story. Second, I will show you how to proceed spiritually as I have done, using the seven sacraments as a template and guide. Third, I will show you what not to do, by using my mistakes as an example.
In all humility, I ask, why do you want me to write to you again since I have written so many times before? Is it my advancing age and ill health that cause you to seek my final counsel? Of course my

confessor has demanded that I answer your request for a letter and in obedience to him, I send this, but believe me, all of you are already as holy, as spiritually articulate, as mystically advanced and as enamored of the divine life as am I. Your sentiments and mine are equal but I do in all humility offer this advice in my final letter that includes my personal life story. I hope that it may inspire your already blessed and holy journey.

My life began March 28, 1515. Now, sixty-seven years later, I am about to leave this mortal coil, this worn-out flesh, this tormented physical body, to be with my Divine Lover in eternal Silence and Peace. Oh this neverending Silence will be so refreshing – but back to my story.

I was born of saintly parents in Spain and had a spiritually rich and privileged beginning. Piety was our food, piety was our example, piety was our goal, so it was no surprise that I wanted to be a saint, even at seven years of age. In fact, my younger brother and I secretly left home, praying that we would die for the Catholic faith. This is not the place to tell you about my grandfather who was Jewish and converted to Roman Catholicism as a result of the Inquisition, but I see now that my ardent need for endurance, my desire to reform the lax practice of the faith and my strict interpretation of the desert fathers' monastic rules might have originated from my rather religiously complicated roots.

As a child, my main interest was always religion. Before I was ten years old, I had already built a hermitage and hut on my parents' property so you see the need to have a structured and strict religious life was with me always. Praying after I saw a picture of Jesus talking with the Samaritan woman at the well, I said to my Lord:

Lord, give me only Living Water that I might drink.

I knew even then that precious earthly water was inferior to spiritual water and grace that gives true life. Dear ones, you too must ask for what you want, state your spiritual desires and don't give up until you get what you want. It's that simple, but you have to know what to ask for and persevere in your request until you and Jesus are in harmony and deep communication.

Pause

Dear mystics, do not make the mistakes that I made of mortifying yourself with too many penances. Instead be true to your Baptismal vows.

> Baptism: Baptism is the sacrament of re-birth through which Jesus Christ gives us the divine life and joins us to his mystical body.

Pause

Losing my mama to an illness at age fourteen deepened my need for an even more intense inner life. Soon after she died I went before an image of Our Blessed Lady and asked Mary to be my mother now that my own mother would never feed me again, would never soothe my hurts again, would never brush my hair again, would never smile her beautiful smile at me again, would never support my dreams or comfort me through my life traumas again. Please, blessed ones do not force your beloved parents to be perfect. Maybe they will not be always there for you emotionally or physically. Instead, ask Our Blessed Mother to be your mother and St. Joseph to be your father. Then you don't have unreasonable expectations placed on your human parents. You have made mistakes haven't you? Let your parents be human also and forgive their shortcomings.

I guess I became a little unruly after Mama died although I always had a code of honor and purity that was common to Spanish girls at that time. But flirting and dancing and gossiping and frivolity with my friends and cousins filled the gap that was in my heart. Luckily these teenage habits were cut short because Papa realized that he needed help to raise me and put me in a convent when I was fifteen. Although I loved being there, I got sick and as was common then, was sent home to convalesce. I went to be with my uncle and older sister at their homes. What a suffering it was to be away from the convent! And then another suffering came because Papa didn't want me to go back to the convent when I felt better so I had to secretly return and was professed a Carmelite sister when I was twenty-one.

Pause

Dear ones, do not make the mistake that I did of mortifying yourself inappropriately with too many penances so that you can feel special. Instead live the sacramental life and use the sacrament of Communion to attain to an inner health and peace.

> Communion: The Holy Eucharist, Communion, is the sacrament and the sacrifice in which Jesus Christ under the appearance of bread and wine is contained, offered and received.

Pause

Now, back to my story. Although my personality is extremely strong, I have fragile health so it is not surprising that I got sick once again in the convent and left for home to recover. Was God telling me not to be a nun? My health always bothered me and the unskilled medical treatment that I was given really impaired and weakened me my entire life. Once they thought that I had malaria, then cancer. I contracted oh so many illnesses . . . and even with physicians' treatments I got sicker and sicker. What saved me? A few things actually . . . but one was a book by St. Jerome that taught me mental prayer. Mental prayer is so wonderful because it gives interior freedom, detachment, humility, and determination, but dear ones you must have solitude and a specific time for prayer, fellowship with other saints, and go to Holy Communion daily, plus say the Rosary. The path is a disciplined one, as you can see.

I began this practice of mental prayer and in three years I was well and back in the convent again although when I left my family this last time to go to the convent, I felt a pain like death itself. Why did I go, you ask? The convent offered me a place where I could practice even deeper silence, a place where I could fast, a place where I could be supported in my vocal prayers, a place where I could counsel the needy and nurse the sick. I am truly surprised that more young women and men don't become nuns and priests and brothers. It is an extraordinarily exquisite life.

Pause

Dear ones, mortification is not the way. Do not make the mistake that I did of punishing yourself too much by performing self-centered penances. Instead follow the sacramental life and be true to your Confirmation.

> Confirmation: Confirmation is the sacrament in which Jesus Christ confers upon us spiritual adulthood through the graces of the Holy Spirit especially those that enable us to profess and spread our faith courageously. Through Confirmation, Christ confers on us the Holy Spirit making us full-fledged and responsible members of the Mystical Body.

Pause

Back to my story. This early convent life was spiritually efficacious and wonderful but remember we needed money to feed all of us, to clothe all of the sisters, to take care of the simple essentials, and that means that we had to entertain benefactors and donors and patrons and the wealthy. So little time was left for silence, prayer, and meditation. Prayer is what saved me when I was sick and yet now I had no time for it. Maybe that's why I got sick over and over again for fifteen years. The pattern was that I would get sick and then they would send me home, sick/home, sick/home. What saved me from the stress of illness? What saved me from a scrupulous and delicate conscience? What saved me from feelings of unworthiness and worldly distractions?

Prayer! Prayer! Prayer! I admit that it was maintenance prayer but still I did pray because my confessors (there were many) advised me to hold fast to prayer and to do so with great zeal. Have you tried that, my friends in Christ? How hard that is to do when we are feeling out of touch with the Divine and must proceed solely by faith and self-discipline and devotion. Like a married woman with nine children I was pulled between so many obligations: obligations to my prayer life, obligations to people, obligations to possessions, obligations to a friendship with the Divine.

Pause

Dear readers of this letter, do not make the mistakes I made of creating egocentric penances and mortifications. Instead be true to your Marriage vows and follow your vocation with joy and loyalty and compassion for your partner.

> Marriage: Marriage is the sacrament in which Christ unites a Christian man and woman in a lifelong union, making them two in one flesh.

Pause

Speaking of obligations, a clear conscience makes life joyful and I can only applaud the married Catholics who are able to be disciplined, sinless, devout and loyal to their partner and to God and their families. Plus do all of the work that is necessary when you run a household. Can you imagine doing all of that with guilty consciences? Eventually all of my own endurances, good intentions, clear inner mind, and devotions to God flowered and suddenly, I stopped feeling as if I was doing anything at all. Suddenly, God lived in me. Somewhat the way Paul says, "It is no longer I that live but God that lives in me." That's exactly what happened and I experienced a conversion – a conversion from petty sinfulness, a conversion from living for luxury and gifts, a conversion from dissipating my time and spiritual talents.

You must be curious about how that specifically happened? Of course it happened because I performed many spiritual practices but also it happened because I was ready. The time was right. Plus things I read in two books were the final pieces of the puzzle.

The first book I read was titled *The Confessions of St. Augustine*; the second was the story of Mary Magdalene. St. Augustine's admission of his own sinfulness and Mary Magdalene's turning away from prostitution to celibacy moved me toward my own holiness. And what happened to me when I gave my entire will to the Divine was overwhelming. Extremely powerful spiritual visions and inner voices became commonplace, plus levitations and locutions. Please don't envy me these happening because your path is unique to you, in fact

they happened to me because I needed big fireworks to wake me up to my Inner Lover. Can I tell you another event that happened to me? This, the most powerful, happened when an angel from God, pierced my heart and entrails with an arrow. This is called transverberation and you can see how Bernini sculpted this occasion in his majestic statue, years later. Believe me, it is only a statue and none of the intense feeling that lived within me for the rest of my life can ever be portrayed by this sculpture because art cannot approximate the depth of the spiritual life. I tried hiding these manifestations from the nuns in the convent but it is impossible to hide levitation because they would come into the chapel and I would be there alone, floating four feet in the air. Isn't Profound Love wonderful!

Many thought that I was a neurotic, or satanic worshipper, or medically compromised or insane, or a paranoid schizophrenic, but others considered me a saint. You see, it is not easy to have these things happening to you, and I remained at the mercy of the Divine Will and steadfastly refused to budge from this position of twenty-four-hour-a-day devotion to LOVE.

Pause

My dear followers of the rule, do not make the mistakes that I made and mortify your flesh with so much pride and arrogance. Instead, live the sacramental life and go to confession daily if you can, cleaning your heart and soul of all obscurations, bondages and stains from sin.

Penance: Penance is the sacrament in which Jesus Christ through the absolution of the priest forgives sins committed after baptism. We must be sorry for our sins, detest them because they offend God and separate us from God, and we must make amends for our sins promising not to sin again.

For a penance, we say prayers or perform good works.

Pause

I was speaking about my commitment to the Divine Will. Let me tell you more about this important process. How did I do that? I sat in silence and I listened to the silence until it spoke in Divine ways. I was present. I didn't follow my own inclinations. That's how I knew what to do. Instructions came from the Holy Spirit. Of course I checked everything out with my confessors unless it was an everyday kind of suggestion, like be especially kind to Sr. Rose of the Sacred Heart today even though she drives you crazy! But one day, a very powerful voice came and that day, the Spirit told me to break away from the convent that I was living in and create a new one. What a challenge! I knew it would cause trouble but in 1562, I obeyed and founded The Convent of Discalced Nuns of the Primitive Rule of St. Joseph of Avila. Oh what joy! Now I could live the way that I needed to live so that my soul could blossom. And for five years a few sisters who followed me from our other convent helped me with my new dream, a dream to live simply and humbly, despite political jealousies, despite persecutions from clergy, despite all of the negatives, which come from having a vision and new way of practicing one's faith! I was so maligned but it was because we were not only strict but because we were so successful. Our rules were: perpetual silence, extreme poverty, we wore coarse robes, wore sandals instead of sturdy and warm shoes and lived in small spaces conducive to prayer, not to company.

These reformed convents were more popular than the rich ones. Truly we were austere but let me assure you that we also had fun. In fact I insisted that my followers didn't become sullen and sour by giving them each a pair of castanets so that we could dance and sing and celebrate life on feast days. I think that my sense of humor saved us from a lot of suffering because I was able to remain light-hearted throughout my illnesses, throughout my arduous journeys in extremely uncomfortable bullock carts, throughout satanic attacks to me in my cell at night, throughout my battles with civil and religious authorities, and throughout my extreme spiritual manifestations.

Remember I told you about the times that I was lifted up 4 feet high in the air while in prayer, levitating in ecstasy? This was no laughing matter but I remained humorous about it so that when

my sisters would find me floating around in the chapel, all alone, I laughed it off, otherwise they would be terribly jealous of God's spiritual gifts to me. Humor does cut through the awesome sacredness of the sacred and made it more digestible. I wanted them to think less about my own specialness and more about the Divine Mystery. I guess that I would be considered a feminist in these modern days because I was strong, a diplomat, a visionary, and certainly never afraid to follow my bliss, no matter the consequences. Fearless was my name.

Pause

Dear obedient ones do not make the mistakes that I did of mortifying yourself too much with too many external penances. Instead live the sacramental life and if you are a male, discern whether you are called to Holy Orders. Don't fret, dear sisters, the Church does not allow us women to say mass or dispense the sacraments, but our inner life is rich with rewards too beautiful to compare with this other privilege. Never mind worrying about being left out! Actually we are left out so we can go IN for comfort beyond the external.

> Holy Orders: Holy Orders is the sacrament through which Christ gives to men the power and the grace to perform the sacred duties of bishops, priests and other ministers of the Church. After changing bread and wine into His holy body and blood, Jesus told the apostles, "Do this in memory of me." With these words he conferred the priesthood on the apostles.

Pause

After those first five years in my new convent, I was again nailed to the cross by well-meaning clerics who told me to do this and that, to write this book and that one, but despite those difficulties and roadblocks, I founded and opened seventeen convents for women of this strict order and with my collaborator and friend, John of the Cross, we opened some for men also. You see I was married to the church that speaks through the laws and spiritual direction of the

priests. We must all be obedient and married to something or someone and must maintain that same obedience that is relegated to a man and a woman who have taken marriage vows. Obedience is the highway to freedom.

In conclusion, dear Sisters and Brothers, it is time for this letter to come to an end. For more information about me, please read all of my books. *The Interior Castle* will teach you how to unite with Divine Presence while encountering all of the temptations, distractions and discouragements on this spiritually dangerous path. If you desire Marriage with the Divine this book will teach you the way. If there is nothing more that you want from material life, and you wish to faint with continuous ecstasy, deep rapture, and an enlightened mind, then this book will be a treasure and guide to the Interior Castle, the dwelling place of LOVE.

But on the other hand, if you need rules to follow, then read the book I wrote for nuns titled *The Way of Perfection*. It gives practical suggestions and advice about prayer, advice about attachment and the traps of familiarity, advice about food intake and fasting, advice about confession, advice about clothing, advice about maintaining the right attitude while in the convent, advice about gossiping, advice about human loneliness, advice about hysteria and generally will help clear up all questions that you might have. We all need rules until we graduate to that state of unity where it is not I that lives but Christ that lives in us. Then we need only the air we breathe and we live beyond rules. The third book you can read is my autobiography that my confessors also told me to write. You see I had so many people guiding my soul and each one wanted me to put my unique experiences on paper, that's why I wrote so many books. Do you believe that I could sound so smart on paper and was literally uneducated? That is a gift of the Holy Spirit.

Now you know it all, you have every piece of information and all of the secrets necessary to follow my path or create one of your own. Death will soon come to me. In fact, it will happen in October 1582, to be exact. Then my soul will be finally ripped out of my body by the force of God's love, and this body will remain uncorrupt and life-like even until this day. Come to Spain and see this soulless but still soulful-looking body for yourself.

I leave you now with all of my titles and accomplishments: a Doctor of the Church, an author of six books, a foundress of

seventeen convents, but most importantly, a Beloved Lover of the Divine. Everything I did and wrote will be forgotten. My soul in vibration with the Divine is Eternal and my only success.

Pause

Do not make the mistakes I made of designing your own penances and mortifications. God and life do very well without our input and shape us with Divine Hands. Instead, stay loyal to the sacraments and when sick or dying, ask for the sacrament of Extreme Unction.

> Extreme Unction: The Last Anointing is the sacrament in which Christ, through the anointing and prayers of the priest, gives health and strength to the soul and sometimes to the body, when we are in danger of death through sickness.

Pause

My sisters, it is so hard to leave you, so I sing this prayer for you as my final gift: Let nothing disturb you; nothing frighten you. All things are passing. God never changes. Patience obtains all things. Nothing is wanting to him who possesses God. God alone suffices.
In Christ,

Your Teresa.

2003

Little Linda (LL) becomes Performance Artist/Chicken Linda (PACL) becomes Roman Catholic Linda Mary (RCLM)

In 1999, Montano was invited to be a visiting artist at Mills College Oakland, California. Below is the text for a performance given during Pauline Oliveros' Composition Class.

Change

1942: LL was born into an orthodox Irish/Italian Catholic family and desired more than anything else to be a saint, no matter the cost.

1942–59: LL was inspired by the colors, sights, sounds, and smells of the Roman Catholic rituals she attended with her family, not really understanding the Real Presence.

1950: LL faints with ecstasy when the priest consecrates the Host and lifts up the Real Body and Blood of Christ at Communion for the congregation to venerate.

1950–60, 1990–present: LL and RCLM go into a small wooden box at the back of the church, face a male priest to tell him her sins so that she can feel her heart cleaned and clear.

1959–61: LL enters the convent for two years, reaching heightened states of consciousness.

Change

1962–91: PACL becomes thoroughly disillusioned with the politics of the Church, the exclusivity of the practices, the oversights of the organization, the focus on action over contemplation, the humanness of the clergy, and finds a place in the art world where she can use her talents, leadership, and ability to transform energy creatively. PACL performs art actions bordering on the dangerous, transgressive, outrageous, and desires to become a performance-art saint although she has no regard for the ethical, emotional, financial, or physical consequences of her actions.

1962–95: PACL makes poor judgments and indiscriminate decisions in relationships and notices the ineffective consequences of living compulsively.

1978: PACL begins to receive real-life messages of mortality, death, close calls, bad choices, personal illnesses, impermanence and practices new age, eastern and earth-centered methods to achieve harmony and understanding of reality.

Change

1990: RCLM feels a need to unscramble the misinformation of early theological programming as taught to her in the 1950s, and gets a highly trained Catholic professional to help her in her theological re-emergence.

1991–present: RCLM begins to use the Roman Catholic sacraments, specifically Confession, to clear her heart and mind of past secrets, guilt, shames, and obscurations.

1991–present: RCLM collages together the best aspects of eastern traditions and earth-centered theologies, current scientific research and post-Vatican-II teachings in her practice of Roman Catholicism.

1991–present: RCLM drops the autobiographical-centered performances of her past and includes the theological. She drops cynicism/irony (almost) for the mystical and the art of everyday life supercedes chosen endurances.

1991–present: RCLM surrenders to and obeys Catholic teachings from her childhood but this time admits to and chooses to see

where the patriarchal aspects are still operative. The truth is, she is there for the Sacraments, not the institution.

1991–present: RCLM has transferred feminism, goddess worship, earth-mother rituals, and psychic insights into a workable and coherent relationship with Mary, the Blessed Mother.

1991–present: RCLM performs in collaboration with the Higher Artist. She no longer makes art her God but God her art.

No change

1999/2002

Chapter 3

Writings

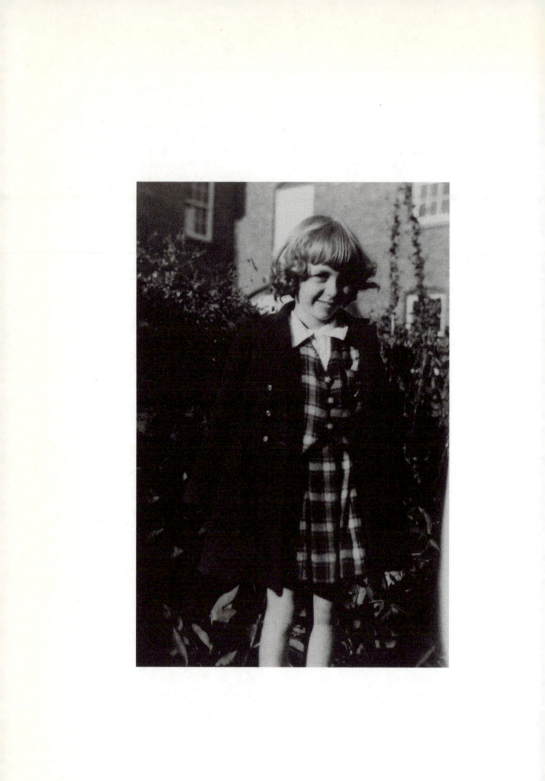

Art as Therapy

The reason I decided to become an Art/Life counselor

This piece was written in response to Montano's concern that art-making had become less about fulfilling the soul and more about having an art career, making money, and getting reproduced in magazines. Never published, this piece was rediscovered by Montano several years ago in the Linda M. Montano archives, which she was assembling in anticipation of selling them to an institution or art organization. Because of the limitations of space, this book contains less than a quarter of what is available in her archive.

I. How long can artists pour themselves into highly charged performance situations without being burned out emotionally? (Moira Roth.[1])

Artists tend to deny the relationship of their work to therapy and subsequently to psychology, insisting that they make highly inspired, intensely complex works which link them to the history of art and aesthetic traditions. This need for professional validation is somewhat arcane because underneath the surface of each artist is a shaman, an instinctual curer and therapist who lives a life outside of and beyond social medicine. Artists have found that the best way to direct their energies, learn hidden information about themselves, and face hidden fears is to pursue the relationships of space, form, color, texture, size, mass, and direction in an obsessive way. Instead of brooding about what is wrong in their lives, artists are trained to use problems as material for their work since work diverts anxiety, fear, and worry into artistic expression. Even though the art practice on some levels serves this therapeutic purpose, most

artists disregard the connection between themselves and the practice of psychology.

II. Do more. Try to tickle something inside you, your "weird humor." You belong in the most secret part of you. Don't worry about cool; make your own uncool. Make your own, your own world. If you feel fear, make it work for you. Draw and paint your fear and anxiety. And stop worrying about big, deep things such as "To decide on a purpose and way of life, a consistent approach to even some impossible end or even an imagined end." You must practice being stupid, dumb, unthinking, empty. Then you will be able to do. (Les Levine to Eva Hesse.[2])

Why do artists deny their connection with psychology? Is it because art history refuses to talk about the reasons for creating? Most art history classes and books stress space relationships, composition and the school that the artist imitates or begins. Sources aren't considered, formulae and technologies are. The only hint that art students have that the artist is concerned about the therapeutic nature of work and ideas is a reference to Van Gogh's missing ear and the movie about Van Gogh's life called *Lust For Life*. If the reasons for creating were more readily discussed among artists in art schools or by art historians, then eventually art-making would radically change.

III. What I am doing now might not be a peak of matured painting, but they are good, follow an idea, and they are the work of a young, active, developing painter. Only painting can now see me through and I must see it through. It is totally interdependent with my ambitions and frustrations. It is what I have found through which I express myself, my growth, and channel my development. Within its scope I can develop strength and conviction. (Eva Hesse.[3])

The attitude toward the artistic process began to change in the late 1960s. Conceptual art, body art and feminist art introduced the "New Way" which de-emphasized traditional classical values and technical virtuosity. Focus was now on feelings, interior need, and the total process of the artist, not just his/her technical virtuosity. In fact, artists working in these new areas were less concerned with art and more involved in personal initiations, psychological transformations, and group therapy. They hardly touched brushes, paints, or sculptural

material. Instead ideas, bodies, and psyches were formed, molded, and esthetically examined.

IV. It seems ironic that Fox has been categorized as a "Body Artist" when in fact the focus of his art is escape from the confines of the body. Fox has explored in his work an astonishing number and variety of means of evading or rising above the limitations of body or corporeality: Energy transformations and transferences, sleep and dreaming, levitation, reincarnation, music, fasting, religious chants, mantras, melting, dissolving (wax, liquid, smoke, dust), hypnosis, automatic writing and accident, hallucination. (Brenda Richardson about Terry Fox.[4])

It is relevant to look at some of the reasons for this emphasis on the person and process rather than the object. Actually artists were doing what they always do, mirroring the social fabric which was slowly unweaving. As a result, there were a lot of loose ends in the late 1960s: a senseless war in Vietnam, breakdown of authoritarian structures, sexual revolution, drugs, reevaluation of the nuclear family, the women's movement, spiritual movement, and many other hidden factors for change. Conceptual art and body art grew out of and psychically foretold these social issues.

V. Powerlessness and lack of self-affirmation led to aggression as repeatedly asserted by psychologists and psychiatrists. Psychological powerlessness is the result of past events but institutional and cultural powerlessness are here and now. (Edward T. Hall.[5])

My own response to the chaos of the late 1960s was chickens! I substituted them for sculptures that I could have made, and presented them in an art context. And in 1971, I literally became the "Chicken Woman," appearing in public places as a living statue dressed in my Chicken Woman habit. In retrospect, it seems that most of the work had a therapeutic reason but was always couched in the language of sculpture. My insistence on belonging to the art community committed me to my work but I was forced to find an individual sculptural language suitable to my needs. That was the beauty of the 1960s and its source of energy. There was permission to do what you wanted to do, find a personal form based on a historical structure but do things your way. And I did! So instead of going for therapy three times a week I would blindfold myself for three days when I lost

touch with who I was. Instead of learning about my early relationships with my parents from an analyst, I interviewed them repeatedly and tried unveiling the information artistically. Instead of spending thousands of dollars on therapy, I spent that much on videos, photography, making a book and insisted on doing things for myself, in my way. Solutions and findings seemed quixotic, sometimes hermetic and often humorous, but I called all of it ART!

VI. Humor cuts into the consciousness like a knife. It's an elegant solution, an elegant gaiety, and this can be overlooked if one's understanding of life is not expansive enough to project beyond the personal problems and feel a kind of Homeric laughter running through the whole structure of life and natural powers. (Joseph Beuys.[6])

In order to move beyond the personal it first must be acknowledged. Feminism sanctified the personal. It challenged women to find themselves and be themselves. Performance became a valid and effective mode of discovery for some women artists. Their work generally looked a little bit like art and a lot like therapy. Hurray I say! Expertise, skill, and audience approval were not sought after. Women's performance was about the raw and unabashed truth of the struggles of being a woman. This early work was a clear-cut case of therapy, consciously chosen as art.

VII. And what about women artists? We have seen it has only been in the past several centuries that women have been permitted to participate, and then only on an individual basis, and on male terms in the making of culture. And even so their vision had become inauthentic; they were being denied the use of the cultural mirror. (Shulamith Firestone.[7])

Even though women began expressing themselves, performance presented a problem after a few years. Everything was fine while sympathetic female audiences were there as mutual performers/supporters and part of the process. The reenactment of eons of repression was mutually beneficial. But after some years, critical problems set in motion and spontaneity was more difficult to attain. The honeymoon of innocence was over and feminist art began suffering the strains of time and habituation. Women were forced to entertain per usual and as a result that initial free way of working was

over. Some women sought the safety of workshops and friendly small groups of mutual friends again and performed there. Other feminist artists remained public and visible.

VIII. The endurance of more art by women into the establishment is certainly good for the establishment. But it is, perhaps, less of a good thing for feminist art. One of the questions we have to answer is whether women want the same things that men have wanted, whether greatness in its present form is in fact desirable. (Lucy Lippard.[8])

Chris Burden chose to be great in the traditional way, by doing great big newsworthy things, challenging himself and audiences with suicidal-type actions which often morally implicated everyone present, that is, if I don't personally stop this now, he dies, but then again, art is sacred and mustn't be "tampered with." For years he was the public martyr whose themes were physical endurance, pain, death, risk, and starvation. It all started in 1971 when he was locked into a school locker for five days having prepared himself by fasting and checking the project with medical authorities. He endured. A hose leading from the locker above provided water and the locker below held a jar and hose for urination.

IX. It was more like mental experience for me. To see how I would deal with the mental aspect. Like knowing that at 7:30 you're going to stand in a room and a guy is going to shoot you. I'd set it up by telling a bunch of people that and that would make it happen. It was almost like setting up fate or something, in a real controlled way. The violence part wasn't really that important, it was just a crux to make all of the mental stuff happen. (Chris Burden.[9])

Out of forty-eight of his performances, twenty-eight are concerned with death. The Art/Life Counselor in me asks "why does he choose such drastic measures?" Karl Menninger sees self-mutilation as a victory, albeit a costly victory, of life over death, a victory of aversion of total annihilation over the other alternative, suicide. Self-mutilation is a victory of the life instinct over the death instinct.

X. Artaud compares his theater to a plague: a disorder of the most horrendous type which brings with it both social and psychological disturbances. (Bettina Knapp.[10])

Is Burden cured? I prefer to think that he has successfully worked on himself. Body art, early feminist art and some conceptual art qualifies as therapy because artists are probing places that formerly belonged to psychological realms. The new artists have been personally stretched, tested, encouraged and made aware via their work. No outside professional help is needed because other artists and friends act as co-therapists and the performance art magazine *High Performance* doubles as a psychological journal.

XI. I was being educated as a social activist. I had worked in mental hospitals. There was a strong emphasis on performance in Judy's [Chicago] program so I was exposed to it from when I first got involved with her. So I simply turned to performance and the first pieces I did were pretty much involved with body and identity and using biological imagery, doing things like tying myself and the audience to beef kidneys. (Suzanne Lacy.[11])

And what of the 1980s? How does the new wave respond to questions of life and death? Quite brashly, assertively, and with a somewhat healthy cynicism. They snub nostalgia, champion an aggressive stance, brandish self-torture as paradox and glory in technological isolation. Remember, we all react to the generation that preceded us. The 1970s' performance artists have touched their own shadow and now are teaching and writing books about what they have discovered. We watch the next generation of performance artists to see what we really have been and look forward to new discoveries to come.

XII. As *The Tibetan Book of The Dead* teaches, the dying should face death not only calmly and clearmindedly and heroically but with an intellect rightly trained and rightly directed, mentally transcending, if need be, bodily infirmities as they would do if they had practiced efficiently the art of dying. (W.E. Wentz.[12])

Performance is practice for the endgame.

UPDATE: After being tied to Tehching Hsieh in his *Art/Life: One Year Performance* for a year, I began professional therapy and now believe that art is not enough.

1977/2002

My Astral History

This piece was originally typed and placed on the door of the Amsterdam School for New Dance for a workshop that Montano gave astrally.

Past

About twenty years ago, as an art performance, I appeared "astrally" at Bud's Ice Cream store in San Francisco, while living in San Diego, California, having divorced my husband and wanting to see him yet also wanting to be with my new mate. So I used art to leave my body and go back to him symbolically and humorously. I sent announcements to him and my friends to go to Bud's where I would "appear." My intention and heart were there in San Francisco but no one saw me.

Present

As art, I will appear "astrally" and seasonally (four times a year) at the Chagall Chapel, United Nations, where I have donated myself as a living sculpture. I tried getting permission to physically appear there, but getting past guards and through bureaucratic red tape and intricate screenings was not possible, so I am performing in this formidable institution "astrally" and "illegally."

Future

At menopause I had to adjust to my new body image. The physical changes and strong gravitational flesh pulls challenged me to examine death and loss. So appearing astrally became a way to practice dying and also a way to address the social invisibility that happens naturally as sexual energy transforms itself with time and age. My aging is beginning to feel like the ripening that it is. And now, I send my astral self to many events as Art. That way, I do my work on many different levels. I recommend astral appearances to anyone not wanting to do the following:

Compromise their immune system.
Breathe airplane air.
Show their cellulite legs and double chin to friends.
Think they've fallen in love once again while away from home.
Sleep in a strange bed belonging to a smoker.
Eat too many cheese nachos at airports.
Have a hot flash at a crowded art reception.

1996

1 Plus 1 Equals 1

This piece was written after Montano had moved from Austin, Texas, to Kingston, New York and re-opened The Art/Life Institute. This piece, never published, is presently in the Linda Mary Montano archives.

According to my mother I was not visible when she was pregnant because I came in January, and her heavy coat hid her big stomach and my presence. One story is "everyone was shocked when you were born, Linda," and after years of research into reasons why I do performance, I've decided that this uterine story might be ONE (not the only) of the plausible reasons why I have always felt a need to "shock" myself and audiences with my art. Sorry for the implication, Mom!

We are encoded at conception and have picked up attitudes and tendencies while in the womb. Behavioral scientists are realizing that. As a result, a new-ageish training course is offered to parents-to-be which prepares the whiz kid of tomorrow by sending them to pre-, pre-, pre-nursery school, The School of the Womb. Did I make this up? In the class the parents are encouraged to read books to the fetus through the mother's mouth, make sounds so sounds at birth won't be startling. You can imagine other permutations.

Having been born before all of that, much of my work is about mending the past. But on the other hand, early conditioning and deprivation has produced some pretty outrageous later manifestations, gestures and actions. The way that I read it, since I was somewhat "invisible" in utero, I carried over the need to be seen into my life and later made an art of it. Does this make sense?

With all due respect to my parents, I would like to illustrate how the theme of invisibility/disappearance/transcendence was first acted out in my life. Once I realized that I might as well make a career out of this propensity for the mysterious, I transferred the gift into a moneymaking vocation – OK so it isn't much, performance doesn't pay, as we all know.

Four ways I learned to leave the body in my daily life

1. As an infant I was allergic to cows' milk formula and threw it up. My mother told me "It used to look like cottage cheese coming out of your mouth." *Example of Objects Leaving the Body*.
2. When seven years old, I threw up breakfast all over my parents' new wallpaper every morning before school, and the reason was because kids were stepping on my coat in the cloakroom and I couldn't communicate this to anybody. Once I told the reason to my parents and was given a private coat hanger, I never threw up again. *Example of Objects Leaving the Body*.
3. When twenty-one, while in the convent, I became anorexic and left weighing almost half my normal weight. Was I solving the riddle of physical transcendence but using drastic methods? *Example of Experiment with Transcendence*.
4. When twenty-eight, I was in a rollover car accident. I remember returning (astrally???) to my shocked body and feeling a re-entry. *Example of Leaving the Body and Returning*.

Art, a place where I practiced disappearance with self-designed semblances of safety

The above "life" examples are pre-performance ways that I solved things and asked questions. As a trained sculptor I later made objects that could appear and disappear using clay, wood, stone, metal, and stuff. Eventually I collaged early childhood memories and impressions humorously and esthetically and called the actions performance, getting rid of the "stuff" in my work. Animals, particularly chickens, became stand-ins for me in the following performances:

1. *Animal as self:* Chickens, *1969*

I presented chickens in cages for my MFA show and saw them as a metaphor for me, hoping they would illustrate my expertise with the concept of art but also be a humorous fill-in.

2. *Self as animal/saint: Lying, sitting, and dancing as Chicken Woman, 1971-76*

By becoming the chicken I could also be the nun/saint in disguise. By doing performance actions on the street, I was drawing to myself attention that I could not give myself and yet learning from audiences how to eventually be with ME. The endurances were short, usually three hours, but were training me publically. And because I had strong internal messages to feel comfortable in poetic "disappearance," I could easily become anyone or anything. Even a saint? A chicken?

3. *Self as other: Seven Characters, 1975*

By 1975, I had formalized and made the gift of being able to get out of my own way, a bit more sophisticated: and with the help of southern California and its invitation to dramatize, I resurrected in myself seven personae, and found that I could easily act as them, perfect them, speak as them and this was much more fun and easier than being me! By then I was beginning to ask, who is the real Linda Montano?

4. *Self as one:* Art/Life: One Year Performance, *1983-84*

Tehching Hsieh's art is extremely rigorous. With his performances he keeps himself focused, in danger, responsible, and honorable. I joined him in his rope piece and the intensity of being tied to him with an 8-foot rope, not touching and always in the same room drove me into three directions:

a. Into the darkness of rage and emotion that I am still in the process of sorting out with traditional/professional therapies.

b. Wholeheartedly into the present moment because training in dangerous actions cultivates a mind of present centeredness.

c. Into an altered state of union with both him and everything; a transcendence and indivisibility that verged on the divine.

5. *Self as art:* 7 Years of Living Art, *1984–91*

After being tied for a year, I knew that I needed to design my own long-term project that would teach me about the possibility of art being life and life, art. Because by insuring myself that I am "in art" at all times for seven years and that the entire universe is my studio, I have lifted the pressure to create since every minute is framed and being used creatively.

Included in the recipe that I have written for these seven years is an invitation for seven well-known women to "guide" me, inspire me, take care of me, and teach me. For example in year one, Joan of Arc was my guide; year two, Teresa of Avila, etc. This ability to be suggestibly flexible is again a trait that has a deep-seated history in my love of invisibility, shape-shifting and transcendence.

Beyond self

We come from the invisible and return to the invisible. While alive, to experience that condition of nothingness seems an appropriate dress rehearsal for the appearance of Sister Death's visit and invitation to leave the body. Meanwhile, I practice as art.

UPDATE: I continued *7 Years of Living Art* another seven years and it was called *14 Years of Living Art.*

1989

Endurance Then and Now

This paper was first presented as Montano's final goodbye performance at the University of Texas, Austin in 1998 just before she moved back to Kingston, New York.

Endurance

I have always been interested in enduring. As a young Catholic girl, I knelt before the bloody gory Crucifix in our upstate New York church and I waited, endured the discomfort that comes from kneeling, endured the isolation that comes from choosing church over play and "fun," endured the possibility that I might not be good enough or saintly enough to go to Heaven or be like Jesus. I was definitely linked to suffering, penance, and the guilt fast track at a young age.

I remember how nuns would talk about Christ and how he endured the suffering of carrying the cross, how he fell down, how he was nailed to the cross, and died miserably, forgiving everyone. His endurance etched itself into my belief system. When I was seven years old, I wanted to be a saint and I thought to do that I had to suffer like Jesus. That became the plot and story line for my entire life quest.

At twenty I entered a convent, "enduring " two years as a Catholic nun, living in silence those two years except for one hour a day when we all talked together in recreation. I loved the community and dedication to a higher good and absolutely pure goal, but I left anorexic, having lost nearly 50 pounds in six months, high as a kite on endorphins. Holy anorexia? Delusions? Endurance gone amuck?

When I was introduced to art soon after, I immediately found a

way to transfer religious fervor and my predilection for penance and suffering into my work, first as sculpture and then as performance art. For example, I sat for hours, lay down for hours, danced for hours in public places, asking audiences to watch me endure. Give me attention, I demanded, witness my long-term commitment. And in so doing, I felt more alive as I soaked in their curiosity. It was as if I couldn't exist without them. Their presence was like a bath of recognition and approval. I wanted them to delight in my actions. Without the other's gaze, I didn't feel anything, so I learned more intricate ways to raise my own energy and get others to view me doing so. Then there would be this synergistic marriage of static electricity going on. They were in this web of my mysteries as viewer, and manipulated into the role of voyeur, midwife to my happiness, and co-creator of my art.

Some images from that time

1. Lying three hours in a bed surrounded by twelve papier-maché chickens, dressed as a saint . . . enduring.
2. Sitting as a saint, in nine places in Rochester, three hours each place, holding a homemade chicken sculpture . . . enduring.
3. Walking on a treadmill for three hours, going uphill, telling my life story . . . enduring.
4. Lying in view three hours with acupuncture needles in my conception vessel . . . enduring.
5. Standing outside ringing a bell as a Salvation Army bell ringer . . . enduring.
6. Living three days handcuffed to Tom Marioni . . . enduring.
7. Living blindfolded for a week, or preparing for old age and potential blindness . . . enduring.
8. Living in a gallery room as five different people, one a day . . . enduring.
9. Studying the martial arts so as to channel rage into good action . . . enduring.
10. Mourning the death of my ex-husband for two years as art . . . enduring.
11. Singing a song for three hours to my husband after his death . . . enduring.

12. Camping out in many galleries, museums, and art spaces, using everyday life as art . . . enduring.
13. Going to the New Museum once a month for seven years, giving Art/Life Counseling . . . enduring.
14. Living for a year tied by a rope to Tehching Hsieh in his *Art/Life: One Year Performance* . . . enduring.
15. Living for fourteen years in seven different colors to honor the chakras and sacraments . . . enduring.

Pause

Now take some time and imagine your own performance. Create an action in your imagination that would mirror one of your life issues and see yourself enduring. Certainly there is a psychological and Freudian view that can be seen in my work but let's also suppose that the work is a very intuitive, shamanic, and ritualistic way that I invented to lead myself into altered states of consciousness while bringing the viewer along with me on this interior and mysterious journey.

Possibly there are many ways of viewing my intentions and I believe that sometimes there is a thin line between neurotic narcissism and tantric shamanic soul travel. Like Catherine of Siena and many other Catholic saints and mystics, I was enamored of endurance so I could tough it out, prepare myself for the hard knocks of life, fight the good fight, bite the bullet, keep it up, go the whole nine yards, get the job done, and give my all. (For me? For God? That took a long time to decipher.)

Once I learned of Hindu yogis and their methods of achieving stillness, concentration, equanimity and inner silence, I felt in the company of kindred spirits and brother-sister travelers.

Later

Tibetan nuns, lost/found in trance, endure rigorous/repetitive mantras, visualizations, penances, charnel-ground watching, all meant to make them impervious to Himalayan cold, pain, the mind and illusions of the relative world. These practitioners are some of my guides, helpers, teachers, mentors, and inspirations on my path.

Pause

Who is your helper? See this person. Thank them. Vow to become a helper to someone else in the future.

We have looked at my background. Let's now look at some universal reasons why we all endure. Endurance is built into our system because under this skin is a galaxy of networks, a mysterious world of muscles, bones, veins, and organs which endure our turbulent emotional states, endure our tortured thoughts, endure our various and punitive diets, endure the torture of climate changes and home-uprooting, endure our lovelessness, endure our fertile negative imaginings and paranoia, endure our tortured memories and traumatic secrets, endure our disrespect for authorities and bitterness toward everyone's good intention.

Pause

See your body in great detail. Clear it of all past endurances that hurt.

We artists love to create solutions to all of the above. In the late 1960s there came into the art stream a group of creators who made body art. Many of us used endurance as a primary material for our work. Some of the reasons might be:

1. That endurance was a reaction against the linearity and dogmatism of minimal art.
2. That endurance artists were interested in leaving the world of buying and selling art; making our work for each other, for ourselves, not for slick documents, mindless magazines, judging audiences, or uncaring strangers.
3. That artists publicly used the drugs of the day, marijuana, hashish, LSD, and peyote, drugs that allowed them to hang out and endure for long periods of time in trance and altered states, as art.
4. That the women's movement and civil rights' movement inspired artists to experiment with issues of sensitivity training and consciousness-raising as art.
5. That the artists of the 1960s formed deep bonds with both eastern spiritual teachers and with American Indian elders who helped us

see and feel new ways of honoring and appreciating our bodies and the earth. These wise teachers taught us self-initiatory and risk-taking rituals which could be used to mark important passages. They introduced us to death-defying actions, risk-taking attitudes, and important maturity retreats. Later, once we learned from them, we translated the teachings into our performances. Now reality TV's soulless translations of our experiments mirror our work but miss the inner meaning.

Then there was the division around gender. How did women endure? And men? Performance art became the art of choice for women artists in the 1970s since it offered a fluid, intuitive, healing, versatile, spontaneous and dynamic method akin to the physical vigils and endurances that women perform at childbirth and in the act/art of childraising.

Some women who endured: Faith Wilding waited; Nancy Youdelman exaggerated; Judy Chicago healed; Carolee Schneemann liberated; Hannah Wilke exposed; Eleanor Antin satirized; Mierle Ukeles respected; Annie Sprinkle shared; Karen Finley raged; Suzanne Lacy aged. All of these women used time and material in new ways, courageously forging ahead of a tired system of painting/ sculpture current at that time.

Men also played with time and initiated themselves but somewhat differently: Joseph Beuys wrapped; Tehching Hsieh deprived; Chris Burden crucified; Stelarc hung; Terry Fox cured; Richard Long walked; Vito Acconci yanked; Tom Marioni drank.

And not to confuse the issue, what about couples? Alex and Allyson Grey processed; Marina Abromovic and Ulay stared; Barbara T. Smith and Vic Hendricks embraced; Linda Montano and Tehching Hsieh got roped.

Pause

Can you imagine how you would initiate yourself into a life passage? Write it, sing it, perform it, keep it secret, but by all means BE SAFE! Or join an invisible Internet community where travel, audience and applause are nonexistent.

Conclusion

My father once told me after listening to me complain about insurance prices, "Life is hard enough. Don't make hard things harder." And in his yearbook, his legacy says that he is someone who makes difficult things seem easy.

By practicing endurance, possibly we can prepare in a strong way for times when we need to be even stronger.

<div align="right">1998</div>

Audience and the Art of Linda Montano

In September of 1999, Montano was invited to perform as an Art/Life Counselor at an art symposium sponsored annually by SUNY New Palz. Montano had an Art/Life booth and gave away copies of this paper, which was written for the occasion.

Audiences have always been an important component of the performance practice I began in 1965. To better understand the purposes and scope of my own work and its relation to audience, it is necessary to first lay a foundation. To do this, I will do the following:

 I. Define the term "audience".
 II. Explore Aristotle's theory of catharsis as it relates to tragedy.
III. Explain the four types of brain waves.
IV. Look at the parameters of performance art in general.
 V. Construct the interface between selected performances from my thirty-three-year career and their relation to audience.

I. The dictionary definition of "audience"

1. A hearing, listening group.
2. Those assembled to see or hear a concert or play, etc.
3. Those who listen to a radio program or view a television program.
4. Those who pay attention to what one writes or says, one's public.
5. The act or state of hearing.
6. The opportunity to have one's ideas heard.

7. A formal interview with a person in high position, especially with a sovereign or the head of the government.

II. Aristotle's theory of catharsis as it relates to tragedy

The purpose of tragedy (or, in my case, some of my performance practice) is to arouse pity and fear and affect a pleasurable catharsis or purging of these two emotions. Although Plato felt that tragedy weakened the viewer emotionally, Aristotle chose the path of purging, listing a few ways to proceed:

1. Medical Purging (Vaccination Theory): Because pity and fear are often present in excess, by applying more of the same there will be a homeopathic release, restoring the viewer to emotional balance, using snake venom to cure snake bite.
2. Vicarious Experience Theory: Viewers take vicarious pleasure in experiencing emotions without being harmed personally.
3. Sadistic Theory: Subconsciously we enjoy seeing others suffer, although in theater it is not real; conversely, in performance it sometimes is real. Others' suffering elicits a feeling of superiority to the sufferer. Power politics is at work here.
4. Relief Theory: Although we identify with a character in a tragedy, we also take pleasure when the drama ends, convinced that their ordeal is much worse than our own so we leave relieved and transformed. This is the "art is good medicine" theory.

III. Explanation of brain waves

Millions of brain cells communicate with each other by emitting tiny electrical impulses. This day/night activity can be registered as oscillations (brain waves) by placing electrodes on the scalp and displaying the brain waves on a computer. The brain oscillates at different frequencies depending on the state of consciousness. The four brain waves are BETA, ALPHA, THETA, and DELTA.

IV. The general parameters of performance art

Since 1965, I have practiced performance art, a slippery and generic title that essentially defines art which belongs to the family of painting and sculpture, but when practiced in real time, with real bodies, can be more permissive, transgressive, healing, transpersonal, combative, autobiographical, dangerous, raw, primal, political, and shocking.

Performance was the disturbing relative of disembodied fine art. As practiced by first generation artists of the 1960s and 1970s it took incredible risks that not only stretched the artist-practitioner with its content, fantasies, dreams, and neediness, but also surprised audiences. In so doing, it became an art for the brave. It instructed, infuriated, bored, and nourished the audience. Who would do this kind of non-right-wing, unable-to-be-funded, on-the-edge kind of work? Actually, those you might expect, because early performance was by and for women, the transgendered, people of color, the survivors of the atom bomb, the disenfranchised, ethnic minorities, the ill, the noncommodified, mystics, gays and lesbians, risk-takers, and those sensitive and willing to be vulnerably present.

What about audiences? Art has always been a dialogue, first with the artist and their muse, then the artist and the idea, then the artist and their material, then the artist and the performance or object, then the artist and their audience. What makes performance art more demanding for the audience is the phenomenon of presence – the presence of the artist, right there – the artist who often does things which are so different from the expected that it takes a great deal of attention, care, and wrestling with the demons of correctness and manners to be a performance art audience member.

The initiation process of belonging may include being spattered with blood, urine, feces, oil, or dirty bath water. Ears might be attacked with invective, words shouted decibels above hearing range. Eyes might be forced to view breasts, cellulite, drool, or undigested/digested tuna fish. Audiences' bodies might be caressed with other bodies, feathers, flying debris, or a warehouse of out of control materials. Audiences might have to walk miles to be included in an outdoor piece or stay cramped in a small space with other equally effusive armpits. Audience members have had to make life/death decisions, cross the nonexistent proscenium and take away knives, guns, razors, scissors or put out fires to "rescue" the performing

artist who is practicing "intervention" art, a practice that is based on the kindness and intervention of audience members for its termination. (An early 1970s phenomenon, Thank God!) In short, the Performance Art Audience Member, or PAAM, is invited to not only be there at the event, but to become a performance artist themselves by virtue of attendance and survival of the event. The initiation is that simple, be there, live, and earn your title.

But why, you might wonder, would the artist or audience endure such a demanding use of their time and energy? My belief and experience has been that I continue in this profession to get high; performance is a cheap drug, and cheaper therapy! But it also has a nobler purpose, one of transformation, for its ability to change brain waves makes it a preparation for meditation. The performative state builds a bridge between the conscious and unconscious, and often the superconscious; sometimes during, but often after, a performance, a drowsy/dreamy feeling, which is in full contact with clear, conscious awareness, is experienced by the artist and the audience members. The EEG pattern is a mixture of Alpha and Theta waves (8 Hz) with Alpha reflecting conscious awareness and Theta signifying subconscious activity, and that is a fantastic balance.

By esthetically/chemically purging subconscious material, by suffering publicly, by exposing excesses of power, by exploring homoerotic images and desires publicly, the storehouse of hidden fear, guilt, rage, and isolation gets cleaned out as art, and the brain takes a chemical holiday at the SPA OF PERFORMANCE ART. So if you sit still and feel, it's possible that Delta (infant waves) and samadhi (Delta) states of attention might visit the scene during or after a performance. An Aristotelian catharsis becomes rapture!

V. Selected performances by Linda Montano and their relation to audiences

1. 1962–69: AUDIENCE AS PLAYMATE. In 1963 I performed my first public action by organizing a group of Catholic women at the college I attended. We glued ceramic tiles we made to a large stairwell wall. It's still there. Deepest thanks to Mother Mary Jane, my first performance teacher and mentor of ecstatic improvization and creativity!

2. 1965: In Italy, for my MA show, audience members were given a number at the opening and these numbers corresponded to Italian found objects that they publicly assembled. Audience members became instant artists and I was freed from the confines of the studio.

3. 1968: Instead of sculpture, my training, I presented live chickens in sculpture cages for my MFA show and performed chicken art in the streets. After these events I was hooked on Live Art.

4. 1970–73: AUDIENCE AS CO-MEDITATOR. After tasting the beauty of yoga and marriage, I began a series of white-faced, white-gauzed, long-term endurances – lying down, sitting as CHICKEN WOMAN, becoming a performance saint. Audiences watched, meditated with me, went into altered brain waves with me, validated my stillness/silence.

5. 1976–80: AUDIENCE AS CO-HEALER. In 1977, my ex-husband tragically died, and for two years I mourned him in my art. I could not have survived without the co-healing of those audience members who breathed life back into me as I performed and performed and performed. I am eternally grateful to everyone who consoled me as art.

6. 1980–83: AUDIENCE AS UNNECESSARY. I became a resident of a meditation monastery retiring from art, although I did organize skits, plays, and performed on the local TV channel but I called that fun. I was in retreat from art and audience.

7. 1983–84: AUDIENCE AS CONCEPTUAL CO-CREATOR. Tehching Hsieh was looking for someone to be tied to him for a *One Year Performance*. Luckily I found him, expressed my interest, left the monastery, and spent one year tied to this artist/genius. We vowed not to touch, rode two bikes on NYC streets, worked jobs, and never took off the rope for that year.

8. 1984–91: AUDIENCE AS VOYEUR, AUDIENCE AS CLIENT, ARTIST AS AUDIENCE GRANTOR. For seven years I was given a window space at the New Museum that I inhabited once a month for seven hours, for seven years. In that space audience members both watched me from the street, viewed me from inside the museum, came into the window as clients and sat across from me while I practiced ART/LIFE COUNSELING with them, granted audiences, and called it art.

9. 1991–98: AUDIENCE AS STUDENT, AUDIENCE AS ADMIN-ISTRATOR, AUDIENCE AS AUTHORITY FIGURE. For seven years I taught performance art as a performance. The students and administrators were co-performers and audience in this experience.

10. 1984–98: AUDIENCE AS COLOR CONSULTANTS, AUDIENCE AS ENERGY MIRRORS. For fourteen years I performed *14 Years of Living Art*, wearing seven color clothes, one color each year, corresponding with the seven colors of the Hindu chakra system. "Audience" members encountered on the street often commented on my red, orange, purple, etc. ensembles! By experiencing the colors and chakras I embodied, they also felt the effect of color on their own energy fields.

11. 1998: AUDIENCE AS ADOPTED FAMILY, AUDIENCE AS FAMILY. In 1990, I met Dr. A. M. and Dr. A. L. Mehta, Ayurvedic doctors from India and we mutually adopted each other. I now practice the art of living with them whenever I can. After *14 Years of Living Art*, in 1998, I began an experiment, which includes wearing orange clothes forever. I also perform *Blood Family Art* with my relatives and eighty-six-year old father. This day-to-day cathartic empowering of my inner child has no product, only daily life. I do perform, teach, and extend my practice with public events dedicated to the art of *Living Art*, an aesthetically chemical, euphoric state of ecstasy, designed to induce compassionate understanding.

VI. Conclusion

Performance art is only for those willing to suspend critical faculties of correctness and culturally imposed paradigms. Join, change your brain waves, be surprised, have an Aristotelian catharsis, but be safe. It is not the 1970s anymore. WELCOME TO THE CLUB!

VII. Performance art audience member certificate

PERFORMANCE ART CLUB CARD

I, _____, am a life-long
member of the Performance Art Audience Club. I vow to
perform/view actions beneficial to others and myself.

1999

A Performance Art Timeline
(Roselee Goldberg): Thoughts on
performance art (Linda M. Montano)

Montano wrote "A Performance Art Timeline" in response to Roselee Goldberg's seminal history of performance art *Performance Art: From Futurism to the Present*, (rev. edn, New York: Harry N. Abrams Inc., 1979, 1988). Goldberg's book was the first of its kind to establish the avant-garde, historical precedence for performance art. Along with many other artists who worked primarily in performance, Montano was tremendously influenced by Performance Art. The piece, which has not yet been performed, is a type of litany call/response that Montano wrote in homage to Goldberg's book. What follows represents Montano's subjective response to certain people, events, and manifestos that Goldberg covered in her text.

❊

"0–Present: Tribal Ritual or Passion Play."
<div align="center">(page 8)</div>

It's natural for performance artists to explore the real, taboo, shocking, raw, transgressive, outrageous, difficult, erotic, durational, scatalogical, penitential, transformational, autobiographical, subversive, confrontational, brutal, banal, and aggressive in their practice, thereby alchemizing beauty from inner/outer truth.

❊

"1490: Leonardo da Vinci dressed his performers as planets and had them recite verses about the Golden Age in a pageant entitled Paradisio.*"*

<div align="right">(page 9)</div>

It's scientifically proven that performance art alters brain waves and performance artists use this technology to create levels of consciousness conversant with eastern/western mystical theologies.

❀

"1589: A mock naval battle, designed by Polidoro da Caravaggio, took place in the specially flooded courtyard of the Pitti Palace in Florence . . ."

(page 7)

It's tempting for ex-sculptors and ex-painters turned performance artists to insist that they developed the form. But in keeping with the *arte povera* feel of the practice, it is beyond ownership by any one group or faction. It belongs to all who embrace the permission to create freely.

❀

"1638: The Baroque artists Gian Lorenzo Bernini staged spectacles for which he wrote scripts, designed scenes and costumes, built architectural elements and even constructed realistic flood scenes . . ."

(page 9)

Now performance art is studied in academia and has been for the past twenty years until administrations tire of having to defend the form or their performance art faculty.

❀

"1896: Alfred Jarry presents Ubu Roi *in Paris to an antagonistic, fist-fighting, violent crowd when the taboo word 'merdre' ('shit' in French with an extra r) is repeated over and over."*

(pages 11–12)

It's not fair to write an article on performance art without including futurist performance artists, constructivist performance artists, Dadaist performance artists, surreal performance artists, Bauhaus performance artists, and all other forbearers of the form like the Japanese Gutai and Viennese Actionists. And of course there are Christian penitents, American Indian elders, African healers, Eskimo shamans, Hindu yogis and countless other legacy-holders and mentors of the form.

❀

"1909: Filippo Tommaso Marinetti wrote the Futurist Manifesto, *an attack on the establishment values of the painting and literary academies. Marinetti*

performed actions at Trieste, the pivotal border city in the Austro-Italian conflict,
designed to support the Italian intervention against Austria and to celebrate the
industrial age with its machines."

(pages 12–13)

It's possible that Consciousness Raising (CR) might be seen as the most powerful cultural force shaping performance art when a feminist theorist analyzes the form. Other art writers might include the influence of the Holocaust, drugs, bombings of Hiroshima/Nagasaki, the popularization of psychology, Vietnam, accessibility of the media, technology, existentialism, Buddhism, and new sexual permissions. Points of view are determined by the defining experiences of each viewer of the form.

❀

"1913: The Futurists embraced the symphony of the machine: Noise instruments
(Russolo), noise music (Protella), body actions based on machines (Balla), mari-
onettes (Clavel), synthetic actions and simultaneity were some of the components
of futurist ideology, an art that spanned the years between the First and Second
World Wars."

(pages 20–24)

It's been stated elsewhere that early performance that explored the body via task, endurance, vulnerability, psychology, presence, difficulty, taboo, permission, intimacy, and sexuality not only compromised the audience's safety, nerves, and sanity, but also confer the status of "performance artist" on them by virtue of their ability to co-create with their presence.

❀

"1920: Petrograd, the third anniversary celebrations of the October Revolution in
Russia. In The Storming of the Winter Palace, *8000 citizens, army trucks, huge*
platforms, 125 ballet dancers, 100 circus artists, a red and white army, an
orchestra of 500, fireworks, and spotlights on the palace, were included in this
large-scale spectacle."

(page 41)

It's sometimes the case that "relics" of performance art are as important to the art world as the actions that created them even though commodity was never the focus or reason for the practice, process was.

"1923: the Blue Blouse Group, Russia. Huge posters were placed on the stage with holes cut out for heads, arms, legs of the actors . . . reciting texts based on controversial political and social events . . ."

(pages 46–48)

Practitioners of performance art want nothing to do with high art.

❂

"1905: Benjamin Franklin (Frank) Wedekind of Munich would urinate on stage. According to Hugo Ball, he also induced convulsions in his arms, legs and even his brain."

(pages 50–53)

Performance art's ability to de-àutomate the artist and viewer makes it a worthy vehicle of mystical technology.

❂

"1916: Hugo Ball and Emily Hennings founded the Cabaret Voltaire, Zurich, a cabaret where Ball performed his new species of 'verse without words' or 'sound poems' sometimes dressed in a huge cardboard costume."

(pages 55–61)

It's always been an understanding that performance artists avoid the marketplace and prefer the stance of nonelitist presence in real-time. Dialogue might be ordinary speech but the intention is always transformational.

❂

"1916–23: Dada (which means 'yes' in Romanian, 'rocking horse' in French, 'baby carriage' in German) was a cabaret art that questioned authority. Hugo Ball wrote 'Our spontaneous foolishness and enthusiasm for illusion will destroy . . . what is deemed culturally respectable."

(page 62)

Performance art is an art of simple, spare, and curt actions, a Dionysian echo of the minimal/conceptual Haiku of the 1960s and 1970s.

❂

"1925: Paris, in the Surrealist Manifesto, *André Breton wrote that surrealism rests on the belief in the higher reality of certain hitherto-neglected forms of association, in the omnipotence of dreams . . ."*

(page 89)

It's not good taste that determines performance artist's decisions but in time, those avant-garde bad taste decisions, become "good taste."

❁

"1925: In Picabia's Relâche, *Duchamp played Adam, nude . . . a fireman poured water endlessly from one bucket to another."*

(page 92)

It's virtually impossible to outline the history of performance without writing a series of books about the many facets of the practice and even then, the task is nervous-making because some names will be forgotten, artist friends always will be remembered, dates might be miscalculated, concepts juggled, events doled out to the wrong performance artists, in the incorrect century even, wrong city . . . a frustrating exercise in imperfection but a necessary one.

❁

"1919: Gropius' romantic Bauhaus Manifesto *called for the unification of all the arts in a 'Cathedral of Socialism' . . . Kandinsky, Moholy-Nagy, and Schlemmer took up residence in Weimar to form a self-contained community within the conservative town."*

(page 97)

It's proven that ritual affects brain chemistry and the endurance and mystical aspects of performance art have been known to induce trance not only in the performer but also in the performance-art audience.

❁

"1919: The first performance art course taught by Oscar Schlemmer at the Bauhaus insisted on synthesizing art and technology in 'pure forms.' Students came to the Bauhaus to be cured of the prevailing Expressionist style."

(pages 98–99)

It's been researched and scientifically authenticated that we all need relationships to thrive and performance art provides for a tribal connectedness often missing in families, churches and society.

❁

"1922: Schlemmer's Triadic Ballet *lasted several hours and was accompanied by Paul Hindemith's score for player piano. This 'metaphysical review' used three dancers who wore eighteen costumes and danced twelve dances."*

(pages 111–12)

It's not only on the east and west coasts of the United States that performance art flourished in the 1960s. Wherever the disenfranchised, marginalized, and courageous lovers of chance, truth, and process happen to be living, performance art will be there also.

❁

"1927: The Slat Dance, *performed by Manda von Kreibig, included a constricting, visibly fascinating costume of long slats of metal and glass. Her dance was the constricted movements and sound of the slats hitting each other."*

(pages 106–7)

Many performance artists have a ball exploring persona, personality, and archetype changes, gender manipulations and cross-costuming whenever possible, Halloween being one of the holidays they remember from childhood with great fondness.

❁

"1928: Wassily Kandinsky designed visual equivalents to Modest Mussorgsky's musical phrases, using movable colored forms and light projections."

(page 111)

It's nonproductive to judge self-inflicted and destructive performative actions as acts of irrepressible nonresponsibility when actually they are highly orchestrated shamanic/prophetic technologies of esthetic mystics.

❁

"1933: John Price opens an art school near Black Mountain, North Carolina, which would come to be called Black Mountain College. Twenty-two students, nine faculty, and Josef Albers of the Bauhaus comprised the faculty."

(page 121)

It's been essential for many performance artists to break down the separation between art and life so as to claim every second as LIVING ART.

❁

"1936: Albers invites Bauhaus colleague Xanti Schawinsky to teach 'stage studies' (visual theatre). In Schawinsky's Danse macabre, *the audience was dressed in cloaks and masks."*

(page 104)

141

It's imperative to remember that performance artists were insistent on being released from the fine art traditions of classical European history.

❀

"1937: Cage wrote in The Future of Music *'Whether the sound of a truck at 50 MPH, rain or static between radio stations, we find noise fascinating.' Chance, indeterminacy, non-intentionality were principles derived from his studies with Dr. Suzuki."*

(page 123)

Performance art is a practice of simple, spare, curt actions performed by divine radicals who are gifted enough with the ability to manifest subconscious fears, dreams, negativities, and fantasies so that they clear their own and the audience's minds and bodies of daily worries. Once released and relaxed, the artist and audience become one breathing protoplasm. Intimacy is born.

❀

"1948: Merce Cunningham and John Cage collaborate using found and chance movements and sounds. The ordinary and everyday become matter for art."

(page 125)

It's the nature of performance art to be disposable. Once the artist's body/mind is stretched, exercised, exorcized and cleared, the art is over, never to be seen as important in and of itself except as a vehicle for higher consciousness and inner contentment.

❀

"1953: At Black Mountain College, there was an "anarchic event," staged by Cage and Cunningham that was essentially a collaboration with film clips projected on the ceiling, babies screaming, coffee served, a dog, poetry read, and other collaged elements. This became the prototype for American performance art."

(pages 126–27)

It's plausible to assume that an artist can switch from a western-based art-making practice, to non-western art, to performance art, to ordinary/secret/hidden everyday life, to death, all in one lifetime.

❀

"1956: Cage teaches experimental music at the New School. Kaprow, Higgins, Brecht, Dine, Mac Low, and many others attend."

(page 127)

It's not skill or technique or fame that interested the 1960s performance artists, rather a noncommodified rawness and subconscious unearthing of mystery was their passion.

❁

"1960: Yves Klein exhibited an empty gallery as art, rolled models in blue paint, painting with them and leapt from a building (Klein's Leap Into the Void *was actually a retouched photo)."*

(page 144–47)

Theories of chance, Buddhist spaciousness, and disillusionment with authority informed Happenings and subsequent performances.

❁

"1961: Joseph Beuys becomes Professor of Sculpture at Dusseldorf University and encouraged students to use any material for their work . . . His lectures became his art."

(page 150)

Now, performance art theory has been learned, practiced, commodified by the media, popular culture, and everyone has a video camera, access to a chat room, or spot on reality TV. They are the new "performance artists."

❁

"1963: Charlotte Moorman organized the first Avant-Garde Festival, a venue for composers and performance artists."

(page 133)

Life is art.

❁

"1964: Carolee Schneemann performed Meat Joy *in Paris, and used 'the blood of meat carcasses instead of paint to cover the performers' bodies'."*

(page 138)

Life is art.

❁

"1970: In Conversion, *Vito Acconci attempted to hide his masculinity by burning his body hair and pulling at each breast."*

(page 156)

Life is art.

❁

2000

Performance Art for the Twenty-First Century

This poem, taken from the Linda Mary Montano Archive, was written on the occasion of the change in millennium. It has not been previously published.

robotic performance art
webcast performance art
surveillance performance art
Internet performance art
homebound performance art
3-D fax performance art
monitored performance art
antiterrorist performance art
healthy eating performance art
millionaire performance art
implant performance art
elder performance art
video-to-computer performance art
healing performance art
space shuttle performance art
cloned clones performance art
grafted tissue performance art
virtual reality performance art
bionic performance art
email performance art
neo-Neolithic performance art
chat-room performance art

interactive TV performance art
ebay performance art
corporate capital performance art
smart chip performance art
portable gym performance art
genetic engineering performance art
spiritual fusion performance art
global communities performance art
chakra balancing performance art
robotic companion performance art
hormone enhancement performance art
equalization of capital performance art
antitheft transmitter performance art
laser sculpting performance art
multicultural fusion performance art
financial philanthropy performance art
personalized TV performance art
online healing performance art
voluntary poverty performance art
disabled performance art
legal jurisdiction performance art
adoption performance art
gun legislation performance art
clean water performance art
vow of silence performance art
intellectual property performance art
religion of origin performance art
bionic senses performance art
bloodless surgery performance art
creative nursing homes performance art
online networking performance art
distance learning performance art
long-distance telecom performance art
mood-altering clothing performance art
self-designed shoe performance art
mood-altering furniture performance art
integrative medicine performance art
universally required karaoke performance art
revisionist performance art

forgiveness sacramental performance art
computer wristwatch performance art
shape-shifting performance art
pain-free illness performance art
DNA and genetic-clearing performance art
photon and graviton performance art
virtual human actions performance art
martial art training in a monastery performance art
sustainable development performance art
biodiversity performance art
nonviolent conflict resolution performance art
respect rather than greedy wealth getting performance art
ecofeminism performance art
intimacy safe relationships performance art
ethical treatment of the disenfranchised performance art
earth-friendly performance art
wise and compassionate children performance art
disease resistant cellular theory performance art
safe food as medicine performance art
ebook performance art
online education performance art
online/at home travel performance art
free web university performance art
net museum performance art
cyberspace mysticism performance art
virtual body morphing performance art
implantable computer chip performance art
space shuttle vacation performance art
children's rights performance art
video camera for all performance art
past-life regression performance art
lucid dreaming performance art
instant transfer of mystical teachings performance art
pill-less ecstasy performance art
maintenance-free hair performance art
virtual-death rehearsal performance art
constant state of mediation/meditation performance art
everyday life is enough performance art
cyber cures for loneliness performance art

artists become effective politicians performance art
live Internet collaborations performance art
generosity performance art
taking care of aging parents performance art
living-online performance art
laughing at everything performance art
vow of silence performance art

2000

Artists/Lifeists

This piece was written after 9/11 in order to define the term "Lifeist," which Montano believes is the ordinary life counterpart to the artist.

1. Sometimes trauma or beauty or ecstasy or oppression makes people want to make art. These people are called artists.
2. Sometimes they live with, or spend time with, or are influenced by others who are called lifeists, because they say that what they are doing is not art but life.
3. Lifeists choose not to make art of their marvelous happenings or imaginings or traumas.
4. Sometimes when artists take vacations from being artists and spend time with lifeists, they might not really feel at home because they are hiding their art-selves. Other times, they are happy to be with lifeists, so that they can drop their art and pay attention to life alone. This might seem frivolous but it isn't. Often it is as nice as art.
5. Sometimes lifeists make believe that they are artists, and want to be on art-like imitations of performances such as a reality TV show.
6. Sometimes artists look at these shows and remind the lifeists that what they are doing is not shamanic enough, not sensitive enough, not esthetically informed enough, not theoretical enough, not ironic enough, not culturally based enough. Artists then feel proud to be smart and better than lifeists.
7. Sometimes lifeists accuse artists of hypocrisy and artists then feel guilty, knowing that maybe they really wanted fame and that

was as frivolous a motive as the lifeists' desire for a lot of money from TV.

8. Sometimes the artists get addicted to spectacle, voyeuristic content, and unchecked homoerotic narcissism.

9. Sometimes lifeists dress like artists or buy homes where the artists live.

10. Then often something large, and leveling, and devastating, and terrorizing, and humbling happens, and it is like an atom bomb, or a Holocaust, or a genocide, or a rape, or a repression, or an Inquisition, or a Crusade, or economic genocide, or sexual betrayal, or bodies falling from the skies, and then sometimes everything stops and for a while there is only life.

Then for a short time, everyone in the whole, wide world, for a short, short time, becomes a true artist of life because of death. And the whole wide, wide, wide world breathes together one silent breath, and maybe the wheel begins to turn again. Here?

2001

Living Art

Time spent artfully alone or not alone

This set of directions was originally published in Montano's book *Art in Everyday Life*, (Los Angeles, Calif.: Astro Artz/Station Hill Press, 1981). It was subsequently published in *Angry Women*, Andrea Juno and V. Vale, eds, (San Francisco, Calif.: RE/Search Publications, 1991).

Section 1: Purpose and intent

Friends often intend to collaborate but rarely find the opportunity. The purpose of LIVING ART is to allow artists and nonartists to designate specific times, hours, days, weeks, or months, to work and live, together or alone. This time then becomes ART. The intention of LIVING ART is to redefine relationships by living together in a marathon fashion after having drawn up a mutually workable contract. The contract lasts as long as the ART.

Section 2: Living art defined

LIVING ART is any work/play which artists/nonartists are willing to perform together or alone. The rules can be determined by the needs of the participants. For example, they may explore silence, fasting, psychic discoveries, eating, basketball, etc., in the search for new styles of relating. LIVING ART becomes LIVING ART when the times and activities which the artists perform are intended to be art. The announcement may be public or private.

Section 3: Time defined

LIVING ART divides time into actual time and ART. Actual time is divided in terms of seconds, minutes, hours, days, months, and years. The artists may choose as much of this time as they think they need to transform and change themselves. When it is intended that a specific time together will be designated as time for LIVING ART then that time will become ART and not time.

Section 4: The contract

The contract is an agreement made by the artists before the event. It states that the time together and activity performed will be ART.

Section 5: The activities

The activities are anything that the artists would like to perform together. These activities, when documented and performed together as ART can change the values and personal vision of the artists.

Section 6: Documentation

The document of the time can be in any mode comfortable for the artists. Record-making should be done without stress so that the process of the art itself can be fully experienced.

Section 7: Directions for performing Living Art

Choose a person/persons with whom you wish to perform LIVING ART.
Select an activity that you would both like to perform.
Draw up a contract stating what the activities are, what time it will be, and what place/places.
Decide on a mode of documentation for the LIVING ART event.

Spend the designated time together and perform the events.
Present the result of your experiment to one of more friends, either
 with documentation, talking, or live performance.

Chapter 4

14 Years of Living Art and *21 Years of Living Art*

Immediately after finishing *Art/Life: One Year Performance* with Tehching Hsieh, Montano embarked upon another endurance performance: *7 Years of Living Art*. This experiment, which was based on the seven chakras and seven primary colors, had its roots in the seven characters in *Learning to Talk* (1977). Montano had the idea for the performance while still tied to Tehching Hsieh. In order to achieve her goal, Montano realized that she had to create a complete environment that included sound, color, clothing, shelter, and even identity. For seven years, beginning on December 8, 1984, Montano would stay in a colored space for a minimum of three hours a day, wear clothing of that same color for the entire year, listen to one pitch for a minimum of seven hours a day, and speak in an accent based on her characters from her 1977 video *Learning to Talk* for an entire year. After completing *7 Years of Living Art*, Montano began a new durational performance entitled *Another 7 Years of Living Art* or *14 Years of Living Art*. At the end of *14 Years of Living Art* Montano gifted the piece to three other artists, who will collectively perform *21 Years of Living Art* (1988–2019).

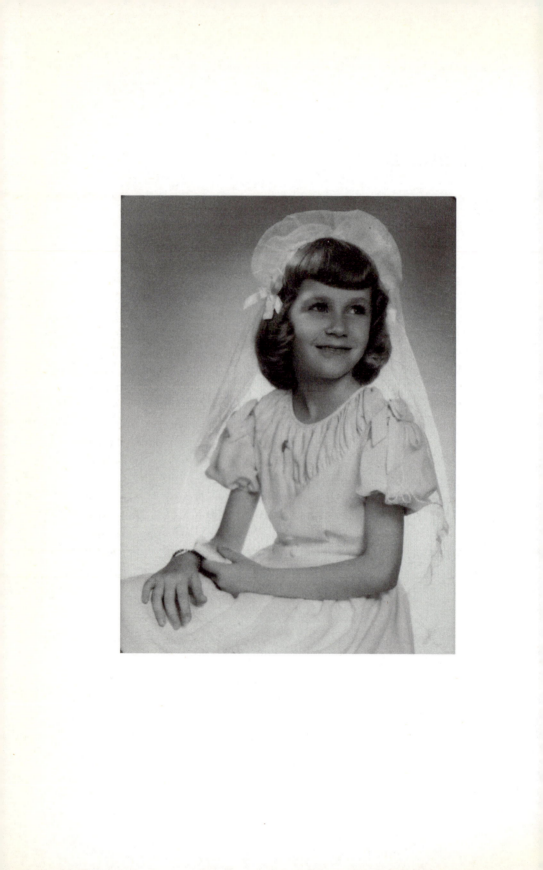

7 Years of Living Art

An experience based on the seven energy centers in the body

PART A. INNER: ART/LIFE INSTITUTE

DAILY, FOR SEVEN YEARS, I WILL:

STAY IN A COLORED SPACE (MINIMUM THREE HOURS).
LISTEN TO ONE PITCH (MINIMUM SEVEN HOURS).
SPEAK IN AN ACCENT (EXCEPT WITH FAMILY).
WEAR CLOTHES OF ONE COLOR.

PART B. OUTER: THE NEW MUSEUM

ONCE A MONTH, FOR SEVEN YEARS, I WILL SIT IN A WINDOW
INSTALLATION AT THE NEW MUSEUM AND TALK ABOUT ART/
LIFE WITH INDIVIDUALS WHO JOIN ME.

PART C. OTHERS: INTERNATIONAL

ONCE A YEAR, FOR 16 DAYS, A COLLABORATOR WILL LIVE
 WITH ME.
OTHERS CAN COLLABORATE IN THEIR OWN WAY WHEREVER
 THEY ARE.

December 8, 1984–December 8, 1991

7 Years of Living Art

Preliminary notes

On December 8, 1984 I will begin a seven-year event, based on the seven energy centers of the body, dedicated to Dr. Ramamurti S. Mishra.

Part 1. Focus

For the next seven years my daily activities at the Art/Life Institute will be:

- Staying in a colored space for extended periods of time so that the color can activate the center so that I am working on (minimum three hours).
- Listening with and without headphones to the pitch associated with that center (minimum seven hours).
- Wearing clothes that are the same color as the color of the center.
- Speaking in the accents to illustrate the center (except with family).
- Focusing my mind on the location of that center during everyday life actions.

Part 2. Outer

Once a month for seven years I will sit in a seven-year window installation at the New Museum where I will read palms, do Art/Life Counseling and talk about art and life with individuals who join me in the window.

Year	Number	Quality	Color	Pitch	Location	Accent
1984–85	1 (one)	Sex	Red	B	Tip of coccyx	French
1985–86	2 (two)	Security	Orange	C	Pubic area	Nun
1986–87	3 (three)	Courage	Yellow	G	Navel	Jazz singer
1987–88	4 (four)	Compassion	Green	D	Heart	Country & Western
1988–89	5 (five)	Communication	Blue	A	Throat	British
1989–90	6 (six)	Intuition	Purple	E	Third eye	Russian
1990–91	7 (seven)	Bliss	White	F	Top of head	Normal

Part 3. Other

I will open this experiment so that once a year for sixteen days an interested collaborator will join me either to observe the process or fully participate.

Others can collaborate by joining in their own way wherever they are.

Why seven years?

I have chosen to work with seven years for many reasons:

1. Biological:

In high school a teacher told us that every seven years each cell of the body is regenerated. We are totally new at conception, at seven years old, at fourteen years old, at twenty-one, twenty-eight, thirty-five, forty-two, etc. I have always been intrigued by this fact and now that I have entered the forty-two–forty-nine year cycle and am approaching fifty, I wanted to consciously watch these years and the passing of time.

2. Spiritual:

In 1970 I began to study yoga psychology with Ramamurti Mishra and since then have used the idea that there are seven energy centers (chakras) located on the spinal column and that each one aids the

healthy functioning of different organs in the body while also promoting psychological/spiritual assistance to the practitioner. I have structured this event on the seven chakras and each year will mentally/physically/metaphysically focus and give my attention to one of the centers for the purpose of concentrating my mind and clarifying energy. For example, in the fourth year, I will focus on the heart center, wear green clothes, listen to the pitch D, do palm reading in the green window at the New Museum and intend that compassion become more available in my daily life.

3. Personal history:

My early training was in Catholicism and we were always encouraged to meditate on the seven sorrows of the Virgin. There are seven sacraments in Catholic theology. In working with this time frame, I feel that I am linking my past spiritual training with my present interests and inclinations.

4. Art precedents:

In 1975, I developed seven characters/alter egos while sitting in front of a television camera/monitor. I practiced accents and gestures for a year. I feel that these selves come out of and reflect the seven energy centers, so I will refer to these personalities whenever appropriate, thereby linking old and new work. The first persona was Lamar, a French poetess, who speaks with an accent and represents the first chakra – intimacy. I will refer to this persona when necessary the first year.

In 1983, I was tied to Tehching Hsieh for a year, joining him in his *Art/Life: One Year Performance*. I experienced a deep blend of art and life, which I would like to continue for an even longer period of time.

5. Personal:

My mother has been seriously ill and has been given a year to live. Doing an event for seven years is a presumptuous way to play with time, impermanence, and the preciousness of human existence. Does it keep her/me alive and in control or grateful for each minute?

Disciplines Collaged together in this Experiment

- Seven chakras/yoga
- Colored room/Tibetan meditation chamber

- Uniform clothes/Catholic nuns
- Creating the ART/LIFE INSTITUTE/any institution
- Beginning the performance on December 8/Father's birthday, Buddha's birthday, Immaculate Conception of the Virgin Mary, full moon
- Large photo documentation of each year/art
- Listening to a tone for seven years/Pauline Oliveros and long tones
- Focusing on a part of the body where the center is located/Zen
- Creating a form where there is no distinction between art and life/conceptual art/Allan Kaprow
- Doing one drawing each year/Art/Zen.

Art/Life Institute

This will be a place where art and life are blended. There will be no separation and no guilt. The precedent was the MONTANO-PAYNE MUSEUM that I established while living in San Francisco with my husband Mitchell Payne. There I turned my home into a museum. Another precedent was my performance *Availability*, when I sat in my San Francisco garage available to interact with anyone who passed by.

Motivation

I am doing this to ensure that I am in the "state of art" or consciousness twenty-four hours a day for seven years while living a relatively normal life. My daily life will be disciplined enough to keep me deeply alert but flexible enough to appear normal. My intention is to reach the place of no-art so that life is enough. Before I reach that place, I will find ways to merge art and life so that I hone my attention and clarify awareness by structuring time with chosen tasks or intentions. In making a seven-year commitment, I am accepting the resulting oppression of that choice (inability to move from New York, no full-time job anywhere else, etc.). My work has never been without handicaps.

Community outreach

Friends in the area can come to THE ART/LIFE INSTITUTE for sitting meditation at night and on full moons. I will open the experiment to others so that once a year, for sixteen days an interested collaborator can join me to either observe the process or fully participate.

1983

Linda Montano

Judy Kussoy

This interview was originally published in *Connecting Conversations: Interviews with 28 Bay Area Women Artists,* Moira Roth, ed. (Oakland, Calif.: Eucalyptus Press Mills College, 1988). At the time of the interview, Montano was doing *7 Years of Living Art.*

Kussoy: Please describe your current piece.

Montano: I'm doing a piece called *7 Years of Living Art.* I see it as an experiment in self-imposed disciplines, which I've designed, collaged, and created in order to allow me to work on areas that will hopefully lead to a kind of attentional state – the same kind of attention that a Tibetan nun living in a cave would have, or a surgeon operating on a patient. What I've done is to discipline things into my life, things which I would like to do anyway but wouldn't do without a structure. I listen seven hours a day to one note, wear one color of clothes each year, speak in a different accent each year, and once a month read palms and do Art/Life Counseling at the New Museum in New York City. The piece is based on the Hindu seven-chakra system, so that each year I go up the spinal column gradually to the next energy center or chakra.

Kussoy: Do you travel around during the year?

Montano: Yes. I freelance teach, give lectures, do Art/Life Counseling and palm reading in different places. Also collaborators come to the Art/Life Institute to work with me.

Kussoy: What is your accent this year?

Montano: It's a Spanish accent (said in a Spanish accent). I used to speak all the time in an accent for the first six or seven months of

this year, but then I found that it was just too much! First I spoke in it, then I thought that I was speaking in it when I didn't use it, but eventually I realized the chemistry of just thinking in the accent was not quite as good as the experience of doing it. I couldn't keep it going. It got to be too much pressure. Every word is poetry when I am doing it. So I went through a lot of guilt, fear, terror, for having to give up a part of my piece but . . . here I am. I've dropped the accent.

Kussoy: Is there any correlation between the accent and the color?

Montano: The accent and the chakra correlate. The first year I was doing the sex chakra, which is located at the tip of the spinal column (the perineum, between the genitals and the anus), and I spoke in a French accent. This year's chakra is about security. I wear orange all year and the chakra is located at the pelvis. I correlate these chakras with my early "characters" which I created in 1976 – the Nun, the Doctor – and I correlate the accent and these characters.

Kussoy: Do you ever feel limited by your seven-year commitment to this piece?

Montano: Not really, as it is quite a generous piece. There are certain things I cannot do, like having a job, because of my clothes – they don't want orange clothes on the worksite! I also can't travel for longer than a month. I wanted the discipline of not having that kind of mobility. I wanted to work within the confines of a discipline because I think that women choose naturally – either through motherhood or jobs, or relationships – certain kinds of compromises, disciplines, and commitments. Since I didn't have any of those – I didn't have my own house, my own relationship, my own children, or a job – I felt that before I got to menopause I needed a way to learn a kind of focused generosity and commitment. Hopefully, the hard work will lead to a kind of mind and heart states that practitioners of very advanced meditations get to, which is compassion, understanding, and wisdom. These are some of my goals. Oh, and I want to come out of this with a karate black belt.

Kussoy: How has the project developed from the first year to the second?

Montano: The first year was like any relationship. It was very hot and heavy and committed in an incredibly intense way. I would

say this year I'm a little more laid back, I'm easier on myself. I miss some of the passion of the first year but then again, the first was the muladhara and so it was extremely intense.

Kussoy: Do you focus on the chakra when you meditate?

Montano: Yes. A lot of it is that I've been an experimenter in many spiritual forms and many art forms and they would always tell me, "Come from the heart, come from the head, listen to the sound, do nothing." etcetera. I got so many instructions that I didn't know what I wanted. As a stubborn person, I always rebelled, so I thought, "Well why hang around if I'm rebelling? Why not just make up my own rules and if I break them, then it's my fault? I don't have to blame anybody else." I was tired of fighting the authorities.

Kussoy: Do you ever fear that you will discontinue the piece?

Montano: The accent was the only thing that I wanted to discontinue. It was the hardest to work into the piece because I knew that it was an overlay. Everything else was somewhat traditional, coming from esoteric spiritual forms and practices. I knew that the accent, however, would make the work more like "art" and would allow me to speak to that world, the art world.

I want to do the piece, but I do get a little bit afraid, like what if I have to go to the hospital, what am I going to do about the clothes they'll put on me? I have even ended up in places where there is no electricity and I can't plug in my sound machine to listen to the note. I have traveled and forgotten to put my orange cloth over the bed and I've woken up and realized that I had forgotten the cloth and the sound. It is both about life and death and it isn't. It's my own life and death, but it isn't like forgetting to eat for eighty days. It's forgivable.

I grew up in a Catholic tradition where there was always a priest that I had to ask permission from; there was Jesus, Mary and Joseph and thousands of other higher beings. I think that part of this current piece is learning to forgive myself.

Kussoy: Are you as uninhibited in life as you are in performance?

Montano: That's what I'm trying to learn how to do. I was very permissive in my art and my life was suffering. Not that there's a really big difference between my art and life, but there are subtle kinds of differences. I was expressive, emotional, and permissive in my art. Now I want to be that way in my life. I'm trying to make

up for these years of being one-sided and off-balance. In order to do that, I'm going to conventional therapy. Because I call every second art – meaning consciousness, or meaning an opportunity to be conscious – the performance is a twenty-four-hour phenomenon for seven years, and so I have more opportunities to perform than when my events were only an hour or a year long. Now it's minute to minute, for seven years.

Kussoy: Is there anything you would consider too personal to present to an audience?

Montano: Yes. So I would cloak and disguise that material now. Mainly it's important to present to myself that information and to understand it, work through it, gestalt it, exorcize it, feel it, and to circulate the energy that's been trapped around that issue. I'm a little less publicly confessional as I get older, a little less willing to expose myself and my friends and my past. I'm more careful and don't mind that. One might call that Reaganism or conservatism or whatever but that's all right. Also, therapy is a formal place to work through these issues, and since therapy is happening in "art time" it's "life performance."

Now I can make my work more universal and applicable to more people. The time for confessional art is somewhat over. Artists are teachers and we've taught ourselves and each other how to deal with confessional material. That's still important to do on a workshop level, on a personal/private level, but universal concerns are bigger now. The "personal" needs to be married to the universal and global. For example, I think the issue of AIDS is going to make us have to deal with our own personal, sexual history, and this will affect our lives and art. Global, nuclear, ecological, and health issues are overwhelming to me, although I'm still incredibly hermetic and private, and deal with them on that level.

Kussoy: Are there any other issues you would like to address?

Montano: Just something about habituation. One of the purposes of this piece is to stay awake – to wake myself up to my full potential. The piece in which I was tied with a rope to Tehching Hsieh for a year (1983–84), in his *Art/Life: One Year Performance*, was psychologically dangerous. This piece *7 Years of Living Art* is not as dangerous. Danger is a very important goad or way to stay awake. I mean, if you're rock climbing and you're on the edge, you're

going to keep your eyes open and your senses open. I want that kind of intensity. I want to be rock climbing every minute of my life. I want to be on that edge.

Kussoy: Isn't that exhausting?

Montano: You get in shape: you start eating differently, you pack mountain climbing food, and when you're not mountain climbing you're practicing or training for it. I want my mind to have that aspect of training. This sounds good, but it's very hard and exhausting. It doesn't always work, but that's the intention.

1988

The Art/Life Institute Presents
Another 7 Years of Living Art

After *7 Years of Living Art*, Montano immediately began the performance again, making it into *14 Years of Living Art*. During Another *7 Years of Living Art*, Montano did the disciplines "internally" but externally wore the colored clothes again for seven years. Not once did she actually go to the Chagall Chapel, but did attend "invisibly." Only one photo of Montano was taken during those seven years and she re-drew the same drawings, but this time with her left hand. Nothing was written about these seven years. Drs. A.L. and Aruna Mehta became her advisors for those years. *21 Years of Living Art* (December 8, 1998–December 8, 2019) began immediately after *Another 7 Years of Living Art*.

INNER

FROM DECEMBER 8, 1991 TO DECEMBER 8, 1998, I WILL PAY ATTENTION TO AND APPRECIATE THE SEVEN ENERGY CENTERS IN THE BODY, BEGINNING 1991 AT THE HEAD CENTER AND ENDING 1998 AT THE ROOT CENTER.

OUTER

DAILY I WILL: WEAR ONE COLOR CLOTHES ASSOCIATED WITH THE CENTER, CHANGING THE COLOR EACH YEAR. SPEND TIME INTERNALLY OR EXTERNALLY IN A COLORED SPACE ASSOCIATED WITH THAT CHAKRA. LISTEN INTERNALLY OR EXTERNALLY TO THE SOUND ASSOCIATED WITH THE CENTER. ALLOW A FEMALE YOGINI AND MALE YOGI TO ADVISE ME.

OTHER

FOUR TIMES A YEAR FOR SEVEN YEARS, I WILL SIT PHYSI-
CALLY OR ASTRALLY AT THE CHAGALL CHAPEL IN THE UNITED
NATIONS, INSTALLING MYSELF AS A LIVING ART DONATION.

1992
February 7, Friday: 12–3
May 7, Thursday: 12–3
July 7, Tuesday: 12–3
October 7,Wednesday: 12–3

1993
February 6, Wednesday: 12–3
May 6, Thursday: 12–3
July 6, Tuesday: 12–3
October 6, Wednesday: 12–3

1994
February 5, Saturday, 12–3
May 5,Thursday, 12–3
July 5, Tuesday,12–3
October 5, Wednesday, 12–3

1995
February 4, Saturday: 12–3
May 4, Thursday: 12–3
July 4, Tuesday: 12–3
October 4, Wednesday: 12–3

1996
February 3, Saturday: 12–3
May 3, Friday: 12–3
July 3, Wednesday: 12–3
October 3, Thursday: 12–3

1997
February 2, Saturday: 12–3
May 2, Friday: 12–3

July 2, Wednesday: 12–3
October 2, Thursday: 12–3

1998
February 1, Sunday: 12–3
May 1, Friday: 12–3
July 1, Wednesday: 12–3
October 1, Thursday: 12–3

NOTES: During *Another 7 Years of Living Art*, I pulled back, did everything "internally" and wore the colored clothes. Not once did I actually go to the Chagall Chapel but did attend "invisibly".

21 Years of Living Art

FOR 21 YEARS (1998-2019) THREE DIFFERENT PEOPLE WILL PERFORM THEIR VERSION OF *7 YEARS OF LIVING ART*, EACH ONE TAKING SEVEN YEARS.

The first person, Betsea Caygill, did external actions for six months and is completing her performance in secret.

Why *14 Years of Living Art* Year-End Reports Are Not in This Book

An open letter

Dear *14 Years of Living Art*,

This letter is an apology to you – you, the biggest, longest, most transforming, most encompassing, most generous, and most complex performance of my life. No, I'm not buttering you up just because there isn't much about you in my book. Really, you are wonderful but I can't sing your praises. Why?

Because there are not 34874878 pages in this book, I will not be able to tell the reader about Dr. R.S. Mishra and the way he introduced his students to the chakras, day after day, year after year using color charts, chants, meditations, and art practice.

Because there are not 276767673 pages in this book, I will not be able to include the essay Moira Roth wrote which describes *7 Years of Living Art*. Everyone who visited me for seven years at The New Museum of Contemporary Art in New York where I performed Art/Life Counseling was given a copy of the essay, which was printed on paper the color of the clothes I wore that year.

Because there are not 57873877 pages in this book, I will not be able to include the year-end reports I wrote for the first *7 Years of Living Art*.

Because there are not 958487875 pages in this book, I cannot include Jennifer Fisher's essay "14 Years of Living Art" that she published in *Parachute*.

Because there are not 94885775 pages in this book, I will not be able to describe the Summer Saint Camp I held each year for two

weeks or name the participants and first meeting with subsequent friends Annie Sprinkle, Veronica Vera, and Barbara Carrellas.

Because there are not 48746746 pages in this book, I will not be able to tell Tehching Hsieh that he is an important influence on my work and has enriched my love of endurance.

Because there are not 485787576 pages in this book, I will not be able to tell the reader about the synchronic aspects of the performance: that I completed menopause at the end of *7 Years of Living Art* (1984–91) and completed teaching in Texas at the end of *Another 7 Years of Living Art* (1991–98).

Because there are not 587857 pages in this book, I cannot tell in detail that I am continuing this performance and it is titled *21 Years of Living Art* (1998–2019), asking three people to perform seven years in any way they wish.

Because there are not 597857875 pages in this book, I won't be able to include a chart created by Caroline Myss (ex-nun) that interfaces the Kabala, Catholic Sacraments and Chakras in a brilliant way or explain how this chart eased my return to Catholicism.

Because there are not 8758587 pages in this book, I will not be able to talk about the website the Robert Shiffler Foundation produced for me at <http://www.bobsart.org> (January 1, 2004). Peter Huttinger curated the site and it includes many images from *14 Years of Living Art*.

Because there are not 45987587587 pages in this book, I will not be able to talk in depth about the courage of Marcia Tucker, director of The New Museum at that time, and her willingness to include a seven-year installation-room at the museum which I visited once a month for seven years. In that space which was painted a different color each year, I saw visitors one by one and performed Art/Life Counseling with them.

Because there are not 549858757 pages in this book, I will not be able to describe in detail the way I drew one image each year and limited myself to one drawing a year for seven years, drawing with my right hand, and then for the next seven years of the performance I drew the same drawing with my left hand.

Because there are not 98498494 pages in this book, I will not be able to talk in detail about the two retrospectives I had of relics from *14 Year of Living Art*. One was curated by Carolyn Eyler (*Linda Montano: Seven Years of Living Art*, University of Southern Maine,

1999), the other by Jennifer Fisher (*Linda Montano: 14 Years of Living Art*, Saidye Bronfman Center for the Arts, Montreal, 2003).

Because there are not 948944787 pages in this book, I will not be able to describe the photo images Annie Sprinkle took of me imitating the seven mudras from my seven drawings.

Because there are not 437508375087 pages in this book, I will not be able to describe the seven-hour sound collaborations titled *Chakraphonics* that I performed with composer Ellen Fullmann and friends in Austin.

Because there are not 5489587587587 pages in this book, I will not be able to talk about the joys of making endurance vows.

In conclusion, *14 Year of Living Art*, my champion, my secret one, this is the last time I will write about you for seven more years. With more space around you, maybe you will learn to fly by yourself.

Love and thanks,

Linda

2004

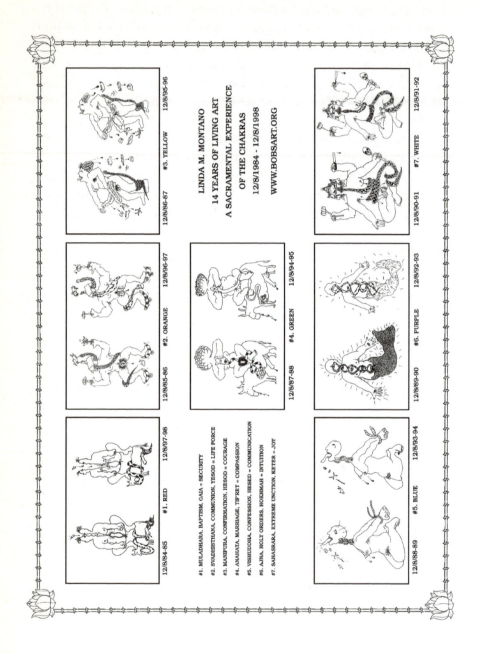

LINDA M. MONTANO
14 YEARS OF LIVING ART
A SACRAMENTAL EXPERIENCE
OF THE CHAKRAS
12/8/1984 - 12/8/1998
WWW.BOBSART.ORG

12/8/84-85 #1. RED 12/8/97-98

12/8/85-86 #2. ORANGE 12/8/96-97

12/8/86-87 #3. YELLOW 12/8/95-96

12/8/87-88 #4. GREEN 12/8/94-95

12/8/88-89 #5. BLUE 12/8/93-94

12/8/89-90 #6. PURPLE 12/8/92-93

12/8/90-91 #7. WHITE 12/8/91-92

#1. MULADHARA, BAPTISM, GAIA = SECURITY
#2. SVADHISTHANA, COMMUNION, YESOD = LIFE FORCE
#3. MANIPURA, CONFIRMATION, HESOD = COURAGE
#4. ANAHATA, MARRIAGE, TIFRET = COMPASSION
#5. VISHUDDHA, CONFESSION, HESED = COMMUNICATION
#6. AJNA, HOLY ORDERS, HOKHMAH = INTUITION
#7. SAHASRARA, EXTREME UNCTION, KETER = JOY

Chapter 5

Transitions

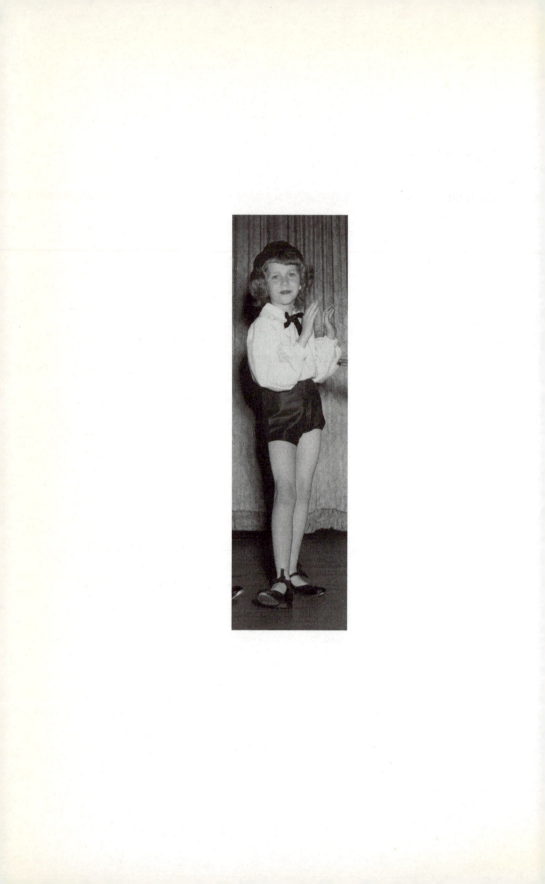

Tenure

From a therapist's file

Montano wrote this piece in response to an Austin therapist who told her
that she couldn't "go home again" shortly before she did in fact return to
Kingston and the Art/Life Institute from Austin, Texas.

Visit 72

Subject of therapy: Client continues to explore disappointment over
loss of job.

Notes

Was it downsizing or the administrators' violation of his First
Amendment rights that cost him his creative writing job? Or was it
the fate of all ex-hippie, liberal professors teaching in tenure track
positions? Weren't all of them accused of presenting content that was
too sincere, too expressive, too emotional, too transgressive, and too
nonpolitically correct? Whatever it was, it just never worked, and S
is really suffering.

Summary of session 72

I encouraged S to focus on his inherent creativity so he could build
up his confidence, which is lacking right now. Told him to re-join the
gym. He's clinically depressed and the job loss is exacerbating it. I am
considering giving him Paxil. Built him up with suggestions that he's
too talented for that old job anyway. And told him the atmosphere

there is toxic to his freedom. I also try distracting him by discussing my issues but it's on his time and his money. We talk about my insurance policies and my fees. Maybe this will dislodge him from his topic and incite some anger that might unseat his self-inflicted hostility. We'll see next week.

Visit 73

Subject of therapy: Anger has moved his focus from "I am wrong" to "They're wrong."

Notes
Most parents, especially from the part of the country where he's teaching, don't want their kids using their 5 cents a minute phone cards to call them Sunday nights with reports of their intellectual excursions into taboo subjects. And administrators don't want the donors and alumni to call them Sunday afternoons using their MCI free long distance service complaining about instructors teaching taboo subjects. Nor do they want to read irate letters from disaffected parents of students who had reported the "transgressive" course material to said parents.

The name of the academic game was, and still is, to teach while keeping the students, colleagues, parents, administrators, alumni, and donors very, very happy.

Summary of session 73
People-pleasing has become a pattern, but the artist in S made another choice: to please himself and sometimes a few others. We begin talking about his family structure, his need to be the maverick artist, and his need also to be the peacemaker. He's incredibly open to looking at it analytically this week. Anger at me has given him some space to see differently.

Visit 74

Subject of therapy: Exploration of the shadow.

Notes

Although he scored well with some students and some colleagues, he flunked the other tests and upset the academic applecart wherever he went. He was a big star, a bad boy, and a scrapper, a person who made others upset. In retrospect he realized that he should have known better. He should have known that they didn't want the bad boy to be a perennial bad boy; that bad boys are great for one lecture, for one workshop, for a one-day visit, not for a seven-year or permanent relationship with the university family.

Summary of session 74

I suggest that he start taking responsibility for that bad-boy artist persona, the shadow, and the dark side. His narcissism is infuriating. Never having had to compromise or be anything but an intuitive, he's impossible to work with sometimes. Self-absorption is essential to his vocation, but he must know when to stop! His genius really tires me. Didn't he know that Big Daddy University would demand obedience? Glad today is over. His body language is offensive!

Visit 75

Subject of therapy: Content in the academy/content and the academy.

Notes

His marriage to the university was soon to end. Divorce was imminent. The last assignment was too close for comfort and would be the reason for his termination. That's what surprised him. The other creative-writing research projects S gave his students were on equally reality-based topics: gender, food, origins, Tantra . . . and these assignments stirred neither the ire of the parents or administrators. In fact, a bound collection of the student essays donated to the library had been deemed a valuable explanation of popular culture, theory, and personal memory. Taboo was OK if it sounded smart or was imbedded in academic jargon.

Summary of session 75

We discussed how lucky he was to be able to address the *verboten* without censure. His intimacy issues are decidedly more informed and

radical than the hypocritical university system that defines taboo when it is as seen as research. We talk about paradox, and the Pharisees.

We talk about paradox and hypocrisy. I enjoyed today's session. It felt like a real exchange. I mention that to him. He encourages me to continue talking this way because it helps him with his communication blocks. Here he can think aloud, talk, and express himself in a safe space without the usual shyness around the opposite sex. I'm beginning to counter-transfer. Have to talk to my boss about this.

Visit 76

Subject of therapy: Client explores childhood and cultural influences.

Notes

Having passed the test of taboo and the academy, he moved onto other assignments: food and memory, trauma and memory, eco-feminism and memory, other important topics, successfully handled. All of them got As. And then he touched his nemesis, DEATH! It was only natural that he would choose death as a topic, having grown up in two countries, India and America, a child of a mixed marriage. All of his summers were spent in north India, just outside Benares where he visited his father's country palace and lived most of the time at his teacher's ashram, practicing meditation, silence, chanting, Vedanta, and Ayurvedic medicine. His guru would take all of the boys to Benares once a week so that they could meditate at the ghats all night. Death and liberation were close friends, not strangers, and his teacher insisted that he watch cremations, 100 or so a day, enough to see, enough to learn from. The same number the next day. This had been going on for centuries. Included in his sadhana or spiritual practice was a boat ride down the Ganges river, past the ghats which were many, not one . . . a ride which included maneuvering between floating bodies, body parts, bloated limbs.

So at an early age, he saw things reserved only for search-and-rescue salvage drivers excavating planes downed in the Pacific Ocean. Instead of making him hard and bitter, all of his early training and meditation made him comfortable and conversant with death so when he returned to America to work, these experiences definitely informed his philosophy, his syllabus and his university assignments.

He was beyond the fear of it all and wanted to share that attitude with his students.

Summary of session 76
Today I should have paid HIM! I learned so much. That's one of the perks of being a therapist. Often it's more instructive and healing for the therapist than for the client. Maybe not! Does anybody else know this secret? All I know is that I learned about Benares today.

Visit 77

Summary of therapy: Creativity/healing/enlightenment.

Notes
He talks about being an American also, and in this country we are comfortable, conversant, and open with sexuality, but not with death. Sex is everywhere and available to anyone with chat-room access, or with $3.00 for a 900-number one-minute call. It is as easy to see and gobble up as candy. As a child of mixed cultures he eventually saw that neither death nor sex were taboo; rather, they are tantalizing curiosities and meals that need to be digested, cooked, tasted, and eliminated. That's how nonattachment was born. Do it all, see it all, get addicted, and then get bored by it all, so eventually you are left with emptiness and real space for Tantric intimacy.

For those not wanting to have a hands-on experience, that is for the less experiential and phenomenologically inclined, creative writing could serve as another path and lessons learned from the imagination. He taught that the taboo didn't have to be really experienced, but if written about, everything could be cleared and energy was then shifted. No muss, no fuss, no addiction. And when free of lust and desire, he said that he could then feel an empty spaciousness, similar to what he felt when he meditated.

Summary of session 77
It's become too chatty. Is it because we are talking about such private subjects? He must be lonely because he does not want to leave the office and he's working to impress me with his theories, his genius, but I feel deep down that he is just touching the surface. I smell some

core issues and painful traumas that he won't touch with a ten-foot pole. So glad the seminar phase of this therapy with him is over and we are beginning to work hard and deep again. I'm drained but touched by his metamorphosis.

Visit 78

Subject of therapy: Motive behind his death assignment.

Notes

That's the gift that he wanted to pass on to his students, meditative mind. And to reach it he discussed interior paths and the art of writing as one of the many valuable ways to achieve pure mind. On January 18 he gave the assignment to write a twelve-page essay on the topic of death and memory. The students looked stunned even though they had studied the topic extensively in his class because he had arranged for the following:

1. A class trip to the local morgue.
2. A lecture by a pathologist.
3. A viewing of morgue bodies.
4. Elizabeth Kübler-Ross movies plus a workshop with her.
5. Visits to a nearby Hospice.
6. Viewing of *Schindler's List*.
7. Tour of a funeral parlor.
8. Four days volunteering in a nursing home.
9. Video of cremations in Benares India.
10. A visit from a person with AIDS.
11. Attendance at a wake and a funeral.

After this research, it was time for his students to write, theorize, remember, and make art of it all. And he visibly shook when he told me this part of the story, because when they put their papers on the class web page, and after the public readings at the cyber café, he was asked to see, in the following order:

the assistant chair
the chair
the dean

the lawyer to the president
and the president himself.

And to each of them he explained his syllabus, his teaching philosophy, his reasoning for the assignment, and his understanding of consequences. The bottom line was (when he told me this he was really crying) that he was not to be trusted with the minds of university students. That's how he ended up in this regression.

Summary of session 78
As his therapist, I insisted that he see his interest in death as undiagnosed slippage! That is, as a child, he was not able to feel or express rage, anger, disappointment, or hostility. Children naturally want to be conversant with those big feelings and need guidance with their expression. He's just learning that and has translated the natural urge to be good and bad into esthetic infantilizations. Our sessions are maturing him emotionally and I am able to explain to him that he needs to get to the core feelings to avoid the pitfalls of unconscious victimhood and outsider status. This way he can choose his course and his urges won't so readily get displaced into a career that has "death" as an agenda (surgeon, wrestler, acupuncturist, thanatologist, grief counselor) without knowing why he is pulled in that direction. I congratulated him for having controlled his urge to "die" by displacing the urge into his art. But I didn't let him off the hook too easily and for the last ten minutes of the session, we did some powerful discharging of early memories and hurts and rages. Of course it restimulated all of my stuff, and I went home and cried in the bathtub.

Visit 79

Subject of the session: Can you go home again?

Notes
So here he is, he went home to his mom. He was tenureless, jobless, and clueless. His dad had died in India and his body was cremated on the banks of the Ganges ten years ago. So now it was the ninety-year-old mom and S. He slithered back into his old hometown, hoping nobody would notice him . . . clueless, downsized, humiliated, and exiled.

His new job description was beyond manageable:

1. Grocery shopping
2. Chauffeur
3. Errand boy
4. House cleaner
5. Medication dispenser
6. Chef
7. Returner of unwanted objects that mom bought on a whim
8. Funeral attendee since all of mom's friends were passing on so fast that every other day he and his mother attended a wake and funeral at the place up the street from her home.

Summary of session 79

I've overstepped my bounds. Told him you can't go home again. Bad therapy. It was irresponsible of me. What happened today? I said goodbye. The occupational hazard of this job is falling in love. I'VE DONE IT!!!!!!

Therapy ends.

Note

I received a card from him six months later. He says that the metamorphosis from being a professor to becoming a hidden life-artist got easier and easier. Differences were blurring, and although he still went to India every summer to his guru's ashram and stayed with his father's relatives, he began seeing a larger plan. What he saw was that he didn't need the corporate world to define his life anymore, he didn't need the money, the prestige, the power. After the twentieth funeral that he attended with his mom, after the fiftieth returned pocketbook to Kmart, after the hundredth bag of microwave popcorn eaten during *Wheel of Fortune*, life began blurring into one indistinguishable mass of mystery and inner smile.

He told me that when he delivered his mom's tax papers to her CPA (Certified Public Accountant) yesterday, he got the message that he would have to deal with money next. Maybe he will call me, come for therapy, and we can talk!!!!!!! I hope so.

1998

Cover everything in your syllabus: Performance art in the 1990s

In the 1990s the first- and second-generation originators of the current form hardly ever practiced performance art. Was it because they lost their audience, their youth, their nerve, their funding, and their concepts? Maybe all or none of the above. After twenty-five or thirty years of exposure to performance-art events, viewers had seen enough, taped themselves doing transgressive things enough, learned enough to be performance artists themselves. As a result they stopped coming to performances as co-creators, co-healers, empathetic witnesses and became restless critics of a genre which often utilizes intuitive and raw production values, hermetic/autobiographical motifs, and arbitrary voyeuristic-making content.

Audiences learned to want their money's worth; they wanted a slick show, not an esthetic catharsis. Performance artists wanted to experience the early freedoms of the form. In the locking of esthetic horns, change was inevitable. Then there was money. Stringent codes of behavior designed by watchdogs of morality and political correctness demanded that unless performances were entertaining exhibitions of might and spectacle suitable for PG13 audiences, then no support would be forthcoming. Fundamentalists pointed to AIDS and said "I told you so" to convince taxpayers that their money was being ill spent on dangerous/outrageous art whenever content offended the moral majority.

How did performance art respond to the challenge?

Performance art is not about money; it is about audience. Those with nerves of steel, skill, and desire continued, and survived the critical microscope of the 1990s. Others moved, retreated, wrote books about themselves, or flexibly re-worked their objectives while hoping for a big museum retrospective of the relics from their past pieces. Some returned to their first love of painting or sculpture, some brought their expertise to the academy where performance was encoded as a subject to be taught, analyzed, historicized, re-mixed, appropriated, deconstructed, interpreted, and practiced again.

And it was just like old times, when groups of friends would meet at Tom Marioni's place and perform for each other; or when

women in LA gave art birth to deep and secret issues at the Woman's Building. Thirty years later the scene is alive in some academies where university performance students give good attention, full energy and unrepressed expression to their work in a classroom atmosphere nourished by noncompetitive critique. Yet they also feel comfortable writing heady treatises on the history of performance. An occasion for good healing and good thinking. Isn't it strange! The academy, when it is protected by a supportive and forthcoming, First Amendment-loving, non-spooked-by-corporate-donors administration, has the capacity to become the foster home of the new avant-garde.

Conversely when the difficult, the arousing, the transgressive is not treasured there as a subject worthy of critical yet careful dialogue, then performance-art professors can come under intense scrutiny by detractors. Rumors fly around about graphic content in the class, about a performative language that is objectionable, about uninhibited student performances, about a grading policy that is nonconversant with that of the department, about the professor's "unique" but questionable teaching style.

Out of context, and without experiencing or hearing explanations for all of the above, it is deemed dangerously nonacademic and the response is often to deny tenure to the professor or eliminate the area in the department.

Does this deter performance art? Not really. Performance art has many homes besides the academic ivory tower; it graciously allows itself to be co-opted by TV and just like the hundredth monkey theory, performance is EVERYWHERE!

What follows are a few real, popular culture, "found" performances that look like, imitate, or at least could be claimed as performance art.

Witness

A "Say No To Drugs" TV commercial, seemingly crafted by a graduate student pursuing a degree in performance studies. In this brilliant use of the formula, a raging, seemingly steroid-fueled, Generation X woman breaks dishes, throws an iron skillet, threatens the camera with looks and detritus, projects the "drugs kill" message from all 40 trillion cells of her body. This is not theatre, this is really performance

art. And it's good, efficacious, and powerful. Performance art used to deter addiction and death.

Witness

In a cosmopolitan airport, a woman cries loudly, hysterically, as she walks alone to the baggage claim. Her wails about her issue echo through the terminal. She doesn't stop, nobody asks, and everybody knows that this is real, and it is art because they are touched to wake up. Fantastic performance art!

Witness

April 1999, David Blaine, a magician, is buried 6 feet under for seven days in a casket below 3 tons of water. TV personalities and movie stars queue up to see him. Tabloids applaud this endurance art.

Witness

Performance art has never advocated danger, death toward the self or others, but wasn't Heaven's Gate a highly choreographed, theatrically bizarre, and costumed ritual reminiscent of the suicidal museum and gallery installations of the 1980s? This example is beyond art and the *Guinness Book of Records*. Don't imitate it!

Conclusion

What now? Some performance-art players have joined the exodus to the Internet and other technologies that offer refuge from art police, fundamentalist censors, and inquisitors of creativity (although all three are biting at the heels of the genre). Others theorize performance art at scholarly conferences, reprint their first-edition books or write more theories about the subject. Is this called retirement? And there are still master performers, public encouragers of creativity, and esthetic revolutionaries who are willing to take the risk of being publicly vulnerable. They deserve our gratitude and support.

THANK YOU STELARC for continuing to coax us out of our obsolescent bodies.

THANK YOU ORLAN for physically exploring the meaning of pain and disfigured suffering.

THANK YOU BOB FLANAGAN for making death erotic.

THANK YOU CAROLEE SCHNEEMANN AND ANNIE SPRINKLE for developing new ways to be intimate.

THANK YOU KAREN FINLEY for courageously raging.

THANK YOU HANNAH WILKE for your insistence on the body as a vehicle for art.

THANK YOU DONNA HENES for embracing the seasons.

THANK YOU (your name or another) for all that you have done.

AND THANK YOU to the unmentioned multitudes throughout the world, still willing to be performatively seen and heard.

Please continue to shock us, warn us, nurture us, wake us up, and teach us how to explore everything: genetics, robotics, weightlessness, border issues, and re-runs of *Wheel of Fortune* watched with octogenarian parents. Catapult us, performance artists, into a new world, one braver than what could ever be imagined. And perhaps the new performance art will be totally invisible but will feel like RAPTURE.

That is uncensored!

1999

❀

Littleton, Colorado: Performance art and accountability

Just after Montano had returned to upstate New York from Austin, the horrific events at Columbine High School in Littleton, Colorado occurred. On April 20, 1999, Eric Harris and Dylan Klebold, two disaffected students, went on a shooting spree at their high school, killing themselves, twelve students, and one teacher. Deeply moved and seeing the parallels to her own situation, Montano responded with the following letter.

Dear Art Teachers of the World,

Are you as interested in analyzing the Littleton, Colorado, Columbine High School shootings as I am? Are you intent on figuring it out,

discovering clues and reasons for the tragedy? Are you also playing detective so that you can handle the pain, not feel it? That's what I'm doing. And I think I figured it out. Do you remember when the media mentioned that the two young men had made videos, ten or so, in a high-school class? When I heard about the videos, I became alerted, my selective memory was activated, and an internal voice said, "How does that relate to me?" What follows is what I thought to myself:

1. Linda, do you remember those twenty-five years that you taught performance art?
2. Do you remember the autobiographical performances and videos that the thousands of students have done in your classes?
3. Do you remember how stretched by the work you were sometimes, how aesthetically vulnerable the students were sometimes, how fragile art makes you feel sometimes?
4. But do you also remember how healing, cathartic, and cleansing those performances and videos were for the class, although sometimes the healing demanded a rigor and guts that was breathtaking.
5. Do you remember, Linda, that the other students gave good feedback, voiced their opinions, and created an atmosphere of dialogue about the difficult issues in the work . . . issues of danger, of transgression, of racism, of elitism, of power?
6. Do you remember, Linda, that students initiated themselves, matured themselves publicly, transformed themselves, moved from anger to repression to rage to confidence to clear thinking, analyzed creativity?
7. Do you remember all of that?

Then why do you flinch when you read that the students made the video that performatively rehearsed the shootings although they were told that they couldn't show it to their classmates because it was too violent and volatile? Is it because had you been the instructor you would be feeling the stigma of implication? You might have asked yourself if you should have stopped them? Reported them? Simply viewed it in the context of video art? Should you have seen what was coming? Should you have become a member of the art police, an arbiter of correctness, or a psychologist-at-large?

Teaching can be a scary job, a job filled with moral, physical, ethical, and dangerous consequences that make the classroom a war

zone rather than an arena for good-natured creativity. We all fear the threat of litigation, termination, and being blamed no matter where we teach. Instead of going into a classroom with the uplifting mantra '"Have a nice day," we now watch our proverbial backs!

At less paranoid moments, I think differently. "No, I would wager that had that censored tape been shown in the classroom, something magical might have happened. Something transformative and healing and purging and cleansing." I've seen that happen in my classes when difficult subject matter has been presented, when violence is reenacted as art, when trauma is aired on the clothesline of esthetic disclosure. I've seen that the violence turns into the Awareness of Violence. Trauma becomes the Awareness of Trauma, defusing the darkness, and deflecting the impulse to destroy. In fact, sharing darkness as art tumbles that scariness into sacred tragedy. Real-time devastation is eliminated. Giving good attention to what is horrible stimulates positive change. So art teachers, video teachers, performance art teachers, I'm just trying to help because I have been there! I have censored and been frightened by the content of student work in my classroom. I'm trying to encourage you and myself to stand up for public freedom of expression, even if it results in the loss of privileges, job, or reputation. Call me if you want to talk about this and sleep well; none of this is easy!

Linda

1999

❖

Dear Hanoi (Jane) Fonda

This was written as a healing tool after Montano had left the University.

To be read in an activist's voice

Dear Hanoi Jane,
Jane, you were right. Right to say that you were wrong back then. It was wrong of you not to do what everybody else was doing, and right now to say that you were wrong then. You are right, you

should not have sympathized with the Viet Cong because many, many Americans thought that you were wrong. You should not have spoken against involvement of American troops in Vietnam because the majority of Americans thought that it was right for them to be there. Majority rules, Jane. You were wrong then and right now. Shame on you, Jane. You should feel guilty now for having been one of the first Americans to be let into North Vietnam by Ho Chi Min. You traitor, you.

But now that you are almost sixty and wiser and have stopped fighting and joined the rest of the world, you have a chance to feel bad for a while and then good. Now more and more people can run up to you in airports these days (as was reported by the media recently), and throw their arms around you, the prodigal daughter, and the good American girl, returning home to group think. We all make mistakes Jane, even you, and as you age, you will discover even more of them!

To be read in an alcoholic's voice

The reason I'm congratulating you, Jane, is because I feel the same way, Jane. Yes Jane, I'm home now and I feel wrong, not better, just wrong. Actually I'm almost sixty too and I'm very sorry for what I have done just as you are sorry for what you did. I'm sorry Jane that I did all of those scary, awful, outrageous performances all of these years. Shame on me, Jane, I'm also a traitor. Just like you!

To be read in a British critic's voice

Ms. Montano, how absurd, how utterly absurd. Your work is revolutionary, important and presents a critical art/life paradigm essential to the historical perspective of the postmodern dialectic. The paradoxes presented in your visionary hermeticism and comedic dramaturgy address not only a performatively brilliant stance but efficaciously interface minimalist conceptualism with Dionysian/autobiographical/tantric excess. As a woman of culture and learning, you deserve the applause and endless commendations that accompany your legendary name.

To be read in an alcoholic's voice

Maybe, but shame on you, Jane. I mean shame on me, sorry! I have always been very innocent and naive and idealistic. Really! I was just like you, but now I see students imitating the performance-art recipe for all of the wrong reasons . . . for the fame, for tabloid covers, for sit-com spots, for e-commerce sites, for Hugh Hefner spreads. And Jane, I do admit that we weren't angels, not at all. We all wanted those movie contracts, those retrospectives, those Broadway shows, but we are still very talented, creative, and good artists from the old school, even though we are in a bit of a muddle right now. It's just that our good intentions and radical work got twisted by time and now we should really feel shame and sorrow for having glutted the galleries and performance spaces with our creative outrages and eschewed visions. Right, Jane?

To be read in a British critic's voice

Poppycock! Ms. Montano, you are a champion of humanity, confidently and optimistically exuding messianic-like depth into your highly sophisticated, elegant, and refined iconography. Your philosophic thoughtfulness is culturally available to all and can be studied online or in scholarly journals, where those interested can obtain copies of your many-paged resumé. Foundations continue to grant you well-deserved awards and your colleagues all agree that the sacred and profane converge in your original ideations. They garner respect for you, for you are not only one of the prime movers in early performance art of the 1970s, but are internationally reverenced and renowned in the history of this innovatively challenging art.

To be read in an alcoholic's voice

Jane, you are sorry for Viet Nam, right? I'm sorry too for a lot of the things I've done. I'm sorry that I taught performance art because now it is being imitated by young whippersnappers who have taken it totally out of its sacred context. It is being commodified. Money has upstaged our pure spirit and honest approach to matter. These young

people joke around and this jocularity is being substituted for what was for us in the 1970s a highly concentrated rite of passage wherein we were able to cultivate trance, attentional depths, and minds bordering on enlightened. Performance art was different then, Jane. Right? Jane, do you understand why I feel so guilty, just like you do?

To be read in a British critic's voice

I will not hear of this. Montano, your teaching style is impeccable and your educational intentionality has inspired thousands. It has permitted them to pursue their art practice with a grace, refinement, and restraint which skillfully and coherently allows them to esthetically and financially travel the depths of their creative subconscious, only to return to freely and unabashedly express their visions to audiences who hunger for their innovative voices and visions. If we were to compare your skills, Montano, to those of the average person on the street, we might mention that you, Montano, have esthetic alertness and precision similar to that of a board-certified eye surgeon performing a cataract operation on a well-loved relative. You are that careful with your art and your life. Let the secret enrollers of the MacArthur Fellowship hear this. Reward this woman, please! Let Guggenheim do the same. Let's buy her extensive archive and produce her DVD! Let's give her anything she wants. We need her voice! We need this champion of culture, this living legend.

To be read in an alcoholic's voice

Let's get back to the truth. You know, Jane Fonda, we were the original performance artists, you and I. We were innocently doing our work without backbiting or competitiveness, without greed or the need for fame. These young people now, on TV, are becoming survivors instead of fine artists. It's all backwards, Jane, and we were never like that, right? We were more interested in conceptual practices, in sculpting form, shape, color, time, and our bodies with our ideas, right Jane? That's what we thought we were teaching when we taught performance art, right?

But I was wrong Jane because today I saw a child-girl in a very conservative upstate New York village, walking around as if dazed and half-drugged, half dressed, as if performing visibility/mask/body art/endurance/taboo all without an announcement of the show, all there for the public to witness. It's the stuff we did, Jane. It looked so familiar. Yet I was shocked when I realized that four years ago, I would have applauded her urban neurosis and need to be seen performatively. Today, Jane, I wanted her to go home to Mom, eat a bowl of homemade soup, and receive a nurturing/authentic hug.

To be read in a British critic's voice

Ridiculous, Montano, get a grip. You are, and always have been, highly principled and a morally outstanding exemplar of virtue. You've ennobled performance art with symbolistic/spiritual nourishment, with a severe and austere re-seeing of endurance. You've provided a cyborgian dismissal of outdated physicality, a virtual embracement of technological advances and a cross-cultural remapping of Lacanian discourse. This medicinal interiority, known only to this art form, is one practiced shamanically for centuries by the creative underground. Thank you, Ms. Montano. Don't feel shame, feel our thanks.

To be read in an alcoholic's voice

But Jane, I'm sorry, not bitter. Sorry, and sometimes I don't know why I'm sorry! Probably you're sorry that you made all of those sexy movies, right? Including *Barbarella*. I'm not being litigious or hostile or aggressive here, but performance art has become a pie-in-the-face, and is no longer a dignified chapter in the history of art. The parody, dangerous actions, and disregard for the sanctity of the genre, scares me Jane. Do you feel the same way? Directors imitated your style and made many other *Barbarella*-looking movies and you ended up mentoring young starlets to be indecent and immodest, just like you were. So, like you, Jane, I apologize and I'm stopping the game, right here and now. No more art for me just like you probably said, no more movies, no more activism for you, right Jane?

To be read in a British critic's voice

For those of us educated to your credentialed greatness and the vagaries of your career as heyoka, trickster, yogi, mystic, Blakeian genius, technician of consciousness, your argument, Montano, does not hold water. You must not leave. Don't give up! Your Mensa-like brilliance, excellent powers of esthetic discrimination , your superior reflections on Truth itself, have lifted the art community to heights unknown in the field. With reverence we honor you as a pioneer of higher consciousness. And with all due respect, I wish many years of contributions to this work of esthetic evolution.

To be read in an alcoholic's voice

Jane, I've included in this letter a twelve-step exercise that has helped me a lot. Hope you can use it too. The part about finding a Higher Power has been super.

Twelve Steps of Performance Artists Anonymous

(All steps to be read in a slurred voice or a whisper.)

1. We admitted that we are powerless over performance art and that our lives had become unmanageable.
2. We came to believe that an art greater than ours could restore us to sanity.
3. We made a decision to turn our will and loves over to the care of the Higher Artist, as we understood that artist.
4. We made a searching and fearless inventory of our past performances.
5. We admitted to the Higher Artist, ourselves, and another person the exact nature of our past performances.
6. We were ready to have the Higher Artist remove all of the defects of our art/life.
7. We humbly asked the Higher Artist to remove our shortcomings.
8. We made a list of audiences we had offended and critics we had outraged and became willing to make amends to them all.

9. We made amends and apologies, except when to do so would injure them or others.

10. We continued to take personal inventory and when we had foolish performance ideas/concepts, we promptly admitted it and didn't do that performance.

11. We sought through silence to improve our contact with the Higher Artist, as we understood this Artist, and asked to know this Artist's will. We also asked for the opportunity to do their Concept, not ours.

12. We tried to tell other performance artists about these principles and practiced them in every aspect of our art/life.

Sincerely,

A fan.

2000

❋

Deconstructing tenure: A purification chant

This was written while Montano was still at the University of Texas, Austin. Montano confesses what she thought others thought about her. NEGATIVITY AS ART = NEGATIVITY TRANSFORMED = ART.

First

Yankee, go home! Take your so-called performance art, your shocking scatology, your post-menopausal new-age self-hazing rituals, your reverse sexism, your curt dismissal of dialogue, your violent subconscious, your failing health, and go home!

Second

Yankee, go home! Take your supposed fame, your single-spaced thirty-five-page resumé, your clownish disregard for administrative authority, your feminist rage, your international reputation, your unruly classes, your bogus spirituality, your tragic death wish, your

working-class snobbery, your inability to communicate, your resistance to becoming a team player, your obsessive-compulsive need to confess and autobiographize everything, and go home!

Third

Yankee, go home! Take your bizarre comments, your dangerous classroom experiments, your miserable grading system, your need to be a guru, your threat of terrorism, your controversial subject matter, your permissive touchy-feely assignments, your habit of analyzing everyone's last name, your distorted art therapy, your bad breath, your reluctance to give formal critiques, and go home!

Fourth

Yankee, go home! Take your off-color comments, your immature social skills, your undeserved book contract, your bribed course evaluations, your litigious slandering, your infantile frozen needs, your unconscious sabotaging, your parsimoniousness, your inability to handle your stardom, your need to compromise the health and welfare of your students by allowing their dangerous projects, and go home!

Fifth

Yankee, go home! Take your victimized pity-partying attitudes, your gender confusion, your subversive exhibitionism, your pagan mythologizing, your pornographic perversions, your high-school-quality performances, your alcoholic stuttering, and go home!

Sixth

Yankee, go home! Take your departures from excellence, your poisonous vibes, your cronish babblings, your mean-spirited negative addictions, your inability to teach, your professional ignorance, your

masturbatory eccentricities, your thrift-shop wardrobe, your poor role modeling, your terrifying endurances, and go home!

Seventh

Yankee, go home! Our customer-driven, intelligent students are tired of your stand-up routines masquerading as teaching, and your detractors are hungry for your crummy salary. Damn Yankee, go home and stay home. GO OM, OM OMMMMMMMMMMMMMM.

1997

Dad Art

An explanation of *Dad Art*

In a paper presented in May 2001 at the Aronoff Center for the Arts in Cincinnati, Ohio, Montano defined *Dad Art*. The panel was moderated by Maria Troy, and included Sally Alatalo, Jacob Dyrenforth, and Kristin Rogers. A continuation of *14 Years of Living Art*, *Dad Art* involved making art from caring for her eighty-nine-year-old Father, who has since suffered a series of strokes. During the performance/paper, a video of her family was shown accompanied by a "soundtrack" of her father's taped music from the 1940s. The original panel, part of the Weston Art Gallery's Intermedia Series, was called *Caution: Live Art*.

What I would like to do tonight is explore my present practice titled *Blood Family Art*, a "situational" performance that I began June 1998. Why did it begin in 1998? Simply put, it was because I was asked to leave my job as an assistant professor of performance art after performing the role of teacher for seven years on tenure track at a very prestigious university where I found that I was unable to fit in, conform, speak academic jargon, and be a valuable team player.

Getting dismissed was an interesting blow to my deep need to be included, a need to be invited to the prom, a need to be one of the crowd, a need to be seen as a diva, a saint, a special asset to the professor community. Never having been fired before (although in typical academic fashion to be fired is called "denied tenure"), I had no experience with having identified so deeply with a position. And yet the divinely ordained karmic setback brought me back home to

my parents' kitchen table, to the library of my childhood. It brought me back to the church where I was baptized, confirmed, and received Holy Communion as a seven-year-old saint-in-training. How humiliating – or lucky! It's the stuff of Anne Rice novels, executive downsizing manuals, and Victorian widow poetry. To save face, I told all colleagues, friends, and therapists that I could find and pay that I was GLAD that I was "home again" and that my then eighty-six-year-old father NEEDED ME since mom died in 1988 and dad had turned in his around-the-neck alert call button because it annoyed him. He did have medical issues that warranted watching and here I was ready, willing, and over-able. But underneath the guise of being needed by Dad was a hidden agenda to be NEEDED by my family. So, true to my performance art profession and training in using everything for my work, I diverted attention from my despondency about my tenure-track position to dependency on my family's dependency. I called what I was doing ART! Giving my new life that title made me feel productive and not really retired, which I am and was then. To structure the terminology more professionally I created subsidiaries of *Blood Family Art* and created *Dad Art, Family Art, Friend Art, Caregiver Art* . . . the list goes on.

So the scenario is this: I'm home and surrounded by my roots. Dad is eighty-eight. I'm around him a lot. I call what I do for him (and me) *Dad Art.* That's how easily my art is born. I name it and it is mine. What follows is a definition of *Dad Art,* a secret, noncommodified, invisible practice that will never receive a MacArthur or a Guggenheim (grant).

Dad Art *practices*

1. Buying groceries for Dad a few times a week.
2. If the butter is on sale at Wise's and the milk at Grand Union, I am sent to the places that have the sales.
3. I pay water, gas, electric, and all other bills and manage Dad's checkbook.
4. I bring back items Dad has bought and doesn't want.
5. I answer the phone for Dad unless he is answering his girlfriend's calls.
6. I get prices for a new bathroom floor from Home Depot, Lowes,

and Carpet World and pursue this until I find the best deal on Congoleum D0571.

7. I drive Dad to Mass every morning unless the weather is nice and he can drive himself.
8. I buy the *NY Post* for Dad every day.
9. I write Dad's Christmas cards.
10. I take him to wakes and funerals for friends of his who have died.
11. I go to the bank for Dad.
12. I take Dad to Eucharistic Adoration on Sundays where I watch him disappear into light-filled energetic states of rapture.
13. I take Dad to his doctor appointments and the ER when he has intense vertigo events that seem more like heart attacks.
14. I negotiate with his doctor for referrals, information, drug changes, and spend inordinate amounts of time on the phone with Blue Cross/Blue Shield talking what seems like gibberish.
15. I insist that the new hearing aids that have caused us to make countless visits to the audiologist in the next village really do work better because the decibel level of my shouting has dropped a few pitches.
16. I check to see if he is really breathing since apnea has become more apparent. I make sure he doesn't fall, trip, or skin his shins since his Coumadin (a medicine that thins the blood and prevents stroke) includes the side effect of uncontrolled bleeding.

(UPDATE: Since December 27, 2001, Dad's stroke has changed *Dad Art* and now he needs a 24/7 caregiving program and around-the-clock caregivers, at home).

Dad and I are learning from each other. Slowly I have incorporated this practice of caring for him into my life with a very easy logistical switch of focus and have moved from being a public person and professor to hiding my talents in privacy. I have moved from singing and dancing on stage to speaking patiently to a hearing-impaired Dad. I have switched from being tied for a year with a rope during Tehching Hsieh's *Art/Life: One Year Performance* to being tied to the position of being Dad's advocate and caregiver. And in so doing, I have rewritten my own rules for endurance, meditation, and creativity. Art is so merciful and flexible, isn't it?

In some ways I feel lucky and better off. Who wants to be out

there in [Former Mayor Rudolf] Giuliani's policed art world and be censored yet again for speaking a truth nonconversant with the mainstream? The new performance-art intimacy is not the new reality TV shows, but it just might be the touch and feel of hidden daily life that we all experience when we connect to those around us every day. Art has become too hard anyway and a tough nut to crack because of its strict anti-inclusionist policies and politics.

Of course this is not all as ideal as I am making it sound! What is? But I am not talking here, in this paper, about the challenges of this art, or my failures to reach out to Dad and family when I am tired, my impatience with it all, my own unfinished inner business which re-surfaces so intensely since I am literally back at home, the place where I get to see what I have not dealt with and still carry around in all of its dinosaur clumsiness.

Yes it is human art, and it is as close to being about trial and error and brokenness as life itself. My old art that was once public and not hidden or underground as is *Dad Art*, prepared me for this performance./Sure it was hard living in a NYC store window blindfolded, sure it was intense being tied for a year with a rope to Tehching Hsieh, but all of those years and years of endurances and strangeness prepared me for NOW. It is homeopathic art that I practice, curing snakebites with snake venom, doing difficult art to prepare myself for difficult life. In using my art muscles for thirty-five years and strengthening myself by doing outrageous actions that made it into art history books, I'm ready. Bring on the life!/

Why just this morning, for example, in the verdant and mountainous Hudson Valley, I was lying in bed on a day when the northeast was covered by a 3-inch layer of sleet. Oh what pleasure, listening to the WDST radio station, dreaming my day awake, and then I remembered *Dad Art*! Remember Linda, this is your daily practice now. After his stroke I began living full time at his house, but when this event happened I was in my incredibly fabulous art studio/loft in Kingston. I made call after call to Dad. There was no answer. This is the fear of all of us with aging parents – the unanswered phone! Nine o'clock, fifteen minutes later, and then again and again. I called his girlfriend and she said that he hadn't called her as he usually does Sunday mornings. That began a racing heart–dry mouth response familiar to all of you responsible for the life of another. I left my cave-home. I drove twenty minutes north in sleet to find Dad in his chair,

hearing aid out. I improvised trying not to sound alarmed, trying not to sound worried, trying not to say what I had imagined. "Did you slip and fall, are you bleeding because of the Coumadin, and did you do this and that horrendous thing?" Concentrating hard on the positive, I could now block images of his having a stroke, falling down stairs, having a coronary, or cutting his hand. Remember Linda, this is art so you can use your mind to do wonderful things and think differently, not falling into AMA fear and trembling. Do this *Dad Art* differently Linda, because it's art. Perform the art of lightening up about life, right now!

So I kindly reminded Dad to leave his hearing aid in, because we needed to check on him. Then he asked, "Is this a good time for me to try the new tub?" Still breathless from the ice storm outside and trying to remember how to put the car in slippery road gear, I said "Sure, Dad." I was so elated to see him relaxed and happy and was more than enthusiastic to help him, having made a vow to Jesus, God, St. Joseph and the galaxy of saints on the drive to his house that from now on, from this day forward, I would appreciate Dad totally, every minute, every hour, every second in a new SAINT LINDA way. I would be patient and I would remember that DAD WAS ART and therefore very sacred. "Really Dad, I will be more compassionate if you are OK," I bargained to myself as I drove there.

Back to the new tub and some history. Dad has always done projects, and when his plumbing burst in the upstairs bathroom, he decided to put in a Jacuzzi bathtub. And he had planned how to get in and out of it for days, lying awake and reporting his newest engineering ideas on getting in and out of the tub to me on a daily basis. So that Sunday, he told me to get a big winter blanket (I did). He told me to put it on the floor of the tub so that it could cushion him (I did). He told me to put a plastic seat on top of the blanket so he could ease himself down (I did). Then he told me to tie a leather belt to one of the three handicap grab bars that the carpenter put on all sides of the tub so that he could pull himself up and steady himself when standing. Dad was making an interesting installation. Now I know why I did sculpture and actually got my MFA in it!

All preparations made, it was time. The new performance was upon us. He put on his bathing suit, then called me into the bathroom. The lowering of Dad began. I assisted, reversing time and roles. Receive, now give, soon receive, on and on.

Considerations

As we reach toward perfection – the perfection of body, perfection of medicines, perfection of spirit – and become highly competent cloned DNA facsimiles of ourselves, we occasionally happen on interesting and new opportunities to address the issues of the twenty-first century. Right now, mine is collaboration with my Dad. The NEA (National Endowment for the Acts) need not know.

I conclude with a recipe for practicing *Blood Family Art*.

1. Move in with your Blood Family for an extended period of time.
2. Make believe that they need you, disguising your own confusion.
3. When your friends ask you "What are you doing these days?" tell them, "I'm making *Blood Family Art*," or say, "I'm retired!" Be vague if you must.
4. Start a Dad or Mom art group at your church, town, or university center.
5. Weekly, ask your inner child if she/he is growing up or if she is able to take care of someone else or still needs 100 percent attention from everyone else. When she does graduate to compassionate human status, give the inner child a graduation party.
6. Begin a Family Art Internet chat group and open branches internationally.
7. When a healthy friendship is achieved with all members of your immediate family, begin another art.
8. Know that you are practicing *Blood Family Art*, even if it is only with yourself.
9. Your ideas and comments.

2001

❀

How My eighty-nine-year-old father became a performance artist

This piece is a continuation of Montano's collaboration with her father that began in 1998.

December 27, 2001, my dad had a stroke. The MRI revealed that it

*D
A
D

A
R
T*

was a major stroke on top of another older stroke along with chronic ischemias. I am his primary caretaker. I perform this honor of being his caretaker as both a daughter and as an artist. Here are some of my findings:

Time

- Performance artists sculpt with time, appropriating it by performing endurances which erase/celebrate its importance. (Tehching Hsieh's *One Year Living in a Cage*.)
- Dad sometimes lives in a biological/neuronal timelessness induced by medication/illness and needs prompting as to time's use and purpose.

Material

- Performance artists lavishly use materials appropriate to their concept. (Karen Finley's use of chocolate as an art tool.)
- Dad now uses water and paper creatively instead of pragmatically, and it is now a material to be played with and enjoyed.

Actions

- Performance artists act spontaneously/illegally/outrageously to reproduce their vision. (Chris Burden has a bullet shot into his arm.)
- Dad acts spontaneously and erratically sometimes because of his stroke, moving from crying to laughing within seconds.

Costuming

- Performance artists create accessories and clothing that are imitative of wearable sculpture. (Pat Oleszko's street costumes.)
- Dad, once impeccably groomed, now disregards the impact of his appearance on others.

Motivation

- Performance artists go anywhere and do anything so that their daily life issues can be transformed into tolerable ordinariness. (Stelarc's body hangings.)
- Dad, stripped of much logic, lives in a liminal state of surreal suspension.

Audience

- Performance art audiences are informed, cultivated, curried, found, invited, ignored, outraged, entertained, disgusted, disenchanted, wooed and become witnesses/co-healers of performance artist's actions. (Adrian Piper's *Library Series*.)
- Dad's audience of concerned family members, attending medical personnel, caretakers, onlookers fearful of their own aging/fate, all become reminders of his changed status and/or become extensions of his physical self, making it easier for him to live comfortably with assistance.

Demeanor

- Performance artists change their consciousness via trance-induced states, ecstatic rituals and repetitive actions. (Marina Abramovic's and Ulay's *Tratakam Meditations*.)
- Dad is medicated, but also close to life's greatest mystery, death. As a result his inner quiet, stillness, and intense presence, gift those around him with a contact high.

Language

- Performance artists create/communicate new languages, new sounds, and new ways of sonic communication. (Pauline Oliveros' *Sonic Meditations*.)
- Dad's verbal associations are often dreamlike, fun, non sequiters that invite collaboration and poetic word play.

Money

- Performance artists, especially those performing in the 1970s, disregarded financial issues and focused on the process of non-commodified esthetic explorations. (Terry Fox's hospital-inspired endurance performances.)
- Dad, once an astute and powerful businessman, has absolutely no access to society's money games anymore.

Continuity

- Performance artists sometimes create multiple personae conversant with cultural stereotypes or their own aspirations. (Linda M. Montano performing as a guru.)
- Dad asks often, "How should I prepare to meet God?"

Conclusion

Performance artists have a choice.
Dad has no choice.

2001

❀

Das (Servant)

Das is a dream that Montano had while in India.

1. Prem

I have always lived a life of 100 percent dependence having been born premature at the Kerala Christian Hospital, surviving tubes, incubators, respirators, eye-drop feedings, and months of medical interventions; coming home to a life of seizures, medications, total bed care, and, of course, caretakers. In India they are called servants and my current, main servant is Das whose name actually means

servant. We never feel uncomfortable with people around helping us and are always surrounded by family, friends, and, yes, servants who are easily incorporated into our lives. Privacy is never an issue, we talk freely unless the subject is intimate.

Servants do our cleaning, our laundry, raise our children, wash our dishes, and do thousands of other tasks, and because my father is a wealthy industrialist, we have two and sometimes three servants doing absolutely everything. In fact, whole families live with us; the father drives and maintains our six cars, sons serve us meals, do laundry, wash dishes and shop, mothers and daughters give massages, help with cooking, and do chores for my brothers and sisters. Of course, I have many servants throughout the day because of my sickness, but I must admit that Das is my favorite; we play checkers for hours and listen to movie-music tapes, singing along. I guess you could say that even though he is from the servant caste, we are really fast friends.

And I need friends because my life is difficult. I'm the second born; the first was a girl. They wanted me and hoped I was a boy, and then I was born sickly. What a disappointment. Although Mummie and Bapuji didn't show their pain, I know they feel sad when they see me. The first-born son has many duties. For example, what am I to do at Bapuji's cremation? I can't even hold a stick in case I have to break his skull if it hasn't burst in the fire. That way his soul can leave from the top of his head. That is our belief. But I'm not well enough or strong enough to do even that. Kamalakant will have to do it as the second son and possibly Krishna will assist him. Maybe I can sit in my wheelchair and help, but then again, the way karma works, I might go before Bapuji.

Sorry, I have to meet with my tutor who is coming into the court-yard. He is very old, very strict and makes me chant Sanskrit, telling me it will heal me either in body, mind, or spirit. That's wonderful and I hope my body gets better, so I listen to Vish, who is a Brahmin too. We Brahmins have a special bond. It's about things past, and ancient rituals, and a secret language of caste recognizable by the sacred thread tied to our chest. A glance and last name tells us who's who. India runs on the system of categories and separation of duties and hierarchies. We are happy with it. We tolerate each other and we need each other to survive. Here comes Vish now, see you later.

II. Mummie

I love Prem probably the best, because he is so emotional. All of my other children are self-sufficient and strong and confident and outspoken. Prem is different. His soulful eyes and sweetness endear him to me. I go into deep meditative states when I'm with him, and experience the same ecstasy I feel in early-morning pujas before the statues of Ram and Sita. I don't have to scold him or correct him or steer him in the right direction because he's already there. My dear, sweet Prem. How I love our afternoons together, watching the peacocks on the lawn, both of us silent, holding hands, happy to be. Ghandhiji says, "Silence is a great help to a seeker after Truth," and I experience that with Prem. Deep, inner silence. What a rest that is. My other children have dreams and ambitions that keep them busy and connected to the world of me, mine, and I. The girls always need a new, expensive sari for this or that event or money for a weekend in Bombay, and the boys want the latest computer or scooter. It's endless. With Prem there are no worldly demands. He is my saint, my darling, and my best friend. Thank God I have enough servants who can do all of my work and that leaves me time with Prem. Of course, running this compound isn't easy and I coordinate everything including the cars (we have six), the gardens (two front side, two back side), the servants (we have fifteen), the food (I plan all meals and cook for special guests and all saints that visit), the money (I pay all of the bills), and the buildings (there are fourteen including the family temple).

Oh Prem, how lucky you are, not worrying about anything, enjoying your time and playing checkers with Das. Your busy brothers and sisters are karmically linked to the world of money and changes/impermanence. You on the other hand sit on your bed like a monk, free of it all – fed, bathed, dressed, and beatific. Prem, you are my monk, my sunyasin, my muni, and you don't even wear orange clothes!

Our family guru, Shantiananda, who lives at our temple, feels the same way about you. In fact, she comes here, dear Prem, to have darshan with YOU! Usually we go to our guru for blessings but it's the opposite in your case, Prem. She said the other day, "Bhakti, your other children will always be questioning if they are happy or

unhappy. Dear Prem IS happiness. Ram has blessed your family with a saint."

Prem, my saint, I'm so sorry, I have to go now to give the menu to the servants for our supper. Bapuji is back from Japan, so tonight we celebrate with ras gula.

III. Bapuji

As head of this large family which includes my gorgeous wife, Bhakti, my children, servants, a huge and demanding compound including buildings, gardens, cars, and even peacocks which need feeding, I'm often overwhelmed. Trips to Japan are my escape, my meditation, my nurturing. Although I was raised a strict Brahmin with a guru as tutor at the ashram which my father financially supported, I have not been able to find solace in meditation, japa, fasting, devotions, or the rituals which are the foundation of our belief. I leave all of that to my dear and darling wife, Bhakti, and also to Prem who is quite peaceful and touches my soul.

It's not that I've become western, although I do study professional magazines from Germany, but I guess you can say that I'm more Asian because my trips to Japan have opened my eyes to another methodology and way of being in the world. Emotionally I am cool, scientific, and resonate with the evenness of Buddhism. Cool-headedness is essential to my career because negotiating multi-million dollar contracts, faxing, emailing, meeting with Japanese and American industrialists, and video conferencing day after day, can be strenuous unless I practice strict mental focus.

After working all day at the office, business continues at bath-houses, teahouses, at geisha parties and at 2 A.M. I retire to my small tatami-floor hotel room and sleep, to begin again next day. Being sociable is part of the game here. I've learned how to play quite well. Believe it or not, I even sing karaoke. My specialty is Country & Western cowboy songs! Speaking of cheating; there are numerous opportunities to do so. Culturally it is encouraged and acceptable for men to do this expected behavior, that is very foreign to Hindu culture and me. Here it is not seen as aberrant or sinful or unfair or unwise, but this is changing in the past ten years since feminist theory has reached this island. Now the wives do not tolerate infidelity as in

the past. I'm glad because it is impossible to be integrated or effective when one is divided or guilty.

Although the delicacy of Asian women and their passionate politeness is attractive to me, I am absolutely loyal to my wife who delights me even after thirty-three years of marriage. You see when one partner in a union meditates and prays, there is something so deeply spiritual and transcendent that happens when they are intimate. No dalliance could match the ecstasy of my life with Bhakti.

Tantra and all of the Kama Sutra teachings are genetically natural to all Hindus, I think, although I'm not sure if other men experience this same level of transcendence with their wives because I never discuss my personal life with them. All I know is that I will never disturb my marital commitment in any way. Having a clear conscience and high morals gives me the energy to be a multitasking family man and enjoyer of good health and strong life force. Now that I think about it, I guess you could say that I'm lucky and maybe even heroic!

The plane's boarding in a few minutes. Soon I'll be home again to my wife, family, and a feast. Three weeks of deep breathing and jasmine nights will help me feel again.

IV. *Shantiananda*

At an early age, I knew that I wanted to live a sacred life, probably because of an auspicious birth on Ram's jayanti which pleased my devoted parents very much. Tragedy struck our family and this distress formed me, the same way local jewelers hit silver over and over, shaping it into bangles. As you know, India is devastatingly beautiful and spiritually extraordinary, but it is also a powerfully dangerous land. Monsoons, landslides, earthquakes, disease, typhoid, snakebites, and all problems associated with the Third World keep us company. We are used to it. But when my mummie died before my eyes, this was too much for a twelve year old and I changed forever. I went from a playful child-woman to a recluse. Mummie had just finished cooking kicheree, I was washing our talees, when she fell over, barely missing the open fire. After the cremation, Bapuji tried keeping all four of us together but couldn't, so we were sent to different relatives all over India. I went to our Massie in Calcutta and that's where my spiritual life began.

Massie was a social worker and on her compound she had donated a large parcel of land to her guru who used one of the buildings for an ashram. I lived there, learning asanas, chanting, sutras, and advanced meditation. Samadhi was a daily joy. All of that came easily to me because my heart, having been broken by those early happenings, was eager to be filled with divine knowledge, a sense of community and inner peace. The call to the inner life was so deep that by the time I was sixteen, it was obvious that I was my teacher's favorite. I sat to her left, was given food from her hand, did all of her secretarial work, greeted her students, and spent all of my time in her presence. That was where she groomed me, so to speak, for the transmission of her shakti into my soul. Powers of clairvoyance allowed her to work on all of the unfinished business and rough edges of my subconscious. That work was painless for me and I hope my karma did not pain her!

She would enter my soul, root out obscurations and I would feel a palpable relief and not know why. All of this was done in Silence which is her path and her way and her sadhdana. It was the simplicity of nothingness. We sat for hours in an atmosphere of almost visible love, perfumed with the sweetness of nonanxiety, vibrating with the neurobiological qualities associated with divine rapture.

One hot evening, we were sitting in her small meditation room. Incense and tropical temperatures intermingled intoxicatingly, allowing us to release into the joy of nondoing. Divinity was palpable. I know that it is hard to define the experience but you must trust me and try to feel this fainting into love for yourself. After midnight, she motioned to me, whispering with a graveled and hoarse voice, the voice of not having spoken for days, the voice of deep samadhi.

But this was different. This was the voice of fragility and when I heard it, the second most earth-shattering attack to my heart happened as my guru lay down in a fetal position and barely mumbled, "Go home to your father now. Go." And even though my Guruji was still young I knew that she was preparing to leave her body-temple and that when I left that room, I would not see her again.

She brought her hand to my forehead. It was shaking. In a simple gesture, she imparted her lineage to me. Basically I was to become

HER, become IT, carry on, and I could literally feel spiritual energy enter my being, and with it I had the transmission of her teachings, her teacher's teachings and her teacher's teacher's teachings . . . all the way back to Padmavati, Kali, and LIGHT ITSELF.

That happened twenty years ago and I cannot tell you how I then went to my village, took care of my own Bapuji for years until he died and from that caretaking seva, I was given the grace and merit to use this inner light and my teacher's blessings in a profoundly powerful and new way. Even though I am now a guru and teacher for many and carry on my Guru's Truth, these memories of physical loss cause tears to silence my pen, washing away words from the page. Gurus cry also.

V. Bharati

I guess that you could call me the family rebel. I'm the first daughter, born into this rich and powerful family that extends geographically and socially back in time. On Divali, (Festival of Lights), engagement parties, and all major celebrations, 300–400 of us attend parties that take months to plan, go on for days, and keep us connected to one another. We Hindus exchange gifts lavishly, we network with each other, help solve life and family problems, and sometimes, after a large event, we continue our visit by traveling in a rented bus to one of our religious shrines or to a summer resort . . . fifty of us might go all together. Family is wealth in India and everything is shared freely and lovingly among us. No distinctions, no favoritism.

Sure, I am part of all of this, but somebody has to think about and take care of other issues. Somebody has to worry about politics, the government, and India's future as a functioning contributor to this planet's well-being. Somebody has to worry about ecological sustainability and social justice. Somebody has to think about non-exclusion. Somebody has to take on the role of activist, for things must change.

Philosophic and political causes have always been my interest. As a child I was immersed in everything Gandhian. When thirteen, Bapuji took three of us to Gandhi's ashram. I felt at home there, more so than in the luxury of my family's palace. There I observed satygara – a peaceful, nonviolent, noncooperation with unjust laws. That's

one translation. Gandhiji's ashram vibrated with this teaching. Non-violence, ahimsa became satygara when Gandhi worked with ahimsa practically and on a political and national scale. Isn't that brilliant? It is the ability to say no without fighting back, to say no and be willing to die for TRUTH, to say no and to mobilize a country to nonviolent protest and freedom.

At the ashram his spirit is palpable, and I saw his small quarters, his spinning wheel. I met elders who not only knew him, but also served as his "stick," walking with him and holding him up as he recovered from fasting and protests.

At twenty, I met my second guru, when I attended a lecture by philosopher, feminist, and physicist, Shri Vandana Shiva of Delhi. This powerful woman changed my world, although I was not formally her student but a reader of all of her books and a frequenter of her lectures. Eventually I learned to think like her, incorporating her beautiful and concerned mind into mine. I began worrying about the same things she addressed as problems, and began in earnest my life as a nonviolent protestor with a small group of activists in Delhi.

Daily we not only lived together but struggled with issues that were hers but became ours. Some are:

1. Drinking water/shared tank systems/availability.
2. Value of human life in Third World countries.
3. Protection of natural resources vs. big business monopolies.
4. Shared rights vs. privatization.
5. US pirating our inventions/stealing intellectual property, hijacking it for their corporate gains.
6. Deforestation, clear cutting, reckless logging.
7. How the commons can be maintained.

All of these are Vandana Shiva's causes, and now I am passionately angered by the injustice that greed births. Admittedly I could pray, meditate, do Hatha Yoga and wipe my mind clean and clear of all of my upsets, but I feel a calling to ecological and social justice. My prayers are not mantras but righteous cries of outrage.

Justice is my life partner. Justice is my child. Justice is my food. Wealth is shared peace, and I will die to uphold this treasured jewel. Thank you Vandana Shiva and Gandhi for telling me the truth.

I promise I will not stop this work until our colonized, eroded, and polluted India is gorgeous and shining again.

WATCH! My fist is raised and it does not strike, but holds tight in my palm the hope of SHANTI, SHANTI, SHANTI.

VI. Sita

If there is a black sheep in this proud family, it is I, Sita, the gorgeous third daughter spoiled by all. I'm the maverick, the problem child, and the difficult one. Of course, Prem gets a lot of attention but that's because he's so sick. Maybe I'm jealous because he has extra servants, Das's twenty-four-hour service, the best food, saffron milk daily, and instant coffee for breakfast instead of the chai that we all are expected to drink. He's physically sick. I'm internally troubled and outrageous . . . at least that's what my seventh standard report stated. "Sita's soul is in the jungle. She is too like the jungle!" Just look into my frightened eyes, you will see for yourself. But no, you can't know because I will distract you with my colorful silk saris, perfect skin, pearl white teeth, and an elaborately complicated vocabulary that masks a quivering self-image. Or maybe the expensive tikas covering my third eye will keep you away? Ornaments and perfect grooming camouflage pain.

Don't think that I was always this way. I had a choice. As a child, our family guru, Shantiananda, tried taming me with breathing techniques and pujas to Ram, Ghanesh, and all of our deities. These rituals held me captive and absorbed my intensity until the age of fifteen when I left the path for reasons unmentionable, to walk life's razor edge. I won't bore you and tell you why I'm so tortured.

- Is it because I have a psychological imbalance and a bipolar medical condition?
- Is it because my planets are malefic?
- Is it because I had a taboo affair with a married Muslim?
- Is it because of my eating disorder?
- Is it because I alone know all of my family's sins and hypocrisies?
- Is it because of childhood trauma and severe punishment by care-taking servants?

- Is it because of past life karma?
- Too many sweets?

As I mentioned before, I am teasing you with possibilities. Maybe all the things I listed are causes of my inner battle with life. Maybe not. Sorry to play games, but I have hidden my story well. In fact, nobody will know the following:

- Why I live a life of opposition to Hindu family traditions and Brahmin values.
- Why I am haunted.
- Why I mistrust.
- Why I harbor a sadness that is untouched by beauty or newborns.

Nobody will know how to fit the pieces of my life-puzzle together so they can:

- Heal me.
- Hold me still.
- Console me.
- Massage essential oils into my shame.
- Invite my talents to shine.

Remember, I am Sita, and in exile. The fourteen years in the forest waiting for the love of Rama has extended into a lifetime. Don't talk to my parents. That will not help. Don't ask too many questions. My heart is on fire and has already burst.

VII. Krishna

As the third-eldest son, I've been groomed to share prominence and leadership with Kamalakant, second-born son. Prem would have had this honor but he can't perform in this way, so KK and I do all of the right things, but I think that I do more than he does.

- I go to engineering school in America full time.
- I date only Hindu girls.

- I go home every December for family reunions.
- I live a life that is conversant with the best of both east and west culture.
- I put away savings so that I can bring my family to America some day.

All of this takes courage. It takes courage to leave a safe home life in India to go to America to study. It takes courage to live without servants and do my own cooking, laundry, cleaning, and shopping. It takes courage to eat bland western food devoid of our delicious spices. It takes courage to travel thousands of miles in airplanes that might harbor terrorists or exploding shoes, so that I can get a good education in America.

But, no problem, I have tons of courage. I'm a pro-soccer player, karate black belt and my IQ is 185. And even though I'm the most western in my family, KK and I still have the prime duty of providing for my sisters, brothers and elderly parents later on. That is called seva, and it is richly rewarded with merit and spiritual goodies.

America did not change that pattern in me, although I do drink coffee now instead of tea. That's western. But otherwise, I'm strictly Brahmin. Strictly devoted to Mother India and willing to help my family, sacrificing for them in any way that I can. This is a gift that we Hindus have and we hope that westerners learn it from us. It is so precious, so important. For example, right now, Bapuji's father is dying in the other room. Our hospitals send elders home to die, and we don't have nursing homes. We feed, bathe, visit, and make sure our sick are spiritually nourished as well. The sunyasin visits every other day and gives lectures and comfort to grandpa.

We are so close, so close, grandpa and I. I sit with him for hours, hold his hand, sing to him, feel his life force come and go, listen to his babbling in Sanskrit, observe his hallucinations of dead relatives in the room, and help him prepare for his next incarnation by keeping him focused on the divine. Four months ago, after his stroke, he was walking, talking, trying to be as independent as he was before. But he knew deep down that he couldn't cook for himself, balance his checkbook, or even enjoy the nightly news. Watching him detach from the world has been a teaching for us all and we help him when he gets too frustrated by the process . . . singing bhajans to him,

massaging him with almond oil, bringing neighborhood children to visit, filling the room with flowers, feeding him mango juice fresh from the trees outside his window, and resting silently in the room with him. Sometimes, I lay on a mat next to his so I can be peaceful and give him that gift.

But it is not all cozy. Yama, the god of death, visits some days and the thick dark hair on my arms raises with fright. I ask him to leave, give me more time with grandpa, who now eats only a little rice gruel. As he goes slowly, my heart feels ripped from my chest, my throat tightens and squeezes my already infected tonsils, my body shakes. I have lost 15 pounds. My hair is thinning. I am taking this very hard even though Vedanta teaches we are not the body or mind. Grandpa is the core and strength of this family, and he is leaving us orphaned. Hold me tight or I will lay my face in grandpa's shawl and if Yama isn't careful he might take me by mistake. Be careful Yama, here I am. Come on Yama, come on. Yama, come.

VIII. Das

The life of a servant in India can be quite wonderful or a tragedy. It depends on the family, and it also depends on the servant. Good family equals good life. Bad family, bad life. I'm good and this family is great, which translates as tolerant and generous and inclusive. These are the best Hindu traits. Germans are good at details, we are good nurturers. To feed all, love all, and include all is our manifesto. Yes, you Christians say, "love one another as Christ has loved you." That's why you love. We love because next life I might be the king and you might be the servant, and if you treated me well then I would karmically have to treat you very well too. So our actions, yours and mine are the same, motives differ.

I love working for Bharat and Bhakti. They are extremely wealthy, their home is a palace compared to my village one-room house that I share with my wife, her parents, and our three children.

I have privacy here, delicious food, luxurious living, and my own 3-inch TV. My main work is making sure that Prem is comfortable, changed, fed, and has my company. After evening meal, I have two hours for myself, take a round, talk with friends, and then go back to

sleep in Prem's room on a mat near his bed.

I guess you would say that we are brothers, roommates, and best friends. Six years together, day and night, with only a few weeks off each year, has made me feel like a member of Prem's family. My wife understands; we need the little money that I make.

Today we will eat masala dosa for lunch. I can't wait. I feel hungry although I will feed him first. Then I will eat in the kitchen with the other servants. We laugh a lot. I hope they saved me a few ras gula. Basically, life is good, delicious, and I have rupees to send home. Prem is calling. I have to go.

Footnotes: An update seven years later.

PREM: Prem attended a Kumbha Mela on a stretcher and experienced a miraculous healing from a naked sadhu. He now attends college and is studying computer programming.

MUMMIE: Mummie ran for the office of assistant to the district administrator and won. She attends weekly meetings in Delhi, flying home weekends.

BAPUJI: Bapuji retired at sixty and is living four months of every year in Japan, where he is practicing horticulture.

SHANTIANANDA: Shantiananda took a vow of silence for fourteen years, lives with her chela in Rishikesh and gives silent darshans once a month, writing on a slate board.

BHARATI: Bharati is an ecology professor at Benares Hindu University, married, and has six children.

SITA: Sita was found dead at home of natural causes.

KRISHNA: Krishna changed his major to become a licensed practical nurse and opened a hospice in Sri Lanka, based on the western model of nurturing terminal care.

DAS: Das was caught stealing a sizable sum of rupees from Bapuji's office, and is currently incarcerated for life in Masore.

2002

❁

How caregiving my eighty-nine-year-old father continues to teach me the art of attention

1. How can you NOT pay attention when your Dad might fall if two people aren't holding him, one on each side?
2. How can you NOT pay attention when everything he eats is bought, cooked, and fed to him by you, and when his health depends on your choice of food, timing of meals, and patience while feeding him?
3. How can you NOT pay attention when every medication (twelve different ones a day) is ordered by you, picked up by you, and dispensed to him by you?
4. How can you NOT pay attention when all fifteen caregivers have 45874676 different needs, personal issues, stories, salary idiosyncrasies, and home emergencies that sometimes make it impossible for them to make it to work on time, or even show up for their shift?
5. How can you NOT pay attention when a ringing phone, slamming door, or loud conversation disturbs Dad's fitful attempts to relax, sleep, or calm down?
6. How can you NOT pay attention when Dad begs to go home and is at home?
7. How can you NOT pay attention when your dad is teaching you how to die?

2002

❁

Elders' prayer

Listen to us!
Don't fear us!
Laugh with, not at us!
Drive us places!
Don't patronize us!
Expect much of us!

Walk slowly with us!
Feed us!
Pray with us!
Pray!
Pray!
Pray!
Someday YOU will be US!!

2003

Death

Mitchell's Death

This is the text taken from the third and final performance trilogy that Montano did in response to the accidental death of her former husband and close friend Mitchell Payne. In 1980, Montano made a video of this piece. "Mitchell's Death" by Moira Roth was first published in *New Performance*. 1, 3 (1978): 35–40; reprinted in Moira Roth, "Matters of Life and Death: Linda Montano Interviewed by Moira Roth." *High Performance* 1, 4 (1978): 2–7 and Montano's *Art in Everyday Life*.

Friday A.M., August 19, I wake at 7 or so. Look at the clock. I wish that chicken would stop crowing. Preacher Man running around the yard, echoing himself into the adjacent meadow. Pauline goes out to find him, comes back. I tell her my dream. A new one. Instead of being bothered by the baby, I throw sand at it when it throws sand at me. Pauline says something about her dream . . . a dead fetus and bloody clothes. She then goes outside and tries to catch the chicken.

At 10:30, I ask Pauline's advice about selling a tape recorder, which belonged to Mitchell and me. Things from my past. Then the phone rings. It's 11 A.M. It's J from Kansas.

Hello Linda, this is J from Kansas. I have some very shocking news for you. Mitchell is dead. From a gun accident. I scream, start to faint, call Pauline. Pauline, Mitchell is dead! I then ask J, why did he have the gun? Who was he going hunting with? Becoming very accusative and angry. Blaming. J said we were going skeet-shooting. I said

when? Wanting to place blame. Covering over my sorrow with blame and anger. I thank J. He says if you need anything let me know. We hang up. Not much information about anything. Pauline is holding me. I collapse in her arms. Jillene is there and looks on. Pauline carries me to the bed. I am shaking. Eyes open. Won't close. Shock. Covers me with a fake velvet red cover with tassels. Pauline's visitors are at the door. She leaves. Is open and effusive with them. Then tells them about Mitchell. Comes back into the bedroom pulled between two emotions, joy at seeing her friends and sorrow. Sweat is pouring from her face, which is filled with disbelief and pain. She looks down at me and I say what shall I do? She says I feel like calling my mother. Then I begin a series of phone calls which don't end. Which go on and on and on. I call everyone. First Mildred. Not home. Then Henry. The phone rings for about five minutes in the shoe store which means that they're busy. Dad, I have some bad news. Mitchell is dead. He died from a gun accident. Henry in his inimitable Zen style said, he should know better than to fool around with guns. He doesn't know anything about them. Whatever he said released a whole big lump . . . it presented the other side. Laughter. Honesty. No emotion in his voice. Another perspective. I call K. Don't want to hang up. We talk and talk and talk. Won't hang up. She cries. We repeat it over and over so we can both believe it. Then B in Alaska. S; I think of everyone. M is in Greece. T is in the Children's Hospital. M calls back. Again talking about it. Repeating. Wanting her here. Somehow the words make it real and not real. Make it credible. Mitchell's image in my mind. Pictures begin. I try to picture where he was shot. Was it the face, heart? Did he suffer? Died instantly? Did his face get blown off? Images. I see the room where it happened. See clearly. Talking. Pauline brings in some tuna salad and brown bread. Can't eat, then eat. So hungry, yet not hungry at all. Feels paradoxical. Eating and mourning. Tears and tuna fish. Pauline's friends visit. We all drink champagne. His brother committed suicide in a closet in Canada. Did Mitchell? Guilt. Did I do it? My fault? Was he despondent? Lonely? Miss me too much? I remember my feelings when he moved to Kansas City. I was very apprehensive. Pre-knowledge? I felt his trip across country. Saw him in Kansas City. Living in his grandmother's house. Nobody living there now. Dark. Going from San Francisco to that lifestyle. But his insistence on the move, on that pilgrimage lasted three or more years. He had to move back. Why? Then our

last phone call two week before. I called, needed to talk. My life had large questions in it. I wanted his help. Mitchell, all I want to do is meditate. Meditate, he said, you know how you like to do that. No, Rose, your life seems right now, don't worry, you're not being selfish. Don't worry, Rose.

Last words. He tells me about his new house. One hundred years old. Asked the people living there if they wanted to sell. Mitchell so impetuous. What he wanted he somehow managed to get. Energy to make things happen. Always that way. Then he would be upset because he had too many wants, too many needs. His friend L, seventy-six years old. A Bromoil photographer. I am relieved. He's found someone to work with. There was always a very old person in Mitchell's life . . . his grandmother, Mr. Delpapa. Mitchell's charm and grace attracted almost everyone. Then his trip to the Art Institute that day. He hesitates to tell me about changing his clothes there at the office, and then coming back to work, changing his clothes, going to work. Is it because I made him shop at thrift stores and now he's buying expensive suits and shirts? Mitchell, we're friends, tell me. We don't live in the same house but there is love. You can tell me about your new lifestyle. Rose, there's an old woman here in Kansas who writes Country & Western music and she's ninety or so and I'm going to see her. She has a small toy piano, and she gets up in the night because it's real quiet then, and she writes songs. I ask are you going to record her? I don't know what he answered. He's eager to go to lunch and the Art Institute. I have your Christmas present here from last year. I'll send it. Good and put some food in it. Bye, Mitch. Bye, Rose. I love you. We hang up.

Images. His face then. Does he have a face now? Is it blown off? Is he dead? I should go to Kansas immediately. I call Kansas. L answers. Informative. Mitch was getting a serial number from one of F's guns. He was in the kitchen. J came over to put some crabmeat in their icebox. Then Mitch invited J for breakfast. I wonder was he really lonely needing some friends around? J said no he had to go and be with his new baby. (That brought up the thought, Mitch really wanted children and I didn't.) J put together a shotgun and they were to go skeet-shooting on Saturday. Then he warned Mitchell, don't put any bullets in it, or be careful or something like that, it's an old gun.

And then one half-hour later, Alice, the maid, who was Mitchell's friend and nourisher, warm, generous Alice, found Mitchell with a

towel around his waist, lying between the kitchen and dining room, dead. She screamed, ran out across the street. They were supposed to have lunch that day. He drove her to the bus stop the night before, and then went to Safeway. Probably his last act before going home. The doctor from across the street came over. Then two ambulances, police, detectives, people to clean up.

L, I want to come to Kansas but I have this feeling that I have to be invited first. Mitchell's parents are in Chicago on their way home. But call later if you want to speak with them. Intuition. Am I really wanted there? But I have to go there. I must see him. I have to go.

Pauline in and out. Comforting and caring. Feeling everything with me. Vitamins every few hours. Then food, sleep, vitamins, foot massage. Pauline, lighting candles. I lie in bed with phone books, phone numbers, memories. His recent throat infection, sick for two weeks. Thought that he had his father's throat cancer and would die. Called me that day and talked with Pauline. Then cut his mound of Venus on his hand. Stitches, distressed. Was he depressed? He died by the phone. Was that a metaphor for wanting to call somebody? But L said that he had made popcorn that morning. He always made it when he was happy.

Family question. Clues. Little sleep. Up at 5 A.M. Phone Dr. Mishra, Ellen Swartz, Giotto. Giotto calls back. You've had a hard year, haven't you? I cry more for myself than for Mitchell. Don't feel guilty Linda. That's like telling a fish not to swim. But Pauline, Giotto, and friends say, don't feel guilty. Guilt is one of the first emotions to come with death . . . then anger, shock, disbelief . . . not in that order. Finally acceptance. But being the ex-wife, and Mitchell's death possibly being suicide . . . accentuated and accelerated the natural grief.

Pauline continued to counsel and prepare me. Reading from books, talking about her grandmother's death experience. That first night Moira came over and we all drank. Do whatever you want . . . shout, scream, cry. Moira giving permission and advice. Go to the funeral. Yes, you must complete that cycle. You must do that ritual.

Saturday, I call Kansas. Are M and N there? I still want to talk with them. To be invited. They aren't there. Mitchell's brother is. Do you think that Mitch was depressed, he asks. I tell him about our phone call and about his optimism and new house. He wonders. You know,

Mitch once hurt himself with a firecracker. Both of us trying to explain away any possibility of suicide. He was careless in some ways and always wanted me to examine something on his body. He tells me that he saw his body in the morgue today. "It was my brother." N, the neurosurgeon, knows.

I am sick from drinking, from shock. Sleep in Paul's room with the phone. Pauline ministering and talking.

Sunday A.M. I fly to Kansas. August 21. Where is Mitchell's body? I hadn't asked anyone. M and B call on Saturday and say I can stay with them. Feel welcome. We want you Linda, come ahead.

Pauline drives Jillene and me to the airport at 6:30 A.M. and then waits in line with me. I am sinking fast. She had packed a food package for me, high-protein bars, fruit. She steers me to the plane. My body shakes. I'm weak. She seems to get stronger than she already is. Is it the adrenalin that comes at the time of crisis? The plane ride to Dallas seems interminable, long, without end. Dallas. I call Sue Thornley. Good call. Supportive. Come and see me and spend time in San Francisco. I feel bolstered. Hang up. Eat two bananas. Get on the plane. Sit next to a man who looks exactly like Mitchell. I also see him all over the Dallas airport, Sue. What's happening to me? I saw you all over San Francisco when you left, Rose. OK. It's just loss I guess. I sneak looks at the man next to me. Can he see me looking at him? I'm spying. Mitchell's neck, hair, eyes, face. But older. I talk with him. Want him to be Mitchell. Read Elizabeth Kübler-Ross. It's not the quantity of life but the quality that we're interested in. That helps. The quality of Mitchell's life was incredible. He loved light. Pups, look at the light on this face. Lying in bed for hours surrounded with photo books. Looking at light, people in light, rooms in light. My eyes are open very wide and have been ever since Friday at 11 when I heard the news.

I arrive in Kansas. L meets me. We drive to M and B's. I talk and am hoarse. Can't talk loudly. We go to M and N's for supper. Then walk into the house that I was sure that I would never enter again. He died there at home. He died there. I walk in shaking, no life left in me. I walk past the phone. Stand on the spot where he died. I'm glued and can't move. People pour out of rooms, doors. It looks like a party but we all have the same thought, Mitchell is dead. We're from different classes, races, backgrounds, countries but unified in death. I hug Mitchell's mom who walks woodenly around the

kitchen, using the phone, greeting me on the spot where he died. I walk into the front room. N and I hug. P and I cry. Warmth coming out of him. N seems tired. Everyone there. I go upstairs. Where's grandmother Alice? She's on her way down. No words. We're gripping each other's hands. I have no words. The vulnerability of grief is already a language. It was an honor knowing you, Linda. I'm surprised at her words. You have contributed to my life.

Dinner, a party atmosphere. M talks about donating Mitchell's eyes so now two people can see out of them. I'm surprised at her bravery. His corneas. His kidneys were not able to be used, but they tried giving them away also. No talk of where he is . . . the funeral. He should be here. I pace between rooms and stand on the spot where he died.

Monday I wake up wanting to see Mitchell's body. Wanting to see Mitchell. Where is he? Nobody mentions him. He is missed. It's as if he's there but he isn't. Or is he? I want to see him. Am desperate. Must see him. I must tell B. She calls the funeral home immediately and we make plans to go. I start pacing. Restless. Not able to believe it. Wanting it, not wanting it. The drive interminable. We arrive. I run in and ask where he is. A somber, sad man says, you've just missed the body. The casket is closed anyway by request of the family. The body is at the crematorium. We go away. I can hardly walk yet adrenalin is high. Paradox.

Drive back again, I must see him. Call the crematorium. Go over. I expect to see smoke stacks but it's just like another funeral home. Large. I run in. Wait one half-hour. I am breathing with difficulty. Internal combustion. Insides searing. Eyes wide open. Like a drug experience . . . seeing, hearing all . . . At high intensity. Highly motivated. A man of about thirty, midwestern coloring and hair comes into the room. Signals. I charge out of the room. Energy propelling me. I hear him say that he is lying on a table, sheets over him. Warning. I run in. The room is 20 × 40 feet. Mitchell's body is lying on a hospital table which is chrome, silver, antiseptic, institutional. Not in a slick coffin. Not in a suit. But is lying on a table with a sheet. He is so available. Not dressed. I can get close. I can't believe what I'm seeing. His face bloated a bit, certainly distorted. A hole the size of a silver dollar on his right cheek. His face intact but so changed. A pink putty fills the hole. Little pieces of it in his hair. His eyebrows ruffled. Not neat. Everything impassive. Not mobile. Like sleep but too still

for sleep. Are you asleep, Mitchell? I touch his arm. Feel it cold and hard through the sheet. Must touch him. Eyes not there but donated so two people have his corneas. Somehow I'd like to meet them. Lips tight, nose funny. Left ear destroyed. The bullet still in his head? I pull the sheet down. Shocked by black stitches. Autopsy. Reminded of his hospital pictures in Rochester. Preparation for his death. Remember days when he would come home from the hospital pale and silent . . . talking about corpses and Sears clippers used to cut ribs. I remember the description and see it mirrored in his body. I talk with him in whispers, wanting more time with him alone. Ask him how he is. How did it happen, Pups? Why? What happened? Shock, disbelief. Wanting to stay with him. Hold him. No repulsion, no fear. His nipples erect. Feet cold and nonresponsive, even when I massage them. Blood stains on his toes. I arrange his hair. It's clean but needs fluffing. Then remember the *Tibetan Book of the Dead*, and whisper in his ear. Don't be afraid Mitchell. It's okay. Go on. Don't be scared. Surrender. Whatever fears you are experiencing are only illusions. Go on. Don't fear. Don't worry. No more worry. I whisper and tears fall on the sheet. I blow my nose on it, not caring about the smell, the decay setting in. A strange smell . . . not his. Hard to identify. Wanting to lift the whole sheet . . . I can't get my eyes off of him . . . a blend of curiosity and love. Wanting to be close. Wanting to participate in some way so that it can be tactile and real to me. I know best by touch, by contact, by closeness. M and I stand there. So glad for M. Right there. He and B were responsive and kind. M leaves. More time alone. Then T says we're leaving. I go reluctantly, unwillingly. After that there began a whole series of events.

1977

The Facing Life Award

At a 1991 faculty show at University of Texas, Austin, Montano had this award engraved over a photo of her aging face.

- If my face is not burned beyond recognition in a fire, or shot at by carjackers, it might look like this when I die.
- If my face is not smashed by falling rocks in an earthquake or covered by Kaposi's sarcoma, it might look like this when I die.
- If my face is not smashed beyond recognition by a rapist or paralyzed by a stroke, it might look like this when I die.
- If my face is not excessively wrinkled by sun overexposure or twisted by Parkinson's, it might look like this when I die.
- If my face is not ravaged with pain from cancer of the breast, colon, bone, brain, or infantilized by Alzheimer's, it might look like this when I die.
- If my face is not vacated by a coma or crushed by an eighteen-wheeler, it might look like this when I die.
- If my face is not shattered by a terrorist bomb or soured from bitterness, surgical intervention, or fear of aging, it might look like this when I die.

1991

Portrait of Sappho

My name is Sappho of Lesbos
Once, I had 206 bones in my body.
Once, I had 33 vertebrae in my body.
My intestines were once 22 feet long.
Once, I had 10 billion nerve cells in my spinal cord.
Once, there were 5–9 pints of blood in my body.
Once, my heart pumped 1.5 gallons of blood throughout my body
 every minute.
Once, I had 12 pairs of ribs in my body.
Once, I had 650 muscles in my body.
Once, there were 3 million sweat glands in my body.

Once, my muscles made up 20% the weight of my body.

Once, my lungs expanded and contracted 12–20 times a minute in my body.

Once, my brain was composed of more than 12 billion neurons and 50 billion supporting cells.

Once, there were 1.5 pounds of skin shed by my body.

Once a month I replaced my outer skin and in my lifetime, I had 900 new skins.

My heart was a muscle the size of a grapefruit.

Once, my heart pumped 766,600 gallons of blood every year.

Once, my heart . . .

Once, my heart . . .

My heart . . .

My heart . . .

1998

❀

Linda M. Montano in Benares

This is the text for a video of the same title that is not released. It was made in response to Montano's trip to India to study death, ghats, and nursing homes (ashrams where the elders pray together) in India. She received a Summer Research Grant from the University of Texas, Austin, that financed the trip.

The summer of 1997, she went to India to Benares, the city of death and the city of light. For some Hindus, the train stops in Benares. To die there assures an end to reincarnation and liberation or moksha is guaranteed. It took two years to prepare for the trip. She got a grant, took every immunization possible, went for travel counseling, and read voraciously. Her best friend and mentor, a seventy-three-year-old Jain woman, originally from India, went with her. They needed each other to get around, the beginner and the experienced one. Interdependent.

They stayed in Ahmnabad with her friend's sister for two weeks. This gave her a chance to get used to cows in the road, Third-World cultural differences, the monsoon season, and the dispensability of

human life. To take any form of transportation in India, or even walk on the roads, is an act of faith, a rhythmic, fatalistic game of chicken. You realize that you are not special, hardly memorable, and literally just one more mouth to feed in this country of 850 million humans, some surviving day to day.

She was sobered by the anonymity and insistence that waking up alive was ENOUGH, eating a meal was ENOUGH, going to the bathroom was ENOUGH, wearing clean clothes was ENOUGH. Communicating well with those close to her was a jewel to be cherished. India was spiritually invigorating.

Rains and washed out train tracks stalled her plans, but eventually she arrived in Benares. For health reasons, her friend could not go with her. She went alone after having made a few phone calls to a man who worked as a research assistant for Americans. She asked him to arrange a place for her to stay and find a videographer for her research.

One of the most compelling journeys of her life had begun because as she aged, she found that she was more conscious of consequences, germs, conspiracies, and her own death, all of which seemed to be traveling swiftly in her direction.

Braving Jet Airways, Indian Airlines, and the Delhi airport, she arrived in Benares where a driver greeted her by holding a sign with her name on it. She felt safe for a second, but the 45-minute trip from the airport in a smallish van was another test of faith. Her adrenal glands, already pushed to the limit, gushed even more flight/fright juice into her already-overworked bloodstream. Would the van hit that cow? Or that baby sitting in the road? Would that other truck careening out of control hit the car? Cars! Scooters! Auto rickshaws came within 3 inches of each other and no one wore seatbelts, helmets, or shoes! Each scooter carried a minimum of six passengers: mom, dad, four kids, grandma, and a baby up front screeching and laughing with delight. A western horror show. Remembering her thesis and goal, to better understand death, she gulped, took in the situation she was in, and repeated an inner monologue. "You asked for this, now surrender, nobody forced you to come here. It is not America and the road laws are different, that's all." That self-instruction allowed her to release her western beliefs in proper road etiquette and enjoy herself.

The driver took her to the research assistant, a tall, elegant Brahmin, who had studied anthropology at Benares Hindu University.

She told him of her plan:

> I want to study elders in India, study how they are integrated
> into family life, and never seem to retire. They appear to be
> respected, not isolated while they work hard on life's greatest
> mystery, their upcoming death.
>
> I would like to videotape a hospice in Benares, Mumuksha
> Bhavan, so that I can experience a place where elders wait for
> their approaching death in an atmosphere of prayer, expecta-
> tion, and the support of the community.
>
> I want to experience what happens when someone dies,
> and is carried through the city streets of Benares and is then
> cremated on the burning ghats.

He explained that the Ganges River is considered so sacred that its
presence transforms the pollution and hidden aspects of death.
She listened to him and knew that she had come home! Was she
a Hindu once? Finally, death would be unveiled. She didn't realize
that she would have to die herself a bit more before she would be
allowed to make friends with death. Doesn't the homeopathic doctor
prescribe snake venom to cure snake bites? Death would cure her of
death.

That night she slept with forty-five bedbugs. The next day she
went to the chief of police to get his permission to videotape
cremations. He fed her and her assistant, something that would never
happen in America! And he seemed pleased with her project. But he
smiled at everything and everyone. A smile she could not decode.
Terror had not set in. A three-and-a-half-hour boat trip down the
Ganges River the next day dislodged her from the role of spectator
to that of participant. Should she look? Should she be another tourist
voyeuristically peering at the worshippers and bathers? Should
she scrutinize early morning ablutions and be another outsider
bothering these people as happened tourist season after tourist
season? Americans, Germans, Koreans, Norwegians, all taking photos
of Indians praying, washing, and gargling in the Ganges, year after
year after year! She was beginning to understand esthetic ethics and
the reasons why some artists choose to quiet their curiosity at home,
forgoing the invitation to become cultural imperialists/colonists.
Forgo the invitation to become image thieves.

An image thief? Wishing that she had thought through her impulse to travel to a foreign country for her art (for her soul it would have been perfect), she asked more questions about privacy and customs and the openness of one culture and the nonopenness of another, wondering what Hindus in America thought about things her culture considered absolutely fine.

It was too much, the desire to see and not look at life, and then she saw something so incredible . . . death! It came floating by, making her breath stop. She didn't even consider taking a photo. She remembered her mantra. "This is why you came here, to learn about death, surrender." A bloated body came floating by. The other American woman in the boat was completely unfazed. She said that the woman, when alive, could have been a victim of rape, abortion, family violence, a botched surgery, or mafia murder! She hypothesized that the woman had had a mastectomy gone wrong since one breast had been cut off. On the other hand, possibly the turtles imported to eat half-burned bodies had eaten the missing breast.

Silence and a thought: "You know, Linda, women are not allowed to do this work, to attend cremations in India. Maybe your presence is offending these people?" Hmmmm, something guilt-making and an added self-inflicted stress to consider. Then 10 minutes later, a headless, bloated, blue, dead infant came by. At first, someone announced, "Here comes a dead dog," but as it got closer, it became obvious. At that point, a dog, a baby, a plant . . . what's the difference, death was becoming DEATH!

Now she was in pure witness mode, not thinking, not feeling, not talking, and was not documenting her experiences. She had been reduced to terror. Her nerves felt as though they were at attention. She realized that she was getting a postdoctorate in a subject that she couldn't even name. She was shaken to the core. Death was not yet her ally or friend. St. Francis called death Sister Death, and she aspired to that level of no-fear!

That night she slept with more mosquitoes. She thought maybe they would bite her and she would die there of sleeping sickness. All she could do was repeat a litany of prayers that sounded more like bargaining. "If I make it back to America safely, I will never, ever, ever, ever, ever _____ (fill in the blank)." And another bribe, "And I will donate _____ dollars to (fill in the blank.)" She called on Jesus, her meditation teacher, Dr. Mishra. She called on

her friends. She conjured up good memories all night for many nights in a row. Her cowering, infantile, immature spiritual game-playing with the Almighty made her sick with herself. But, it did bring a modicum of comfort to her desperation.

She wondered if she would be thrown into the Ganges if she didn't respect the traditions of this ancient city with its rules that state that only men go to cremations. The threat of annihilation made her swallow her feminism when the research assistant and videographer went off without her to document the bodies being carried through the narrow streets while the stretcher-bearers chanted, "Nam Ram Satya Hai, Nam Ram Satya Hai." She would go on her own to those places, see what they had seen and then plan to review the video footage once she got home, knowing that she could edit. She knew that everything would work into the collage of Benares and her final installation that would hopefully function as a call to meditation.

After observing burial rites, she turned her attention to the research of "nursing homes" in India (the videographer taped an asrama for the aged in Benares). Having heard her own mother make her promise that she would never put her in a nursing home, she was CHARGED with the task of bringing the Hindu method of prayer, japa, repetition of sacred sounds, and positive respect for the elders to every nursing home in America, hoping to reform them and make them prayerful places. Or was she just kidding herself, trying to insure her own future position in a spiritually cognizant nursing home by bringing a Hindu model of how to do it to America.

She envisioned that she would die in an atmosphere of meditation, surrounded by other elders. This would be an ideal setting! Hmmmm, a possibility? It would be a wonderful nursing home where all the elders would be praying, saying mantras or the rosary, just like in India. She knew she was here to design her own retirement and death. In order to engrave death even more deeply into her image bank, she spent long hours at the burning ghats, even though she was a woman. Fate compelled her to see the places where 100 cremations are performed each day. The place where bodies are first immersed in the Ganges water, then burned, then returned to the Ganges as ashes. If not enough wood can be bought because of lack of funds, partially burned bodies are put back into Mother Ganga for her to magically purify and transform.

She watched, felt, and brushed against stretchers carrying the dead

bodies. She noticed how feet burned, smelled the air to see how burning bodies smelled, watched as skulls were crushed with a stick by the male chief mourners so their relatives' spirit could fly free from the top of the head.

She watched, felt, chatted, gasped, moved from shock to surrender, graduating from Benares.

For Benares was healing her of death. Generous, dear Benares let her see enough cremations, enough ritually dispensed bodies whose lives had been respected with prayers, enough paradoxes and enough beauty/truth. But there was even more. A few days before she left the ultimate heart-opener happened when five Benares teenage boys, hanging out at the burning ghats the way they do in the US at the malls, helped her lighten up about death. The ghats aren't a mall; it's just that their teenage posturing, attitude, and actions were similarly casual and filled with mall spirit. They were talking, laughing, riding, and then parking their bikes. They were innocent – not ironic, not mocking. They were real, and drank chai right next to the mystery and experience of death, too young to be affected!

Her gaze traveled between the burning bodies to the lively teenagers. She combusted, it was too much. She burnt a fuse, got singed, something snapped, skipped a beat. She got over something when they began teasing a responsive goat with courting sounds! Along with the teenagers, she laughed, insisting on LIFE.

That laughter, next to death, dislodged her addiction to the fear – of seeing, knowing, doing, and fear itself. Finished, she had seen enough ancient sacred actions and temples and life-force and now she could tolerate anything; even the truth and terror of her own mortality.

Thank you Benares. I will never, ever, ever, ever forget you.
What's next?

<div align="right">1997</div>

<div align="center">❋</div>

Death in the art and life of Linda M. Montano

Montano performed *Learning to Love Death* (Houston, Texas, 1993) in Diverse Work's bathroom where she lived for three days, fasting on fruit.

At the end of the three days, she came out of the room and read the paper "Death in the Art and Life of Linda M. Montano." Then her friends, Doctors A.L and Aruna Mehta (Ayurvedic physicians) officiated at a Vedic Fire Ceremony designed to eradicate the fear of death for everyone attending the event. "Death in the Art and Life of Linda M. Montano," was originally published in *Voices Made Flesh: Performing Women's Autobiography*, Lynn C. Miller, Jacqueline Taylor and M. Heather Carver, eds, (Madison, Wisc.: The University of Wisconsin Press, 2003): 265–81.

[Slide 1: Dr. A. L. Mehta and Dr. Aruna Mehta]

Two Ayurvedic doctors, their compassionate image greets the audience.

[Slide 2: Linda as an eighteen-month-old adorable infant]

This lecture is interactive: if you so choose, follow the suggestions so that you can perform along with me, but do so only if you are comfortable with this imagination process.

It is a great honor to be presenting this paper. But I want it to be more than a paper. My vision includes the reader and listener, so all of us can address the most challenging life event that we all face: the death of the physical body. Let's begin with this image.

Pause

Choose to remember when you first:

Saw a death
Heard about death
 How old were you?
 How did you feel?
 Fascinated?
 Detached?
 Curious?
 Frightened?
 Mystified?

Anxious?
Indifferent?
Sit with that young self.
Hold his/her hand.
Dialogue with that aspect of yourself.
Talk about life.
Talk about death.
If necessary, adjust your current belief system about death.

I: The therapy of seeing

[Slide 3: Linda at seven. Lost front tooth]

I was born in a small village, upstate New York, into a strict, conservative, Roman Catholic family. Interviews I did with my mother revealed that I was outgoing, always giving flowers. Surviving milk allergies and childhood diseases, I lived even though approximately 200,000 people die every day.

[Slide 4: A European cemetery]

My childhood was immersed in Catholic ritual, prayers, and parochial school. At recess, the girls would walk around the cemetery next to the school, telling stories about death, premature burials, stories about unearthed coffins that were found filled with fingernails stuck in the gorged satin lids.

[Slide 5: Open coffins]

All of us have watched TV shows like *Hard Copy*, *20/20*, etc. and have our own stories of death. For example, we have heard of coffins designed with windows so the deceased can see outside, or with bells to inform the living of the mistake that was made, or of videos included both above and below ground, leaving messages for the living, and TV in the grave for the dead who might still want to watch the nightly news.

[Slide 6: Jesus on crucifix, muscles anatomically rendered]

Death was always a fascination for me, but one that felt taboo in its mystery. At seven, I was taught by the nuns that if I sinned, the devil would send me to hell when I died, where I would burn forever, but that Jesus died for our sins and offered an opportunity for salvation. None of it seemed very happy. It was about piercing and crucifixion – a sacred, somber event. Often I would faint in church – everything was so ponderous and unspeakably, devastatingly ecstatic.

[Slide 7: Junk sculpture by Montano of crucifixion]

At twenty, I appropriated my greatest fear, death/suffering, by making a crucifix. This junk sculpture magically related me to Jesus, allowed me to speak the same language, and to be Christ the only way I knew how – by depicting suffering myself.

[Slide 8: Fiberglass sculpture by Montano of skeleton]

A later fiberglass sculpture (1967) entitled *Death* was another attempt to explore my feelings about the subject, to look at a taboo by making art about it. Art became a safe space, often the only place where I could explore my fears and fascination.

Pause

How would you make art about death? What would it look like? Be like?

[Slide 9: A tomb in Naples]

Death elicits emotions of terror, sadness, and anxiety, but I continued to study it and look at it, hoping the denial would diminish.

[Slide 10: Catacombs in Italy]

II: The therapy of knowing

[Slide 11: My Guru, Dr. Ramamurti S. Mishra at forty years old, smiling]

An incredibly influential spiritual friend and teacher in this process has been Dr. R.S. Mishra (Brahmananda Saraswati), my guru and patient guide. Since meeting him in 1971, he has said, over and over, "Linda, you were not born, you cannot die. You are not the body and mind. Unless you understand your own death, you will have dis-ease."

His teachings are simple yet complex, eastern yet western – once I began meditating under his direction, my Roman Catholic fear of death and the devil were no longer the dreaded enemy, but eventually became words and issues that I could experience and examine from another cultural and mythological perspective. Yoga literally saved my life and my soul, and I would like to thank all of the eastern teachers – Jain, Hindu, Tibetan, Zen, Sufi – and the South Americans for opening my psyche to their spiritual technology.

[Slide 12: Mexican skeletons playing musical instruments]

Pause

Who is your death teacher? What do they tell you about death? How does your death teacher prepare you for your death? These two stories I will read of death experiences are totally different but equally inspiring.

First
Some masters pass away in sitting meditation with the body supporting itself. Kalu Rimpoche, one of my teachers, died in 1989 in the Himalayas with a number of masters and a doctor and nurse present. His closest disciple wrote:

> Rimpoche tried to sit up, had difficulty. One of the lamas felt it would be good to support his back so he could sit. He wanted to sit absolutely straight, indicating with a hand gesture and saying so. The doctor and nurse were upset by this, so Rimpoche relaxed his posture slightly. He nevertheless

assumed a meditation posture, placed his hands in meditation mudra, opened his eyes in meditation gaze, and his lips moved in mantra. A profound feeling of peace and happiness settled on us all and spread through our minds. All of us present felt that the indescribable happiness that was filling us was the faintest reflection of what was pervading Rimpoche's mind . . . slowly Rimpoche's gaze and his eyelids lowered and the breath stopped.

Second

In a March 1996 *National Enquirer*, Katherine Hepburn is quoted as saying, "If I'm going to die, I'll be damned if it is here in a hospital surrounded by strangers. I'm going to die in my own bed with my family at my bedside." After she signed herself out of a New York hospital where she had been admitted with pneumonia, she told a relative, "Dry your tears and don't be sad, because I'm going to join Spencer now. I've waited almost thirty years for this moment. I want to take him into my arms again."

Neither of these great beings feared death. How does your death teacher help you not fear death?

[Slide 13: Montano blindfolded for a week]

To prepare myself for my death, I continue to study meditation and after experiencing the exhilaration of meditation training, I began going inside publicly *as art*, doing sensory experiments (often blindfolded for a week) to explore dying to one of my senses. Ramana Maharshi, an eloquent death teacher, suggests we die daily. He overcame death anxiety after years of meditative experiences.

[Slide 14: Montano, lying as if dead]

In 1970, I began a series of death simulations. Lying as if dead, having seen my embalmed grandparents in coffins, as if asleep.

*[Slide 15: Lying as if dead, hypnotized to sleep, dream and
sing the dream, 1973, Berkeley Museum]*

In placing the template of death over my work, I contend that
everything that I have ever done has been an art of death or
manifestation of grief. Basically, my art has been appeasing my own
death anxiety by allowing me to die over and over and grieve, as art.
I use these slides from other cultures and their death rituals to expand
and illustrate the thesis that we all deal with death uniquely and
culturally.

[Slide 16: Israeli funeral procession]

In Israel, the body is not taboo. It is tenderly washed, not embalmed.
It is shrouded and buried. If the death has occurred in the Holy Land,
it is not coffined.

[Slide 17: Gypsy King's body surrounded by Gypsy mourners]

Gypsy tribal kings head extended families, including several hundred
members who must attend their funerals. The wake continues three
days, all camp in and around the funeral home. The open casket
contains a change of clothes because the dead are thought to return.
Gold coins are placed in the casket on the eyes. Emotions include
loud weeping. They kiss the forehead and knuckles and a funeral
feast is eaten in the same room where the body lies. The funeral pro-
cession is a spectacle with music, violins, and flowers. At the grave,
the casket is opened again and all cry out in Romany their sorrows.
The women fall on their knees and hit their heads against tomb-
stones, knocking themselves out. More coins are thrown in the
casket, wine poured in, and wailing continues. A cloth is then spread
on the ground next to the grave and a feast is eaten.

*[Slide 18: Montano sitting in a chair, white gauze as a garment,
white face]*

[Slide 19: Dead African chief sitting]

A dead Nigerian chief sits, swaddled, after having been washed and rubbed with aromatic herbs. Chiefs are buried in a sitting position, symbolic of his reigning in life from a throne or royal stool. The chief is lowered into the ground and a ceramic pot with a small hole is placed over the tomb. The hole allows the chief's soul to pass through it.

[Slide 20: Montano sitting as Chicken Woman, 1971]

[Slide 21: Ibo medicine man]

An Ibo (Niger) medicine man is painted white to keep away the spirits of death. At death, his tools were gathered, sacrificial blood spilled on them to keep death away; the closest kin were painted white; the women danced a dance of sorrow. Then the dead person was taken from his hut, seated on a chair to be viewed and buried in their own backyard. A small leaf roof marked the grave.

Pause

Are you the descendant of an ethnic group? How does your group address death and death rituals? If you have no death traditions, how would you personally design a ritual? See it, feel it, hear it, practice it?

[Slide 22: Gilded skeleton]

At certain times in our history, death has been glorified, romanticized, gilded, sentimentalized, but the 1990s have changed the climate of death.

[Slide 23: Marble tomb of European King and Queen]

Anyone who has seen a person die of AIDS or advanced cancer knows that disease is not romantic. Gurugi says TV has made Buddhas of us all, referring to the fact that we see images of suffering as did the Buddha when he left his father's palace and saw a corpse for the first time. AIDS deaths can include tubes, respirators, sores, lesions,

inflated, and cooled mattresses, balding, infections; men and women reduced to skeletons.

AIDS and the media have politicized death. It can no longer be avoided or sentimentalized. Our next challenge is to keep it from being commodified.

III: Movement and death

[Slide 24: Montano dances on the Golden Gate Bridge in
a blue prom gown]

This dance was a memorial for all those who have committed suicide on the bridge.

[Slide 25: British funeral procession]

In all cultures, the therapy of movement is included in the death ritual. In America, cars move funereally, with police escort, lights on, stopping traffic and the oncoming/outgoing breath of the onlookers.

Movements in other countries may include contortions of the limbs, jumping, running, rolling the eyes, injury to the self, using weapons. The commonality is that actions continue until the mourner is exhausted and clear of emotion.

[Slide 26: Korean funeral procession]

In Korea, a canopy-covered *sanyu* holds the dead.

In New Orleans, brothers and sisters dance in defiance of death. A marshal and band precede the hearse and there is an explosive shout erupting from the crowd under the hot New Orleans sun:

Are you still alive?
Yeah
Do we like to dance?
Yeah
Do you want to dance?
Yeah
Well damn it; let's go.

[Slide 27: Montano walking uphill on a treadmill telling her life story, wearing a smile device]

[Slide 28: Aboriginal funeral pole]

Making funeral poles is a major emotional outlet for Australian Aborigines. Cut from blood-wood trees, 20 foot high, 3 foot diameter, they are smoked over a fire after carving. Each man makes one. It is not a profession but a social duty. Songs and dances are held around the poles. Relatives dance as if there is something wrong with them – with their legs, arms. Women hold their breasts as if injured. At the grave, they slash their scalps with knives, beat their bodies with clubs, and perform other ritual expressions of grief. The poles are left on the burial site to weather.

[Slide 29: A marble sculpture funeral pole Montano made in Italy]

IV: The therapy of mourning and burial customs

[Slide 30: Hungarian woman in white mourning clothes.
A hand-embroidered death cloth hangs by her side]

[Slide 31: African son of the deceased, painted white to keep away
the spirits of death, views the dances with a profound look]

[Slide 32: Montano with acupuncture needles in her face]

After my ex-husband Mitchell Payne's tragic death in 1977, I mourned on video, in performance, and by writing. After two years, I was able to join the world again. In other cultures, inner pressures resulting from loss include making inarticulate sounds such as moaning, sobbing, screaming, keening, shouting, and ululating.

Pause

Listen to your heart. What does it say about death? Listen to each room of the heart: room 1, room 2, room 3, room 4. Give your heart attention.

[Slide 33: Montano and friends dressed as nuns/priests, telling guilts]

I mourned by listening and by telling guilts from the San Francisco Museum of Modern Art balcony.

[Slide 34: Temple of silence, Persia]

Persians bury their dead in the temple of silence. First the dead body is laid on a stone slab. With a nail, three circles are drawn around it and no one but funeral bearers can enter the circle. Sandalwood incense keeps demons, disguised as flies, away. A dog leads the funeral procession, and tradition says a dog would howl in terror if the body were not really dead. The body is placed on iron, not wood, because the body is taboo, restricted, and would defile the elements. Therefore, it is not cremated because it would contaminate the fire. So the body is placed on a ledge inside the hollow temple of silence. Vultures strip the body in a few hours, then the bones are gathered from the ledge and thrown into the deep pit in the center of the temple of silence.

[Slide 35: Benares, India, cremation ghats]

A Hindu, on the other hand, can be cremated. At death, the body is garlanded, the navel is oiled, nostrils plugged, big toes tied together, relatives informed, women lament; mortuary specialists perform the ceremony since death is defiling. The banks of the Ganges and especially the city of Benares are the most auspicious places for cremations. There, the waterfront is given over to burning ghats – a place where funeral pyres are built. When the body reaches the site, it is immersed in Ganges water then placed on the pyre, smeared with ghee (butter), and the son lights the fire – torch at the head for a man, at the feet for a woman. Mourners march around the fire and although they are forbidden to look into the flames, they must notice if the skull bursts. If not, the son hits it with an implement, since Hindus believe that at death the soul is trapped in the skull, and breaking it releases the soul. Then the mourners bathe in the river and recite "Vain is he who seeks to find the changeless in the human form. Life must terminate in death."

The following is a list of purification rites collected from different cultural traditions. They include restrictions, which help "revenge the death" and appease ancestors, ghosts, etc.

D
E
A
T
H

- Pull out hair
- Shave head
- Not wash hair
- Not comb hair
- No butter in hair for year
- Mimic battle
- Sift sand on body
- Wear a band on wrist
- Sacrifice a herd of oxen
- Neglect gardens and fields
- No jewelry worn
- Paint body
- Wear copper ring
- Go into seclusion
- Cutting the thumb
- No touching cooking pots
- Erect memorial stones
- Burn down the hut
- Carve poles
- Fasting
- Girls deliver water to all homes
- Go bareheaded
- Wear black
- Wear white
- Leave hair unbraided
- Plant tree on grave
- Say novenas.

Pause

If you had complete permission to mourn any way you would like, what would you do or not do?

244

In my own experience, guilt and unfinished business with the death of friends have been my biggest obstacles with this subject of death. I invite only those who feel most comfortable to join me in the following visualization in saying goodbye to a dead loved one. The visualization is taken from the book *The Tibetan Way of Living and Dying* by Sogyal Rimpoche.

> Can you imagine the face of a dead loved one? Keep your heart open. With your whole heart and mind, visualize that this loved one is looking at you with a greater love and understanding than he or she ever had while alive. Know the dead person wants you to understand that he or she loves you and forgives you and wants to ask for your forgiveness, then truly say farewell and really let go of the person.[1]

[Slide 36: Montano handcuffed to Tom Marioni]

In 1973 I was handcuffed to Tom Marioni for three days.

- Was it a mourning ritual?
- Is danger a way to avenge death?
- Is this kind of mourning a premature death-like action, which homeopathically keeps death away – tricking death by acting as if it already happened?

[Slide 37: Montano tied to Tehching Hsieh]

Was being tied by an eight-foot rope a ritual of penance and alteration of consciousness?

Tehching Hsieh, master of endurance, was looking for someone to be tied to for a year, no touching and remaining always in the same room. By staying tied to Tehching Hsieh in his *Art/Life: One Year Performance*, I died a little every day, learning humility and collaboration.

[Slide 38: Mildred Montano as a young woman]

When my mother died, I had a chance to redefine my beliefs. It was ten years after my ex-husband's death in 1977, and, with my

mother's death in 1987, I was ready for some new information about death.

[Slide 39: Balinese effigy burning]

A Balinese effigy is burned at funerals in that country.

In my life, it seemed as if each of my selves was an effigy dying, as my mother died slowly of colon cancer. After five years, she died painfully in the hospital – drugged, prodded, poked, and in excruciating pain.

[Slide 40: seven slides of Montano in seven different colors corresponding to the seven chakras]

Each year of *7 Years of Living Art* and *Another 7 Years of Living Art*, I changed accent, persona, color, sound. It was my way of dying to myself – I was losing my mother, my friend, and myself. And I gained an expansive spaciousness and feel of the void that is ever-present.

Pause

Who have you lost? What does your spaciousness feel like?

VI: Current preparation

We Baby Boomers are aging and as we age, we transform and observe the body's decay – the change in metabolism, graying at the temples, middle-age stomach, lowering of energy levels, lessening of muscle tone, loss of hair. How, without silicone implants, cosmetic surgeries, collagen injections, vitamins, and liposuctions, can we deny the temporariness of the body? We cannot disregard death.

[Slide 41: Montano as half-male, half-female]

Pause

Meet yourself as a 108-year-old. What is the message your elder self gives to you?

VII: Therapy of study

As death comes further and further out of the closet, blushing with shame and the innocence of newness, we continue our research. How to do that? Here are some suggestions:

[Slide 42: Henry Montano as a young man]

1. Talking with our elders: my eighty-year-old father said, when I was complaining about car insurance and my house: "What's all of that in the face of eternity?"
2. Writing our wills, our living wills, making provisions to donate organs. In China, coffins are made and then placed in the home as furniture.

[Slide 43: Montano as a priest-nun]

3. Choose the officiate for our funerals now. Will it be Father Amara or Sister Rose?
4. We can decide ecological ways to dispose of the body.

[Slide 44: Tree burial]

A. Plains Indians' scaffold burial.

[Slide 45: Balinese cremation]

B. Balinese effigies are burned with the body.

[Slide 46: Tibetan monk blows femur horn]

C. Himalayan priests summon flesh-eating birds with a horn made from a human femur to eat the dead body.

[Slide 47: Tree burial]

 D. Sioux Indians bury their dead in trees.
 E. Will we decide to take up space and be buried on this shrinking planet?

[Slide 48: My Guru in his sixties]

5. We can take charge of our death by defining and experiencing consciousness while we are alive. Brahmannanda Saraswati's teachings direct me in this area.

[Slide 49: Mexican candy skull]

6. We can face death by living life fully and laughing with it and at it.
7. We can face death by letting go of those who have already died.
8. We can re-see and re-join our spiritual roots for comfort and protection.

Pause

How do you envision a ceremony for *your* death? Who will be there? What will be said or done?

As we complete this process together, let's take one last look at the subject from seven different aspects of ourselves.

Pause

[Slide 50: Montano in red, hands on first chakra]

Can you imagine the earthy you addressing death? How would that aspect of yourself relate? What would be said or done?

[Slide 51: Montano in orange, hands on second chakra]

Can you imagine the earthbound you addressing death? What would they say to death about your possessions?

[Slide 52: Montano in yellow, hands on third chakra]

Can you imagine the courageous and gutsy you addressing death?

[Slide 53: Montano in green, hands on fourth chakra]

Can you imagine the compassionate and loving you addressing death?

[Slide 54: Montano in blue, hands on fifth chakra]

Can you imagine the clear communicator aspect of yourself addressing death?

[Slide 55: Montano in purple, hands on sixth chakra]

Can you imagine your intuitive self addressing death?

[Slide 56: Montano in white, hands on seventh chakra]

Can you imagine your bliss-filled self addressing death?

[Slide 57: Life mask of Linda M. Montano as if dead/alive]

Thank you and remember, "Love! Nobody knows what will happen the next day" (Dr. Aruna Mehta).

❁

Death notes

Death notes is included in this article for those wanting grief counseling.

In 1987 my mother died. It was a five-week hospital death. Colon cancer. I was with her much of that time. These are some of the things I learned.

1. Ask the dying person questions and wait for verbal/nonverbal responses. For example: "Should we stop this medicine?" "What do you need?" etc. (I didn't always ask my mother's opinion and now I wish I had.)

2. Listen, listen, listen.

3. See if they have unfinished business they want to work with, i.e. unexpressed thoughts, feelings, wishes, etc. (My mother said, "I always wished I had written a book," knowing that I would hear her and do it for her. I have.)

4. If they prefer, let them leave consciously, alertly, with awareness. (Because one medicine was stopped, she became comatose. I didn't know that would happen and I missed saying goodbye because of that.)

5. If they agree, play nature tapes in the hospital room. It creates a no-panic atmosphere. (I played one and nurses used to come in the room because it felt "good in here.")

6. Help the way they need to be helped, not the way you need. (Once I was chanting, praying, laying my hands on her abdomen, teaching her to breathe. My mother, always the comedienne, opened her dying eyes, looked at me with an Imogene Coco look and said, "Linda, *please*!")

7. Confess by their bedside. (Clear your heart but do it telepathically. Tell everything you need to tell. Do unfinished business without their hearing. *Sotto voce*.)

8. If the person is on heavy painkillers, they might change their behavior toward you, positively or negatively. Be ready. (My mother became a hippie on morphine. She pulled me close to her, tried to show me her aura, touched the peach fuzz on my cheeks. We re-bonded!)

9. Get counseling yourself from either friends, twenty-four-hour telephone hotlines, hospice volunteers, etc. (I talked with a hospice volunteer for four years on the phone while my mother was sick and dying. Hurrah for hospices!)

10. Know what "patient's rights" means and use the information appropriately. (I asked one nurse, "If this were your mother would you allow a nurse to take blood and do 'vitals' while your mother was comatose and had only a little time left?" The nurse said, "No." I said, "Then please do not take blood and stop all orders at the desk.")

11. Be prepared for each family member and close friend of the dying person to have a completely different response to everything. Emotions are close to the surface; everyone's death-anxiety button is being pushed.

12. Use TV and VCRs as teaching tools. (When my mother wanted TV on I turned to cartoons. The flying horse image from *My Little Pony* did wonders for her attitude and actually kept her pain-free.)

13. Inconspicuously breathe together (match your breathing pattern to theirs) and gently sound the exhalation. (Steve Levine teaches this technique. It's Tibetan and comforting for both patient and caretaker.)

14. Whisper messages near an ear. Keep messages positive and in words they need to hear. (When I said, "Relax, Ma, Mitchell and Karl will take very good care of you," she responded positively. These were friends who were dead and whose company she loved.)

15. Go as far as you can go with the process at the end. (Those last fifteen hours when she was comatose, I felt a need to meditate, give her space, not touch her as much. Check out your own situation, it will be different.)

16. After the death, participate in the process as much as you can given place, circumstances, etc. Help wash the body, close the eyes, etc. (I didn't see the spirit or soul leave. Some people do.)

17. Never, ever judge how you or anyone else mourns or deals with a death (I demolished and rebuilt an abandoned building for two years after she died. I rarely cried, but my body sweated).

18. Be watchful for messages, dreams, symbolic visits. (She comes as a butterfly, or sometimes a wave of feeling. I continue a dialogue with her.)

19. Daily: Prepare for your death in your own way.

Your comments:

2002

Chapter 6
How-To Manual

What follows is a collection of artist's statements, syllabi, and performance directions intended to serve as a performance and pedagogical guide to the reader. Very often the vitae of the saints contained such directives. In addition, many female saints, particularly those associated with convents, wrote directives to the nuns in their charge. In this last section, Montano provides a performance directive or "How-to" manual.

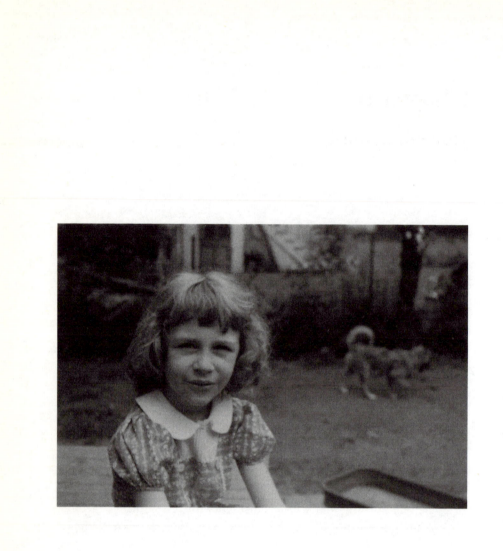

Statement: MFA *Chicken Show*

The fact that some things can be scattered, distributed, frag-
mented, and not merely visual, yet termed sculpture, intrigues*
me.

The fact that some things move, change, approach the art viewer
on their own legs, and it is still called sculpture intrigues me.

The fact that some art cannot be bought (or wouldn't want to be)
intrigues me.

The fact that some sculpture smells and needs to be taken care of
physically intrigues me.

The fact that you can drive around with the art on/in your car,
intrigues me.

The fact that some art doesn't have to be called art intrigues me.

The fact that the quality of vitality can be taken literally in a sculp-
ture intrigues me.

The fact that sensory awareness and information gathering can be
achieved using many different media intrigues me.

The fact that the absurd can be raised to the dignity of art intrigues
me.

The fact that this art might not look like art, but could be seen as
material for a circus or a farm intrigues me.

The fact that as artists we can work ourselves into esthetic obses-
sions over an idea that is so banal, so natural, so simple, so
obvious intrigues me.

*Feel free to substitute the words, bores, frightens, freaks me out,
sickens, amuses, disgusts, doesn't faze, for the word intrigue.

1969

What Is Performance?

Performance is like housecleaning.
Performance can be autobiographical or confessional.
Performance can be entertaining or comical.
Performance can address ecological or environmental issues.
Performance can become an initiation into a higher spiritual level.
Performance might be formal, theoretical or linguistic.
Performance can change hardened political policies.
Performance can be done alone, in groups, or anonymously.
Performance might address food, origins, death, or personae.
Performances can be nurturing rituals or scatological farces.
Performance might do none of the above.
Unlike the static arts, performances are often in our faces. You can
 smell them, touch them, see them, and hear them.
Performances might blow open the door of your life issues or the
 doors of your personal past.
Performances encourage the performer to open the heart and then
 you can go for personal counseling with a questioning vulner-
 ability.

Today we are happy to have a visitor from the Mental Health Office.
After you perform, get in line, and ask him a question about your life
if you choose. And now perform three arts: the art of being a healing
audience member for your classmates, the art of vulnerability when
performing your own work, and then the art of talking to this visitor
about your art/life. It takes a lot to keep a heart in love.

1994

Performance Statement

Performance:

Is not always acting
Is not always speaking
Is not always being current
Is not always ancient
Is not always offering a narrative
Is not always relating to the audience
Is not always relating to the self
Is not always talking
Is not always silence
Is not always trance
Is not always masked
Is not always ritual
Is not always persona based

Is none of the above and all of the above.

Performance is permission to be alive.

1994

Why Computation is Like Meditation

Computation component: Minette Lehmann
Meditation component: Linda M. Montano

Quality	Computing	Meditating
Light	Reflected Blue Glow	Blue Inner Glow
Time	Disappears	Dissolves
Space	Virtual	Eternal
Color	On Screen	In Mind
Sound	Digital	Inner
Sight	External Screen	Internal Screen
Touch	Mouse/Keyboard	Hands/Touch Hands
Elements	Incidental	Incorporated
Effect	Arrest External World	Arrest External World
Communication	Teleconference	Telepathy
Memory	Filed in the Machine	Surrendered No Return
Pain	Carpal Tunnel Syndrome	Stiff Joints
Power	Order the World	Leave the World
Fear	Lost Information	Lost Truth
Travel	Information Highway	Astral
Relationships	Not Necessary	Not Necessary
Worry	Obsolescence	The Unknown
Desire	To Know Everything	To Know Nothing
Expectation	Worry-Free	Worry-Free
Ambition	Master the Machine	Become a Guru
Future	Cyberspace	Spacelessness

1996

Recipe for Seeing Life without Guilt

1. Take one life, any life, with its dysfunctions and dramas.
2. Consciously make a soap opera or performance or video or fairy-tale of this life.
3. Work until there is no longer a neurotic attachment to the content of this life. That could take years. Even if this takes time in solitude, remember you are still an artist.
4. Never feel guilty for wanting success, money, or a postmodern informed intelligence, since they are your inheritance as an artist and the myth of suffering is over.
5. Live in a city where natural disasters, political disasters, health crises and personal anxiety is high, so you can learn the lesson of impermanence from the environment and don't have to spend twelve years in an isolated cave meditating for enlightenment.
6. Mix steps 1–6 with effortless effort, equanimity, consistent disciplines, and the concentration of a surgeon performing an operation on their best friend's four-month-old infant.
7. Improvise with this recipe to suit your taste.
8. Be a star.
9. Be a star.
10. Be a star.

2001

No More Fear of the Catholic Church

Would it be possible to defuse the old programming that Catholicism unknowingly suggested in the 1950s? A possible method:

> How about having a day-long performance? Maybe a year performance that includes nuns and priests praying in public? A practicing Catholic broadcasting Catholic stories? A Catholic grade school reading the lives of the martyrs and saints from the roof of their school until the book is finished? This experiment in understanding would culminate in a re-enactment of a martyr's life story, performed by an endurance artist whose life is mirrored in the martyr's life. How about it?

1999

Performance and Hazing

Birth is a rite of passage and so is death, our final performance. Between birth and death there are other passages: our first word, school, dating, love, puberty, jobs, marriage, downsizing, childbirth, sickness, old age, and more sickness.

Common characteristics of rites of passage are:

Isolation
Change
Rebirth/Transformation

For example, birth! We are isolated in a hot, tight, airless uterus, squirming, trying to swim. Mom eats biscotti, drinks cappuccino, drops wine on our bald, misshapen head, and after nine months of this we choke ourselves out of that impossibly tight space to be slapped to tears and then de-clogged in our eyes and de-mucused by suctions and latex fingers unclogging our air passages of soft, gooey, curdled milk phlegm. Isolation, change, transformation, and a baby is born into the circle.

The cycle continues and we get to do the ritual of inclusion again and again on our own, unless our culture addresses rites of belonging in a sophisticated way (see American Indian vision quests). We are relegated to our own devices. We make up somewhat pitiful rituals of belonging for ourselves because we all need a group of peers recognizing and clapping for our isolation cycle, friends giving us attention for our change cycle, and family rejoicing with us when we are reborn. We come from our struggles and life passages feeling unconnected to each other and ourselves without ceremony!!

I have always felt that performance artists/body artists create brilliant rites of passage. We are not performing public penances or self-inflicted masochistic rites. We are not acting out neurotically. Conversely, performance gives artists a chance to practice for the passages to come and also to perform in substitution for the audience members unaware of their need to make a big deal out of their life or not skilled enough to make up a ritual of inclusion for themselves.

And I also have always felt that hazing is a brilliant rite of passage although it is often performance gone amok and powered by power-crazy actions. Maybe it's the alcohol that throws it all off. But admittedly, the Greeks are smart enough to know that they need to belong. Smart enough to know that they need ritual. Smart enough to know that they need to get high. Once they clean up their methodology, they will be performing an important service to their brothers and sisters.

1999

Teaching Performance

Many artists who do performance also teach it. Sometimes acting creatively as a teacher with students can be as rewarding as teaching itself. In fact it has been said that teaching is or can be considered performing (see Joseph Beuys) since what is similar between the two activities is the heightened awareness, which results from focusing on a very inclusive and compelling activity to the exclusion of anything else. The mind becomes one-pointed and that is a high art. As performers, artists choose personal ways to focus their attention. As performance teachers, artists observe the focused actions of students. Along with the other students waiting to perform, they observe the videos of students in a think-tank environment. The energy can be quite electric because they are not only performing but critiquing, and analyzing, and making corrections of their own work and the work of each other. That's the ideal.

Let's digress and look at education, in general. As a graduate student, I took my sculpture degree for granted. I was protected by the ivory tower, even though I taught sculpture in a nearby women's college in Madison. But that teaching was different from teaching performance.

My real interest in the education process began when I taught in 1979 in San Francisco, at the Art Institute, at San Francisco State University, and later on in various places throughout the country. Although my contact with students was rewarding, I felt as if I was suddenly thrust into a situation that left many unanswered questions about the process of education and my role as a new teacher of performance. This paper will address three of those questions:

1. Motivation and teaching performance.
2. Criticism and teaching performance.
3. Performance teaching alternatives.

Motivation

Performance has been a solitary, noninstitutionalized and untaught process for me. I ventured into it without any guidance, in fact I had left graduate school when I began performing full time and continued in the field in a somewhat isolated way for the next seven years, trusting my own visceral responses and feedback even though friends were often helpful and made guarded critiques, realizing my propensity for "no comments, please."

Teaching was an entirely different matter. I approached it by going through my own work and looking at the questions that I had asked myself as an artist, and translated those questions for the students so that they could solve the problems in their way. For example, I had structured my work on the number 3 and would lie for three hours in a bed in a gallery. It was only natural that I would ask students to do three-hour events, having learned from that form myself.

But there were some difficulties with that method. I had motivated myself to ask my own questions and demonstrate answers in my work. Now, I was providing the stimulus, reason and inner direction for their work, justifying the changed methodology by reminding myself that performance was now an academic subject. By teaching it, I was aiding the evolutionary process of art. That is, what I had discovered on my own, students were now learning in an accelerated way so that they could eventually ask their own questions and expand that genre. That's what teaching art in the academy was all about. Evolution! The question I am left with is this: What is the most efficient and noninvasive way for an artist to communicate her/his process and motivate others to find their own way?

Criticism and teaching performance

I literally shunned criticism and comments about my performances for years. I had nothing to say about what I had done because the actions seemed to be solving unconscious needs that I didn't want analyzed. In some ways the strength of the work lay in my tenacious insistence on positive approval and no criticism. I would do an action, run home, hide out until I felt like doing something else and occasionally ask a friend, "How did you like that?"

Conversely, as a performance teacher, I was expected to give criticism to students who had done as many performances in school as I had done on my own. Often they studied with as many as six different professionals in the field, for example, Howard Fried, Paul Kos, Barbara T. Smith, Tom Marioni, Moira Roth, Daryl Sapien, Chris Burden, and David Ross, all teachers at the San Francisco Art Institute. Students evolved and became well versed in both performance history and criticism of the actions they performed in my class, but did so under their own tutelage, so to speak.

As a nonconfronter and interior learner, I had to change my strategy and ask myself:

> How, as a teacher, am I supposed to perform the art of giving constructive criticism? How am I supposed to teach? What needs to be said after a performance when words seemed to break the spirit and mood of the work and disturb the atmosphere of the piece?

I found that the switch from the performance mode to the analytical and critical mode somewhat unnatural. (After years of teaching I began mastering this art quite well.) A few introverted students seemed shattered by criticism given them that sounded harsh, superior, or negative (remember it was the time of punk and many students seemed to think that bullying and being fresh was fun).

To address the many methods of learning as represented by the numerous types in the class and different personalities, I would find alternative ways of giving critiques. Sometimes they would write reactions and give them to the performers, softening the voice-blow! The balance of sometimes talking and sometimes not was refreshing. Another academic quandary was that of assignments. As a teacher

you feel as though you are forcing and coercing the muse of the students into productivity and competition. I was inviting (for a bribe) the grad students to do something by Thursday and then asked them to wait around in class while we discussed it. Then next Tuesday something else was due. Performance was no longer ART but education. Muse wrestling!

Then there was the issue of content. Some performances were so autobiographical that they called for and elicited encounter group responses, not analytical analyses. A question I continue to ask is: What kind of performance atmosphere is conducive to learning?

Performance teaching alternatives

So I went to the experts and asked what they did. The following quotations are performance teachers' responses to the question "What is the ideal way to teach performance?"

Dick Higgins: I would teach possibilities and erase inhibitions by avoiding as much information as possible.

Allison Knowles: I would give an historical run-through of performance using slides and books. Then students would write and execute performances, i.e. make an event based on time.

Bonnie Sherk: Art is education. Performance is being relaxed, spontaneous, fluid, yet controlled. Observation is important. Understanding whole systems helps.

Pauline Oliveros: I would give some factual information concerning attention and perception. And then I would ask people to come back with their own interpretation of that information. But ideally I consider myself a facilitator, not a teacher. Students could formulate their own questions and answer them.

Jim Pomeroy: I can't say anything specifically germane to this. My main emphasis is responsibility. People being responsible to themselves and to each other. I don't see that authority games make much sense.

Jock Reynolds: See what other people have done with given situations, places and environments with which to work. The richer the stimulus the better.

Carolee Schneemann: My classes are like communes. I work with

movement and ways of intensifying physical contact so that taboos can be broken. By teaching traditional ways of relaxing and working with the self, old ideas of competition and excellence can be examined. Physical work changes attitudes.

Howard Fried: How about starting with assignments? I tell them at the beginning that once I give them assignments, they should relate to the assignments as art and not assignments. Basically a lot happens in the class that sets up ethical expectations about how students put out. When someone gets to the point where they have to reject the public feedback, assignments, and criticism system, then it becomes difficult for everyone in the classroom. When people start getting to be pretty good artists in school then it's hard relating with them critically. It's a funny situation but so is school.

Norma Jean Deak: I try to teach my own process that is language and writing. I have students get in touch with personal material and then ask them to write this material and later perform their texts. The class atmosphere has to be nonthreatening because the students are in a vulnerable position.

Cheri Gaulke: Just do it! I did performance without a structure or background, and now I teach performance and try not to inhibit students. It's hard to tell students what to do, but I deal with it by giving assignments that allow for spontaneity.

Nancy Buchanan: Take a long time. Work with sketches and non-threatening exercises. Try to get students to introduce themselves through performance. Explore communal work/ritual which takes the most trust and work, doesn't it?

Faith Wilding: Begin with pieces about self. Perhaps recreating a childhood scenario. Why choose performance over any other art form to express this content? Find out what their day-to-day personal rituals are. Give some background on the origin of performance, ritual, and theatre. Practice techniques that will help communicate ideas and images. Role play and dress up. Progress to group pieces and more elaborate personal events.

Barbara T. Smith: Ideally live together for at least a quarter and form not only a community but also an interactive work process. Then see how each would express this experiment. Food, eating, money, and Zen-like experiments would be part of it. Things that give no answers to the mysteries and the dilemmas.

Allan Kaprow: Parable for a Performance Class.

Imagine a few friends. They're physically youthful (they enjoy hiking).They're very smart (they know all about Futurology). They've got great hearts (they really like each other). They laugh a lot (even at themselves). Driving on the freeway, the drone of the traffic passes through them and they hum along.

Imagine a few friends. They're physically youthful (they practice yoga). They're very smart (they know all about conceptual art). They've got great hearts (they fall in love easily). They laugh a lot (the world is mad). They meditate every day (to stay in touch). Driving on the freeway, inhaling the fumes, they wonder if we can survive the century.

Imagine a few friends. Some of them enjoy the outdoors (some are not well). They're very smart (but not about the same things). They've got good hearts (though you'd think it was a secret). They laugh a lot (at each other's jokes). Driving on the freeway, in the rain, noticing the windshield wipers are smearing and need to be replaced, they might say, "This would make a good piece."

Eleanor Antin: You've seen how you teach. You've seen how I teach. There's no ideal way to do anything.

1981

Teaching Performance in the 1960s and 1970s

In the 1960s and 1970s painters and sculptors were eager to break out of traditional forms. Drugs, the women's movement, spiritual ecstasy and disillusionment with art as commodity inspired artists to create actions that were time-based, referential to their bodies, autobiographical and confessional.

It was an exciting time – street actions, long, drug-induced video trances and therapeutic disclosures were substituted for objects. The artist's inner environment was the source of the work. Criticism was hardly necessary because none had been developed for the genre; the audience was often the artists themselves and a small group of artist-friends (for example, core groups such as the people associated with Tom Marioni's MOCA in San Francisco, the Judson Group in NYC, and the Woman's Building in LA). Consciousness-raising and personal integrity were the priorities. Nothing could be bought or sold. Performance continues twenty-five years later to be pivotal and essential. Conceptually it addresses issues of belonging (Karen Finley, Annie Sprinkle, Carolee Schneemann), the environment and multi-culturalism (Guillermo Gómez-Peña, ACT-UP), the inner landscape (Ann Hamilton), the person as mask (Lydia Lunch, Rachel Rosenthal, Stelarc), and life as art (Tehching Hsieh, Allan Kaprow).

In my class students look at their own personal history, issues, patterns, fears, hopes, and taboos in a creative way.

They might sing a fear as a lullaby, make an object that represents a life issue and use that object in an action. They might incorporate photos of their mother on home videos. They might experiment with gender confusion. Whatever is needed to dislodge the mask is explored in a safe and supportive atmosphere. Once the story is

seen and told, giving better attention to daily life begins to happen automatically and the student may get closer and closer to the spontaneous, authentic self.

To support the process, videotapes, visits from performance artists, periodicals and texts are used. As soon as safety is assured, students begin performing in outside venues (other performance spaces for non-art audiences, i.e. galleries, nursing homes, daycare centers) so that expression can be tested and shared in a variety of situations.

Performance gives permission to do whatever we need to do in an elegantly structured and conceptually profound way, so that the artist literally creates and acts out their own reality until an unobstructed life force can be felt. Then there is only breathing and compassion for all of existence. That is art enough.

LIFE/ART CARD
I _____
AM AN ARTIST OF MY
LIFE AND ART.

1999

Sister Rosita's Summer
Saint Camp

While undertaking *7 Years of Living Art*, Montano ran a Summer Saint Camp out of the Art/Life Institute on Abeel Street in Kingston, New York. This particular ad appeared in the bathroom stall of Franklin Furnace in New York.

Come to **Sister Rosita's Summer Saint Camp** and learn disciplines, how to look for miracles, talk in accents, wear a habit (all yellow clothes), how to get up early, exercise into oneness, take pilgrimages to sacred places, take cold showers to prepare for next winter, eat sparingly (rice and beans every day), fast one day a week, research stories about saints, and also performance artists.

Some disciplines you will learn are thrift; how to walk and smile simply; how to live without hot water; how to live without art; how to live without sex; how to remember to turn lights off when leaving a room; how to make a hair shirt and other penitential objects and enjoy using them to inflict penances on the self; how to live on air when hungry; how to live without the use of your refrigerator over the Christmas holidays; how to spot a martyr; and many other useful skills.

At the successful completion of these hardships you will receive **Performance Art Saint Certificates** from THE ART/LIFE INSTITUTE.

To Apply:
Send a two-page bio and answer the following: Why I want to be a performance art saint and how I have been one in the past.

Bring:
Walking shoes, sleeping bag, swimming suit, your habit (all yellow), everything, tape recorder and tapes.

Where:
Exit 19 on Thruway. Take Broadway to Abeel. THE ART/LIFE INSTITUTE is located at 85 Abeel Street.

Donation:
$250 one week.

Send:
A self-stamped envelope with bio, photo and/or self-portrait to

LINDA M. MONTANO
85 ABEEL ST
KINGSTON NY 12401

1987

You Know You're a Performance Artist If:

1. You dress like an angel, astronaut, nurse, etc. and sing/dance to Jackie Gleason music at your local mall for no apparent reason.

2. You take your front dental plate out at your thirtieth class reunion and sing *My Funny Valentine* with the person you liked in the first grade.

3. You gather 1008 identical toasters, spas, outdoor barbeques, metal garages, and place them on your front lawn for a week, and then distribute them to the first 1008 practitioners of Tantra.

4. You take a plane to a city you've never visited, choose a departure gate, wave and cry uncontrollably as passengers leave for their plane. Crying continues until you exit the building.

5. You bring chocolate syrup, honey, or yogurt to your bathroom and pour it over yourself while trying to straighten out an HMO claim on the phone.

6. You dress your pets, your children, and partner in identical clothing every Wednesday.

7. You sleep in a coffin that you have made in order to face your fear of dying.

8. You feign loss of control of limbs, words, or bodily functions while watching TV (choose any program) alone on a Saturday night.

273

9. You web cast daily every fifteen minutes every detail of your finances and after a month of disclosures you take an email poll to determine if you should tithe/adopt/support a church, child, senior citizen, Third-World country, hospice, unemployed family, artist, teenager, or yourself.

10. You voluntarily retire, give yourself the gift of time and take a vow of inner silence.

2004

A Sample Art/Life Counseling Phone Session

This is one of Montano's many performative interviews that she has done over the years with herself as the subject having collaged information from past counseling sessions.

All incidents changed to protect privacy.

Audrey: Hi, is this Linda Montano? My name is Audrey and I got your number from your website and read about you. Do you still do Telephone Tarot?

Linda: Actually I don't Audrey. Now that I'm a practicing Catholic, I gave it up! But I do Art/Life Counseling. Is there something you want to talk about?

Audrey: Yes. I'm an artist, forty years old and I've been working on some ideas that I need help with.

Linda: OK. What I will do is ask you a few questions first. Feel free to edit the questions or change them and really question my questions. OK?

Audrey: OK.

Linda: What is your childhood theme or first memory? Say your first thought positive or negative.

Audrey: Actually my first thought resonates with the idea I've been considering. It's about violence. When I was seven, I saw a neighbor hit his dog with a large stick and it killed the dog. After that I went into a kind of silence and emotional post-traumatic stress, I think they call it, and it has affected my dreams.

 Of course I have good memories, a lot of them, but this is the one that surfaces as a theme in my life and work.

Linda: Let's start with this information then. You can do the same kind of process with any theme or memory. This is just an example of the kind of thinking you can do. As an artist you have the opportunity to creatively alter, defuse, transform, reflect on, dissipate and reroute memories that get in the way of a happy and centered life. That's what's so great about art. It's all material if you want to use it. Of course in the mix are the esthetic and ethical concerns, but for now we will stay with content.

First, remember that you have a storehouse of options and media at your disposal and thousands of ways to express your theme or idea.

I've found that if you can remain raw in the beginning, it helps the surgery. So write down your incident as truthfully as possible. The sounds, sights, smells, feelings. Don't edit. Do you have access to a sound studio?

Audrey: I have a pretty good amateur tape system and can record things at home. I also dance.

Linda: Good. After you write the story, find sounds or music that resonate with the story, and, if possible, present it simply, non-esthetically and in this raw way to your therapist. After working for a while with the therapist, if she/he feels that it is appropriate to present the material to a few close friends in your home, do so. That way there is no critique, no judgment. If perchance the desire for audience and exposure and a larger sharing is on your agenda, then ethical and esthetic issues get raised. For example: Is my idea readable? What do I want from the other person? Do I want the eyes of the audience? Pathos? Empathy? An esthetic catharsis? As I age, I'm less willing to go toward "shock," even though it might be in my life and in my material. But that is your decision and depends on what you and your audience can handle. Sometimes warning them of what they are about to experience is helpful.

Audrey: I have avoided emotion in my work because I fear going to that big place. Any thoughts?

Linda: The important part is honoring the memory. Before I started therapy, I thought art could do it all. Then I shared it all with therapy. I found that I needed religion to even it all out. Some work has changed drastically. It is definitely a smorgasbord of art, healing and spirit.

276

You might work out the *Sturm und Drang* with the therapist or with prayer. By the time you get to the public, all the pain of the memory and terror might be wrung out and your performance might look very nonaggressive. For example, you might cradle a stuffed animal in your arms and sing softly to it. Or cry as you talk to it. Or raise seeing-eye dogs for the blind as art. Or volunteer at a dog shelter as art. Or make a 14-foot dog puppet and dance with it for three days at noon until 4 P.M.!

Remember, your aim is to evolve from repressed trauma to embraced compassion. I don't want to sound like a grandmother but try being Dali Lama-ish about your work.

Audrey: That makes sense. There's enough struggle in my daily life. Maybe my art can be a place where I get some different kind of nourishment.

Linda: The performance of the 1970s was so much more self-referential in a narcissistic way. Now times have changed and artists are employing the genre to evolve their consciousness not haze themselves. TV is doing that to every new artist! Just look at *Survivor* or *Temptation Island*. A lot of performance art concepts are commodified there. Right?

Audrey: Yes. I know you were tied with Tehching Hsieh in his *Art/Life: One Year Performance*. Isn't there a new TV program about a woman being tied to four men or something like that?

Linda: I still find the workshop setting and doing-it-for-friends setting the best. Once it gets out to a larger public, trouble arises. Cutting, shooting, and re-enacting of 1970s concepts can often hide the simple need to be healed via creativity in a safe and healthy and appropriate way.

Audrey: Linda, I'm trying to write this all down. Can I pay you for this? What do you charge?

Linda: Nothing. Just do something for somebody else in the next seven years. Give your niece some art supplies.

Audrey: What do you do to keep your mind vital? I find the emotional so bothersome and so punitive.

Linda: A few years ago I was having an exceptionally hard time. I did this subconscious re-programming on myself. It is a collage of a lot of techniques that I learned from others. Try it; see if it helps. You can do it as I describe it or write it down and do it later, whichever you like.

1. Notice that cultural beliefs run our thinking.
2. Some are negative, out of date and are stored deep in the recesses of the mind.
3. Locate the belief storage container.
4. Be the architect of a new one if you don't like yours.
5. Pick out a negative thought that has been running your life.
6. Write it down. Edit it and make it positive, even saccharine.
7. Now go inside and imagine your favorite friend or inner guide or teacher standing next to your belief system container.
8. The formula is, I _____ [your name], NOW BELIEVE ____ ____.
9. As you say your new belief out loud three times, give the old one to your friend and let her discard it.
10. Repeat when necessary.

Audrey: That sounds great. Mine was "I'm always feeling terrified and terrorized." And I changed it to, "I, Audrey, now believe in that inner harmony, and practice spacious and trusting beauty inside myself." Is that saccharine enough?

Linda: Excellent!

Audrey: Thanks, Linda.

Linda: You're welcome. Happy art/life to you, until we meet again. (Sung to Dale Evan's "Happy Trails To You.") Bye.
Perfect.

2002

(Self-)Interview

Teaching performance art

This self-interview was presented at College Art Association in 2002 for the panel "Free Radicals in the Classroom: Maverick Artists/Visionary Educators," moderated by Linda Weintraub.

Question: When did you first become interested in teaching?

Montano: Since 1966 I have been teaching art and have become familiar with teaching on the following three levels:

Teaching sculpture and object-making at Catholic women's colleges, 1966–71.

Teaching performance art itinerantly with no administrative responsibilities in hundreds of places, 1971–91.

Teaching performance art in a university while participating on committees and in the life of academia, 1991–98.

Out of those three experiences, I prefer the visiting-artist model since that better suits my skills, my personality, and my style.

Question: What is your style?

Montano: I teach performatively, that is, what happens with people who spend time with me in the classroom is sometimes identical to what happens in performances. The classroom is a laboratory for the creation of presence, community, structure, intimacy, analysis, information, and transformation. That has always been my goal. When I wear my performance art teacher mask, I allow myself to engage the body, mind, and spirit of those playing the role of student. But the bottom line is that I must be engaged, attentive, having a "good" time for the whole thing to work.

Question: That sounds like a theater workshop to me. Is there a difference?

Montano: Videotaping one of my classes would reveal that many of the activities look the same as those you would see in many other places. So what you are saying is true. But also I'm convinced that fate puts us together with certain people who can tolerate each other's style. This gives that group a chance to get very high together, for lack of a better word. When they leave the lab/classroom, they adjust their methodologies to daily life and make that a performative dance [see Montano, *Art in Everyday Life*, 1981].

Question: Who were your mentors?

Montano: Every spiritual teacher I've ever had, especially my meditation guru, Dr. R.S. Mishra as well as composer Pauline Oliveros and performance artist/teacher Eleanor Antin. All were holistic and were totally themselves when they taught. Plus, they had a ball!

Question: Describe a typical class.

Montano: I start with the body. We might stretch to Indian Ragas, slow walk while accompanied by the TV news, or imitate geriatric courting birds. Addressing the physical first allows for instant trust, instant community, and a change of focus from the stresses of everyday mind. Play silences the judge.

Then what follows is a sound exercise or what Pauline Oliveros terms "sonic meditation." These soundscapes are effective ways to clear out the debris of ego, worry, and make room for the authentic presentation of self later on in the class. And for the soul, silence might be "felt" or a chakra visualization offered to deepen inner awareness.

None of these examples are set in concrete since all is based on mood, weather, the day, and the needs/demands of the group. Often we have left the room, gone to a stream, and sat the entire class. This is the bottom line: How to create creative presence, attention and trust so that students can perform their secrets or lies, their autobiographies or celebrations, and their concerns or outrageousness for each other in a healing/beneficial environment.

Let's experiment now and do a fast, McDonald's version of one of my classes. First, stretch your shoulders. Good. Feel your

muscles breathe. Good. Make a sound. Disguise your voice and tell your own inner child something that you need to hear. Now make an animal sound that sums up your experience of the College Art Association meetings. Now feel the texture of silence and breathe for 30 seconds. Good.

Question: How do you grade performance art?

Montano: One of the reasons that I am not able to perform the role of professor is because I insist that excellence is not measured by ADCB, but by the ability to change, to feel, and to charge brain waves via the creative exploration of autobiography as art. Sure, in some classes my students have written extensive heady and theoretical research papers on ritual, gender, the body, the purpose of audience, and the history of performance. These papers serve as gradable objects, but I am still most at ease as a teacher when I don't have to serve as an arbiter or judge of another's excellence. I would often say to the students: "Grade yourself at the end of the semester." Or, "You start this class receiving an A." And at the end of the semester, I would say, "Do you feel that you deserve an A?" If they say no, then I would comment, "Then do x number of hours of community service to compensate for any lack of effort you might have given your work." Or sometimes I would announce, "All of you are getting As," and from the shock of that gesture, the rest of the semester we would rock and roll in relief. Why are grades so problematical? I think it's because performance art from its inception was about the edge, the outside, and the permission not to belong.

Performance artists teaching performance art in the academy have this great opportunity. They can give students:

- Permission to use both brains.
- Permission to move from trance to analysis.
- Permission to create critiques that heal and don't hurt.
- Permission to clean up our acts in front of each other.
- Permission to take the practice home and make daily life, art.

Question: Are you teaching now?

Montano: Right now I only do occasional gigs as a teacher. Fate has designed it so that I'm there to assist my eighty-eight-year-old father [now eighty-nine, and just had a stroke] who acts like MY

teacher. I call my current work *Blood Family Art* with subheadings
for *Dad Art, Sister Art, Niece Art,* etc.

My goal is to stay put, stay home [this was written pre 9/11,
when staying home became almost mandatory], not even
thinking of taking an airplane anywhere, and still teach as I did
with Linda Weintraub's students at Oberlin via sending perfor-
mance videos back and forth. This exciting model of invisibility
and nonpresent technological permission-giving led to different
levels of disclosure that I would like to continue to practice, using
video or video-conferencing as the teaching medium. Here are
some reasons why I love video and distance-teaching as the
medium of exchange:

- Video is familiar and easy for today's students because it mimics
 TV, their techno-friendly babysitter of choice.
- Video elicits a performative response and satisfies the universal
 need for stardom/visibility/play. We all love to show off.
- Video temporarily eliminates authorities/judges/censors/
 audiences and since the camera morphs into the robotic self,
 seeing/viewing the "live" self, freedom is assured.
- Video is cold and allows the performer to be hot/cold/intimate
 or distant.
- Video is a meditative facilitator, allowing the user to technologi-
 cally journey/journal themselves autobiographically until their
 history and personal story is repeated long enough to be
 silenced into self-acceptance.

Performance art is popular, taught everywhere, commodified by
the media and in need of explanation, clarification, context and
historical interpretation. While the originators of the contempo-
rary version of the genre (1960–80) are still alive (since 9/11 this
is even more applicable since travel is no longer a reliable option)
and available, it would be wise to use US WELL either in person,
or better yet, let us STAY HOME and we'll teach by video or phone
while we wait for the 4837487 other technological versions of
distance-learning to appear.

Question: Why would a performance artist want to teach perfor-
mance art?

Montano: Are you referring to classroom issues and things that

happen there like danger? Like censorship? Issues of content? Of divergent moral/religious beliefs in one classroom?

Are you referring to parental disapproval? Are you talking about the difficulties faced by teachers of performance art who have to "satisfy" deans? Colleagues? Donors? Fundamentalist alumnae?

Teaching performance art honestly and sincerely is one of the most demanding professions on earth. Those willing to dance their way through the challenges must go into the academy with:

- Their eyes wide open.
- Their aikido stances strong and centered.
- Their wisdom polished by compassion.
- Their ability to adjust to all of the other personalities matured.
- Their esthetics impeccable.
- Their history of the genre studied.
- Their humor intact.
- Their skin thick and thin at the same time.

To conclude: Let's take a minute of silence to first see/feel light and then send this light of protection to all teachers of performance art. And to those of you contemplating teaching performance in the future, congratulations, and may the force be with you.

2001

Chapter 7
Letter from Linda

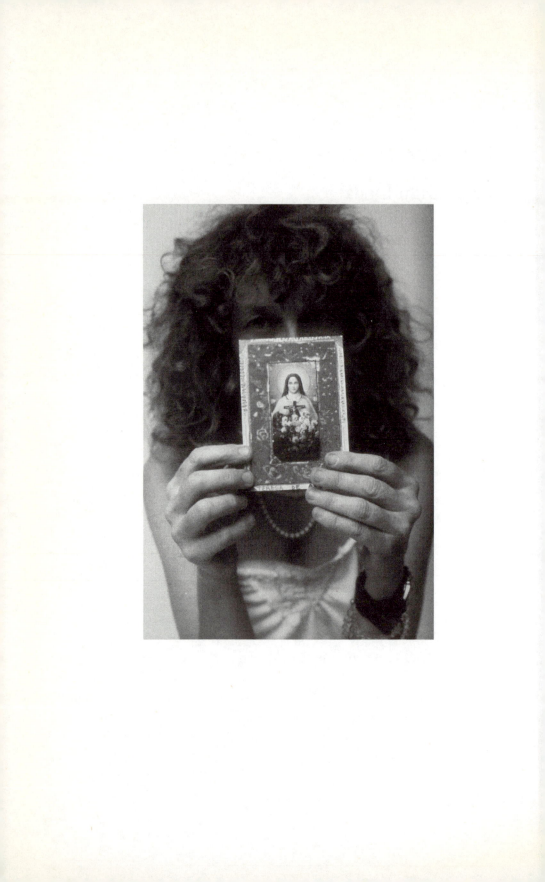

A Goodbye Letter from Linda

Dear Linda-The-Writer,

What a surprise! Where did all of these words and this book come? Not that I'm really surprised because when I remember your past, there are a few reasons why you might write so much:

1. Remember when you were a child and learned to write? Because you didn't talk much, you used to give heartfelt notes to mom and dad, secretly putting them on their pillows. The notes usually said, "Dear mom and dad, sorry I fought with _____ today. I will say an Our Father and Hail Mary for you. I love you very much. Your loving daughter, Linda." Maybe these apologies are the reason you write now?

2. Remember when you went in the convent and wrote interesting weekly letters home? When you left the convent after two years, our mom said, "Linda, why not write a book and call it *Letters From Linda*?" Maybe mom's suggestion is the reason you wrote this book now?

3. Remember when your guru from India, Dr. R.S. Mishra pointed a prophetic finger at you and said, "Linda you will write many books." Maybe that's why you are writing this book now?

4. Remember during your fifties how you wrote twenty-one stories and numerous art essays to help you deal with the complexities and volcanic/unleashed energies from inner changes? Maybe that's the reason you have a book now?

5. Remember how whenever job issues, love complications, dreams, thoughts about performance, inner ecstasy, current or old traumas, responsibilities as Dad's caregiver or world chaos entered

your mind, you would write? This is why you have a book now?

Whatever! That was then! This is now! As the voice of Linda-The-Boss, I am asking you to consider my new idea. Here it is: I want you to take a seven-year no-writing-vow beginning on your sixty-second birthday, January 18, 2004. You've taken many vows before and seen their effectiveness. Although I realize this will be difficult for you because you do love to write, please think back to that seven-year no-interview-vow you took and remember how effective that was? Right? So don't panic. I guarantee it will be OK! Your life will definitely be different because you won't be able to go to India and write your novel about an American performance artist who becomes a sadhu. Maybe in seven years you can go. Maybe not.

You won't be able to write about our Dad's death if he goes before you do, so read what you have written already in this book about transition, or find new ways to grieve. You won't be able to write fairy tales, videotexts, and treatises on aging, or poems to friends. Don't worry; take Indian singing lessons with Anita Ji S. instead!

It won't be that hard. Time flies and you can still send emails to Pauline, Minnette, Moira, Steven, Annie, Barbara, Veronica and your email group. But make them short and sweet; don't get flowery or clever.

You can still make those final edits in the reprint of *Art In Everyday Life*. That's OK. And immediately, you must write a letter to Routledge, thanking Talia Rodgers (and staff), for believing in you.

Please write a lovely story of thanks to your bright star, art sister, Jennie Klein . . . art historian extraordinaire and surrogate mother of this book. What an inspiring loyalty to the project she has! And it is her yogic powers of concentration, humble intelligence, positive good nature and editing excellence that allows this book to be a Montano-Klein collaboration, not a solo event, that's for sure!

And you must write a letter of thanks to your friend, mentor, and teacher, Dr. Aruna Mehta, who you call on the phone every day and who always encourages you, your life, and your book with words of blessing. What a Mother of Kindness!

And write a letter of thanks to your nephew, Nicholas Montano, for his CD technical support, and also to Danny Wasko and Bill Stevens for techno-wonders.

And email letters of thanks to all of the too-many-to-mention people who made this book possible: the ones who interviewed you and then let you use their interviews in your book, and the ones who had published your writings elsewhere and then gave you permission to reuse your work here. To Bonnie for her editorial expertise, to Moira for always respecting performance.

Lastly, it is our Dad you must thank very, very specially. You wrote most of this book while you were his caregiver and were observing his virtues of concentration, love of excellence, and appreciation for learning on a daily basis, since 1998. His good influence helped you create this book!

After doing an errand for him, you would run to The Saugerties Library and write something. Remember that? Thanks Dad-Friend-Dad-Collaborator, who just before his stroke gave me the go-ahead and let me make art of his life, with full consent and full enthusiasm, telling visitors how they should "act" for my video camera! Dad, I extend your video permission to this book as well, respectfully including stories that might be helpful to all.

Linda-The-Writer, things change and sometimes good things come to an end. Don't fear and pout because I've asked you to make this new vow. Trust me, closing the door to writing will open a new laboratory door into another level of spiritual understanding.

In conclusion, I ask you one more writing-favor, a gift for the readers of this book, thanking them for spending time with you in print because they are very busy and also have so many other ways to be in touch these days: e-conferencing, camera phone, cell phone, web cam and many exciting things to come! Look Linda, they are here, not there, so give them something nice that they can use, a nice saint certificate of appreciation! You are not the ONLY SAINT, you know!

Good-bye, Linda. Never forget how much I care for you and I always do what I think is for your highest good.

That's it for now.
Love, always,

Linda-The-Boss

PERFORMANCE ART SAINT CERTIFICATE

I _____ (your name)
AM A PERFORMANCE ART SAINT, AND I
DAILY BLESS MY ART AND MY LIFE.

Witness: Linda M Montano, Founder of The Art/Life Institute
Saugerties, New York, January 2004

Interviewers' Biographies

Terri Cohn is a San Francisco-based writer, curator, and art historian. She has been a contributing editor to *Artweek* since 1988, and her writings have appeared in numerous other publications including *Sculpture*, *Art Papers*, *Release Print*, *New Art Examiner*, and *Camerawork*. She has written and lectured extensively about conceptual art and new genre public art, and contributed a chapter to *Women Artists of the American West* (McFarland & Co., 2003).

Paul Couillard is the Performance Art Curator for Fado Performance Inc. and a co-curator of the 7a*11d International Festival of Performance Art. He is currently editing *Canadian Performance Art Legends*, a series of books on senior Canadian performance artists. The first installment, *La Dragu: The Living Art of Margaret Dragu*, was released in 2002.

Alex Grey is a writer and a visual and performance artist based in New York City who collaborates frequently with his wife Allyson Grey and their daughter Zena Grey. Alex Grey's most recent monograph is *Transfigurations* (Inner Traditions, 2001).

Allyson Grey is a visual and performance artist who has had one-person exhibitions at O.K. Harris Gallery New York and Stux Gallery, Boston.

Judy Kussoy was a student in Moira Roth's art-history class in 1988 when she interviewed Linda M. Montano.

Hilary Robinson is Professor of the Politics of Art and Head of the School of Art and Design at the University of Ulster, Belfast, Northern Ireland. Her publications include *Visibly Female: Women and Art Today* and *Feminism-Art-Theory 1986–2000*. She is currently completing a book on the implications of Luce Irigaray's philosophy

for feminist art practices. She is a member of both the Executive Committee and the Research Committee of CHEAD (Committee for Higher Education in Art and Design); on the Management Board for the Art Design and Communication Learning and Teaching Subject Network; Chair of the Board of the Ormeau Baths Gallery, Belfast; and on the Committee for Women in the Arts, College Art Association.

Jenni Sorkin is a curator and writer. She has published in *Third Text, New Art Examiner*, and *Art Journal*. Her article "Envisioning *High Performance*" was awarded the *Art Journal* Article of the Year ward for 2003.

Notes

Preface

1 Peggy Phelan, *Unmarked: The Politics of Performance* (New York and London: Routledge, 1990).

2 Jeanie Forte, "Women's Performance Art: Feminism and Postmodernism," in *Performing Feminisms: Feminist Critical Theory and Theater*, edited by Sue-Ellen Case (Baltimore, Md.: Johns Hopkins University Press, 1990): 251

3 Teresa of Avila, *The Way of Perfection*, translated and edited by E. Alison Peers from the critical edition of P. Silverio de Santa Teresa, scanned in 1995 by Harry Plantigia from the Image Book edition, 1965 and posted at <http://www.ccel.org/t/teresa/way/main.html> (January 31, 2004).

Introduction I: An astral interview

1 *Lying: Dead Chicken, Live Angel*, Nazareth College, Rochester, NY, 1971; *Sitting: Dead Chicken, Live Angel*, Rochester, NY, 1971; *The Screaming Nun*, Embarcadero Plaza, San Francisco, Calif. 1975.

2 This is a reference to Montano's penchant for wearing tap shoes during many of her early performances.

3 Peggy Phelan, *Mourning Sex: Performing Public Memories* (London and New York: Routledge, 1997): 18.

4 *Handcuff: Linda Montano and Tom Marioni*, Museum of Conceptual Art, San Francisco, Calif., 1973; *Three Day Blindfold/How to Become a Guru*, Woman's Building, Los Angeles, Calif., 1975.

5 Elaine Scarry, *The Body in Pain* (New York and Oxford: Oxford University Press, 1985): 34.

6 Jennifer Fisher, "7 Years of Living Art," *Parachute* 64 (November/December, 1991): 23–28, and Moira Roth, "Linda Montano: Seven Years of Living Art" (unpublished paper, 1984).

7 Amelia Jones. *Body Art: Performing the Subject* (Minneapolis, Minn.: University of Minnesota Press, 1998): 14.

8 Annie Sprinkle and Veronica Vera. "Our Week at Sister Rosita's Summer Saint Camp," *TDR* 33, no.1 (Spring 1989): 104–19.

9 Barbara Carrellas, a performance artist who collaborated with Annie Sprinkle. She did not do Summer Saint Camp.

10 Jennie Klein was unable to stick to many of the nun rules while participating in *Dad Art*. Performance Saint Training is hard work.

11 Linda Montano, *Performance Artists Talking in the Eighties* (Berkeley, Calif.: University of California Press, 2000).

12 Phelan, *Mourning Sex*: 2.

Chapter 1: Interviews

1 Paul McCarthy and Chris Burden are performance artists based in Los Angeles who became famous in the 1970s for risky performances that involved the use of their bodies. For more information on these two artists see Paul Schimmel, ed., *Out of Actions: Between Performance and the Object, 1949–1979*. Los Angeles, Calif.: Museum of Contemporary Art, 1998.

2 Martha Rosler, "The Birth and Death of the Viewer: On the Public Function of Art," in Hal Foster, ed. *Discussions in Contemporary Culture*. (Seattle, Wash.: Dia Art Foundation/Bay Press, 1991): 9–15.

3 Andrey Tarkovsky, *Sculpting in Time: Reflections On The Cinema*, trans. Kitty Hunter-Blair (London: Bodley Head, 1986).

4 Montano has since re-entered the Catholic Church as a practitioner and would probably answer this question differently today (2001).

5 Museum of Conceptual Art, founded by Marioni in an old printmaking factory.

6 The Woman's Building was founded by Judy Chicago, Arlene Raven, and Sheila Levrant de Bretteville in 1973 as a home for the Feminist Studio Workshop, an experimental program in art education. In addition to the FSW the Woman's Building housed a number of galleries devoted to feminist art and hosted performance spaces. For more information see <http://www.womansbuilding.org> (accessed August 1, 2004).

7 Vol. 1, no. 4, 1978.

Chapter 3: Writings

1 Moira Roth, "A Star is Born: Performance Art in California," *Performing Art Journal* 3 (1980): 92.

2 Les Levine to Eva Hesse, as quoted in Lucy Lippard, *Eva Hesse* (New York: New York University Press, 1976): 35.

3 Eva Hesse, in ibid.: 14–15.

4 Brenda Richardson, *Terry Fox* (Berkeley, Calif.: University Art Museum, 1971): 8.

5 Edward T. Hall, *Beyond Culture* (New York: Anchor Books, 1977): 6.

6 Caroline Tisdall, *Joseph Beuys* (New York: Guggenheim Museum, 1979): 90.

7 Shulamith Firestone, *The Dialectics of Sex* (New York: Bantam Books, 1970): 166.

8 Lucy Lippard, *From the Center* (New York: E.P. Dutton, 1976), 10.

9 Jim Moisan, "Interview with Chris Burden," *High Performance Magazine* 5 (1979): 9.

10 Bettina Knapp, *Antonin Artaud: Man of Vision* (New York: Avon, 1969): 118.

11 Suzanne Lacy in an interview with Richard Newton, "She Who Would Fly," *High Performance* 1 (1977): 5.

12 W.E. Wentz, ed. and trans., "Introduction," *The Tibetan Book of the Dead* (New York: Galaxy Press, 1960): 12.

Chapter 5: Transitions

1 Sogyal Rimpoche, *The Tibetan Way of Living and Dying* (San Francisco, Calif.: Harper, 1993): 317.

Select Bibliography

Bell, Rudolph M. *Holy Anorexia*. Chicago, Ill.: The University of Chicago Press, 1985.

Blumenthal, Lyn, ed. "Linda Montano." *Profile* 4, 6 (December 1984).

Bordo, Susan. *Unbearable Weight*. Berkeley, Calif.: University of California Press, 1993.

Burnham, Linda. "Tehching Hsieh and Linda Montano, 'Art/Life: One-Year Performance 1983–1984'." *Artforum* (October 1983) 22: 75.

Burnham, Linda Frye and Durland, Stephen, eds. *The Citizen Artist: Twenty Years of Art in the Public Arena: An Anthology from* High Performance Magazine. Gardiner, NY: Critical Press, 1998.

Carr, C. *On Edge: Performance at the End of the Twentieth Century*. Hanover, NH: Wesleyan University Press, 1993.

Firestone, Shulamith. *The Dialectics of Sex*. New York: Bantam Books, 1970.

Goldberg, RoseLee. *Performance Art: From Futurism to the Present*, rev. edn. New York: Harry N. Abrams Inc., 1979.

Grey, Alex and Grey, Allyson. "The Year of the Rope: An Interview with Linda Montano and Tehching Hsieh." Reprinted in Linda Frye Burnham and Steve Duran, eds. *The Citizen Artist: Twenty Years of Art in the Public Arena. An Anthology from* High Performance Magazine. Gardiner, NY: Critical Press, 1998. Available online at <http://www.communityarts. net> (August 1, 2004).

Finley, Karen, ed. *Aroused: A Collection of Erotic Writings*. New York: Thunder's Mouth Press, 2001.

Fisher, Jennifer. "7 Years of Living Art." *Parachute* 64 (November/December, 1991): 23–28.

Forte, Jeanne. "Women's Performance Art: Feminism and Postmodernism," in Sue-Ellen Case, ed. *Performing Feminisms: Feminist Critical Theory and Theater*. Baltimore, Md.: Johns Hopkins University Press, 1990.

Hall, Edward T. *Beyond Culture*. New York: Anchor Books, 1977.

Jones, Amelia. *Body Art: Performing the Subject*. Minneapolis, Minn.: University of Minnesota Press, 1998.

Juno, Andrea, and Vale, V., eds. *Angry Women*. San Francisco, Calif.: Re/Search Publications, 1991.

Knapp, Bettina. *Antonin Artaud: Man of Vision*. New York: Avon, 1969.

Kussoy, Judy. "Linda Montano," in Moira Roth, ed. *Connecting Conversations: Interviews with 28 Bay Area Women Artists*. Oakland, Calif.: Eucalyptus Press, Mills College, 1988.

Lacy, Suzanne. "Interview with Richard Newton," *High Performance Magazine* 1 (1977): 5.

Lippard, Lucy. *Eva Hesse*. New York: New York University Press, 1976.

——. *From the Center*. New York: E.P. Dutton, 1976.

Marranca, Bonnie. "Art As Spiritual Practice." *Performing Art Journal* 72, 24, 3 (September 2002): 25–30.

Miller, Lynn C., Taylor, Jacqueline, and Carver, M. Heather, eds. *Voices Made Flesh: Performing Women's Autobiography*. Madison, Wisc.: The University of Wisconsin Press, 2003.

Montano, Linda. *Art in Everyday Life*. Los Angeles, Calif.: Astro Artz Press and Station Hill Press, 1981.

——. *The Art/Life Institute Handbook*. Self-published book. Undated.

——. *Performance Artists Talking in the Eighties*. Berkeley, Calif.: University of California Press, 2000.

——, ed. "Special Feature: Food and Art." *High Performance Magazine*, 4, 4 (Winter 1981–82): 45–79.

——. "Summer Saint Camp 1987." *TDR*, 33, 1 (Spring 1989): 94–103.

Moisan, Jim. "Interview with Chris Burden," *High Performance Magazine* 5 (1979): 9.

Phelan, Peggy. *Mourning Sex: Performing Public Memories*. London and New York: Routledge, 1997.

Richardson, Brenda. *Terry Fox*. Berkeley, Calif.: University Art Museum, 1971.

Rimpoche, Sogyal. *The Tibetan Way of Living and Dying*. San Francisco, Calif.: Harper, 1993.

Rosler, Martha. "The Birth and Death of the Viewer: On the Public Function of Art," in Hal Foster, ed. *Discussions in Contemporary Culture*. Seattle, Wash.: Dia Art Foundation/Bay Press, 1991: 9–15.

Roth, Moira. *The Amazing Decade: Women and Performance Art*. Los Angeles, Calif.: Astro Artz Press, 1983.

——. "Linda Montano: Seven Years of Living Art." Unpublished paper. 1984.

——. "Matters of Life and Death: Linda Montano Interviewed by Moira Roth." *High Performance*, 1, 4 (December 1978): 2–7.

——. "Mitchell's Death." *New Performance* 1, 3 (1978): 35–40.

——. "A Star is Born: Performance Art in California." *Performing Art Journal* 3 (1980): 92.

——. "Towards a History of California Performance: Part One." *Arts Magazine* 52 (February 1978): 94–103.

——. "Towards a History of California Performance: Part Two." *Arts Magazine* 52 (June 1978): 114–22.

Scarry, Elaine. *The Body in Pain*. New York and Oxford: Oxford University Press, 1985.

Schimmel, Paul, ed. *Out of Actions: Between Performance and the Object, 1949–1979*. Los Angeles, Calif.: Museum of Contemporary Art, 1998.

Sorkin, Jenni. "Envisioning High Performance." *Art Journal* 62, 2 (Summer 2003): 36–51.

Sprinkle, Annie and Vera, Veronica. "Our Week at Sister Rosita's Summer Saint Camp." *TDR*, 33, 1 (Spring 1989): 104–19.

Teresa of Avila. *The Way of Perfection*. Trans. and ed. E. Alison Peers from the critical edition of P. Silverio de Santa Teresa, scanned in 1995 by Harry Plantigia from the Image Book edition, 1965. Available online <http://www.ccel.org/t/teresa/way/main.html> (January 31, 2004).

Tisdall, Caroline. *Joseph Beuys*. New York: Guggenheim Museum, 1979.

Wentz, W. E., ed. and trans. "Introduction," *The Tibetan Book of the Dead*. New York: Galaxy Press, 1960.

Index